DRAWING
Cartoons

DRAWING Cartoons

COLIN SHELBOURN

THE CROWOOD PRESS

First published in 2010 by
The Crowood Press Ltd
Ramsbury, Marlborough
Wiltshire SN8 2HR

www.crowood.com

British Library Cataloguing-in-Publication Data
A catalogue record for this book is available from the British Library.

ISBN 978 1 84797 172 2

DEDICATION
To Pam for pointing me in the right direction,
and Dogs for making me laugh.

Typeset by Phoenix Typesetting, Auldgirth, Dumfriesshire
Printed and bound in Singapore by Craft Print International

CONTENTS

ACKNOWLEDGEMENTS

Thanks to family and friends for tolerating an obsessed cartoonist for the duration of this book.

I am grateful to everyone who agreed to be interviewed for Chapter 11. All the interviewees were unfailingly helpful and generous with their time. It was a genuine pleasure to talk to a few of my cartoon heroes.

Drawing Cartoons is in part the outcome of teaching on holidays and workshops throughout the UK. Over the years, my trainee cartoonists have road-tested much of the material in the book. Thanks to them all – and keep drawing!

I shall be forever indebted to Colin Paterson, superb artist, ace hockey player and the only art teacher who thought my cartoons should be encouraged.

Finally, thanks to Dad, who showed me how to draw in the first place.

INTRODUCTION

Congratulations! You've picked up this book. What are you thinking? It could be: 'I wonder if I can draw cartoons?', or it could be: 'I wonder if this book is the right size to stop my table from wobbling?' But most likely you're wondering if you can draw cartoons, in which case ask yourself this: 'Can I hold a pencil?' If the answer is yes, then you can draw cartoons.

Cartoonists come in all shapes and sizes and their drawings range from the marvellously sophisticated to the deliberately naïve. Carl Giles, the *Daily Express* cartoonist for nearly fifty years, drew wonderfully detailed landscapes, peopled with recognizable characters, intricate machinery and richly expressive animals. Purple Ronnie, on the other hand, draws stick figures. They're both cartoonists, they both have something to say and they can both raise a laugh.

Detailed drawings and stick figures represent opposite ends on the scale of cartooning. Which end of the scale you inhabit depends on how much you practise, what you want to depict, the market you're aiming for and even, on some days, the mood you happen to be in. There's no one to tell you where on the scale you should set up your drawing board. That's one of the beauties of cartooning; there are very few rules. For every rule that does exist, you can always find a cartoonist who earns a living by breaking it.

This book will teach you the basics of cartoon drawing, skills suitable for anyone, from a complete beginner to the accomplished traditional artist who wants to try something new. It is based on over twenty-five years as a professional cartoonist and more than ten years of teaching cartoon workshops to adults and children. Some of the techniques are new to this book – you'll be the first guinea pig. Others are tried and tested. Most of them were new to me when I began teaching. They have been developed and refined with the help of the cartoonists who have attended my workshops and cartoon holidays.

We will look at developing our skills in easy stages. We'll go from stick figures to fully rounded cartoon characters with personality, expression and movement. Once we've got the hang of the basics, we'll move on to more advanced techniques: colour; computer artwork; drawing for the Internet; producing artwork for print; and setting up a professional studio. There's no fixed aim – when you have acquired all the techniques you want, go off and practise them. We're not all trying to be Carl Giles. If stick men are more your thing, at least you'll know how to draw lively, entertaining and funny stick men.

We'll also look at some of the techniques for generating ideas and thinking up jokes.

And throughout we'll keep in mind one of the primary skills of the cartoonist – how to cheat.

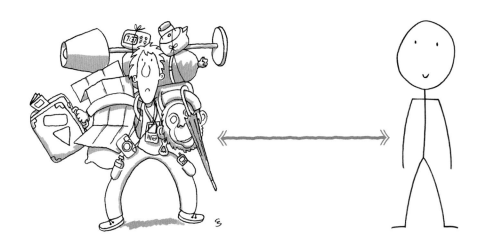

WHAT IS A CARTOON?

The original definition of cartoon comes from the fifteenth-century Italian word *cartone*, referring to the sketches produced before embarking on a fresco or mural. The word later evolved into a general term for a sketch. It is still sometimes used in its original sense of a preliminary piece of artwork – go and see an exhibition of cartoons by Picasso and you'll see superb, sketchy line drawings and very few jokes. Today a cartoon refers to anything from a single panel cartoon in a newspaper to a two-hour computer-animated epic from Pixar.

The art of drawing a cartoon is all about what you leave out. So we'll start by deciding what we're leaving out when we refer to a cartoon. A loose definition would be 'a drawing intended to convey humour or a message'. Animated cartoons, comic strips and graphic novels are a specialized case and we'll tackle them separately, later in the book. For now, by drawing a cartoon we want to create a single piece of artwork, executed with style, panache and wit, which will cause our intended audience to pause and smile or laugh. If they swoon with admiration at your artistic skill, that's a bonus.

The Four Basics of Cartooning

Cartoons and cartoonists come in a wide variety of shapes, sizes, colours, nationalities and political hues. Some cartoons convey a strong message, while others are simple line drawings, designed to lighten up a page of dull text. There are many ways to define what is or isn't a cartoon, but below are four things that I look for.

1. The idea

The idea is what we're trying to draw. We don't require realism, just the essence of the subject. We don't even have to be able to draw very well to achieve that. For example, if

we're trying to draw a man, we can do that in a few lines if they give the right clues.

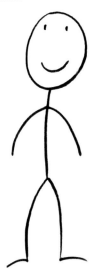

Not very elaborate, but we know instantly what it is meant to be. The same goes for drawing a woman.

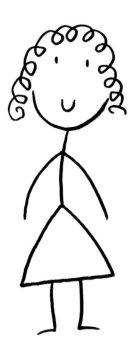

That's the world's population, all six billion, represented by a couple of circles, a squiggle and a few lines.

2. Personality

A cartoon is more attractive and engages the reader faster if it has a personality or attitude. It also turns a small, representational sketch into a cartoon. For example, take this outline of a vase.

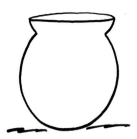

It's okay as vases go, but not very interesting. However, give it a face …

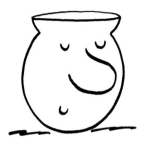

… and it instantly acquires the ability to display emotion and hint at an underlying personality.

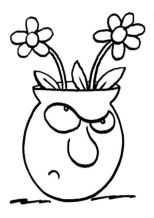

Now we're more engaged and want to know more.

3. Movement

Does our cartoon character look as if it has energy, the ability to move about, leap off the page or interact with other cartoons around it? Even if our character is standing still, there should be a sense that it could move if it wanted to.

4. The joke

It's always good if a cartoon can make the audience smile – even if that's only you. We don't necessarily need a caption, or even a joke, but it's worth having an attitude to what we're drawing, something to say about it.

And now here are four things that aren't necessary in a cartoon:

- brilliant draughtsmanship – if you've got it, great; if not, don't feel inferior
- the ability to draw everything under the sun. If you can't draw the thing when it's right in front of you – there are *always* ways to cheat
- straight lines
- realism.

Not drawing realistically has advantages. The closer to photorealism, the more it is thrown out of whack by the tiniest incorrect detail, a wrong angle, something not quite to scale. The more sketchy we are, the less likely anyone will notice that we've got something wrong. And we can always claim it's meant to be like that – *it's a cartoon!*

The other thing to bear in mind is that people don't spend long looking at cartoons. A newspaper cartoon will capture a reader's attention for maybe thirty seconds. A cartoon strip double that. So don't get precious about the drawing, especially in the early stages. Besides, what do we know? The drawing we think went wrong might be the one that everyone else thinks is quirky and hilarious.

Having got that out of the way, let's take the four things we want in a cartoon and apply them to a drawing of a dog:

- the idea:

Not the most realistic, dog but it certainly couldn't be a cat or an alligator.

- personality:

We've added eyes and a mouth.

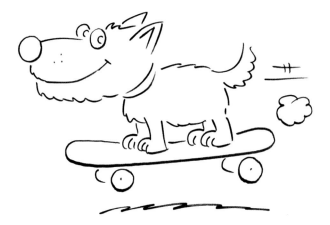

- movement:

We've slipped a skateboard under him.

- the joke:

He's now speeding along nicely.

Okay, we're going for a bad pun here. Can you guess the breed of dog? It is, of course, a skate-*border* collie.

Don't Worry ... You *Can* Draw

For the duration of this book, we will give ourselves permission not to worry about the classical techniques of representational art. They'll only get in the way and make us think we can't do it. Nor are we allowed to be overcritical about our drawings. A cartoon should be enjoyable to draw and entertaining to look at. Don't tell anyone, but being a cartoonist is the best job in the world. We get paid to play, poke fun and make people laugh.

It's easy to teach children to draw; you point them at a piece of paper and stand well back. Unfortunately, around thirteen or fourteen years of age, something happens. Along with the spots and hormones, inhibitions kick in and suddenly some of them can't draw. Nothing is good enough. It doesn't look like what it's meant to be, so therefore it can't be any good. A few years further on and their critical faculties have been honed to perfection and they are set for life as someone who always says 'I can't draw'.

This is tremendously sad. We can all draw to some extent and it doesn't require a miraculous, innate talent, which, at age thirteen, some of us have and others don't. But if we're approaching the subject again as an adult, it is very hard to get past the idea that we can't do it, we gave it up at school so we'll never be any good at it.

Recognize this? If so, don't panic. I've been running cartoon workshops for adults for more than ten years. The groups invariably include people of very mixed artistic ability. A few of them are keen amateur artists who perhaps do watercolours regularly, or have been attending life drawing classes. Some have dabbled a bit, off and on, but not taken it up at a sustained level. And then there are 'un-artists', the ones who wish they could do it, but haven't put artistic pencil to paper since they left school. Guess what? – it's the last group which has the advantage. They arrive at cartooning without preconceptions or training and what they lack in confidence is more than compensated by not having complicated techniques to unlearn. If I give a class fifteen seconds to draw a model as a stick person, the un-artists have done it. It might not be very accurate, the legs may look a bit wonky or one of the arms has gone off the page, but whilst they have drawn a complete stick figure, the practising artists have produced a splendidly drawn left knee and run out of time.

So let's get this out of the way right at the start. Find a piece of paper and a pen or a pencil, or a lined exercise book and a biro. Now we're ready to start.

Draw a box, roughly rectangular.

Draw another box alongside and slightly to the right.

Draw a circle on the front of the first box.

Add a couple of triangles pointing up.

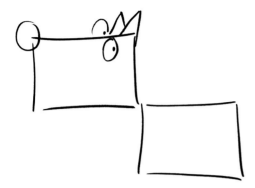

Another pair of circles and two dots.

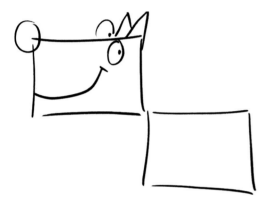

Add an upwards curving line in the first square.

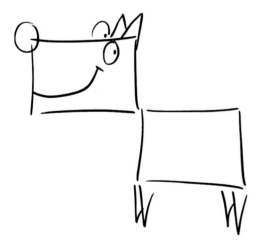

Then four longer, pointier triangles, going down.

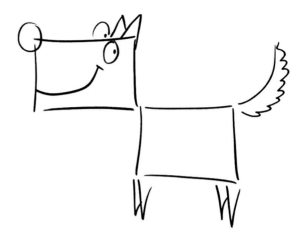

A curvy, scribbly bit at the back.

Well done, we've just drawn our first cartoon dog. An all-purpose box terrier. It looks a bit rough, but the basic elements are there. We could jazz it up a bit by adding some fur, colour in the eyes, add some highlights, improve the legs a bit, pop in a shadow and maybe a dog collar to forestall anyone asking if it's a cat. But underneath it's still the same basic pair of boxes. The important thing is that it looks fun, it was enjoyable to do and anyone who wasn't watching won't realize how easy it was.

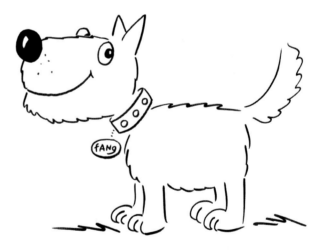

Next, let's expand our wildlife repertoire.

13

Start with a circle ...

... then add a triangle pointing left.

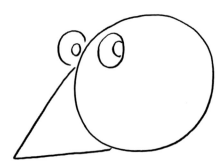

Two more circles.

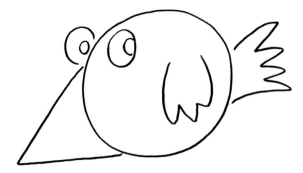

A squiggly bit in the middle and another on the back.

Two quick lines underneath ...

... and a few more at the bottom.

Now we've drawn a cartoon bird. We're doing brilliantly. You'll notice that we're making use of very basic shapes. In fact, with only four we can draw just about anything (with a bit of cheating).

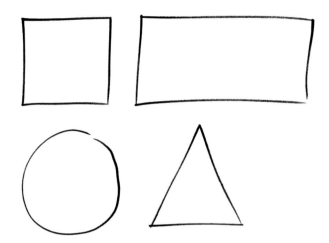

Our basic shapes: a square, a circle, a triangle and a rectangle.

With the aid of four simple shapes, the whole animal kingdom – and most of the human one – is at our mercy. And now that you're convinced you're about to become a cartoonist, it's time to get tooled up.

EQUIPMENT

Put any two cartoonists or illustrators in a room together and sooner or later the question will arise: What pen do you use? This can get quite heated. Nothing in the computer world matches the partisanship of someone wedded to a Rotring Rapidograph.

I'm going to break this into two sections. We'll start with the basics, the bits and pieces that will get us drawing and can be carried around when we're cartooning on the hoof. Then we'll move on to more advanced equipment. You are *not* to look at this until you are up and running. It can be enormously off-putting as a beginner to be told you need a studio full of equipment you've never seen before. Confronted by the 'essential gear' in some art books, even seasoned professionals can feel inadequate. I haven't used a parallel rule for ages and the last time I handled a French curve I was thrown out of the nightclub.

The Cartoon Starter Kit

Some books make great play of choosing exactly the right dip pen and presenting your artwork on expensive art board. When you're starting out, this is counterproductive. We've enough to absorb without learning how to handle tricky pens inclined to splotch ink everywhere. And faced with art board costing several pounds a sheet, even the most experienced of us feels inhibited. Cartooning should be a relaxed, free-form way to draw. We don't worry too much at this stage about precise materials, especially if our first drawings are not for print. Following is my recommendation for a basic cartoon starter kit.

The basic cartoon starter kit

Pencils A good old 2B or 3B pencil will do. When I'm out and about with a sketchbook, the Berol Karismacolor range is fun to use, although they might not now still be available. These are similar to 3B pencils but by adding water with a brush it's

possible to make a grey wash or tint. No water handy? Spit on a finger and smear it about with that.

Blue pencil This is an extremely handy piece of kit. Choose a light blue or sky blue colouring pencil (Derwent Studio Light Blue 33 is ideal, but don't feel the world is crashing about your ears if you can't find one in your local shop). Why do we need a blue pencil? For these two main reasons:

- If our drawings are going to be scanned, faxed or photocopied in black and white (as opposed to greyscale or colour), a light blue line will be invisible to the camera and/or scanner/fax machine – so we're free to sketch without having to rub lines out. This saves time and avoids wrecking the surface of the paper. This last bit is important if we're going to ink over the drawing later and we don't want it to look like we've drawn on blotting paper.

- Secondly, even if we're not drawing for print and just doodling away in a sketchbook, the blue line doesn't attract the eye. We can ink over it and most people won't even notice it's there. And sometimes it's interesting to look back and see what the original blue line looked like and how we deviated from it in the final drawing. (*See* the Interlude at the end of Chapter 3 for examples.)

Oh, there's another reason. When we've produced something for print and someone is kind enough to want to buy the original, we can point to the blue lines as a sign that this is, indeed, an Authentic Cartoon Original.

Black felt pens There are hundreds of makes, styles and types out there. Go into an art or stationery shop and play. Most art and graphics shops have a little pad of paper near the display of pens to allow you to try them out. Aim for a medium thickness nib – 0.5 or 0.7mm – and a solid black which won't blot or bleed on the paper you're using. Maybe add a fine pen for the fiddly bits and you're done.

In recent years, I've fallen deeply in love with the Faber-Castell PITT artist pens, especially their Brush pen, but I'm not monogamous. They're great for smoothly varying lines, although you can't work very quickly with them. Others prefer something like the Mitsubishi UniPin Fineline pen,

which can do very fast, flourishing lines. Brush pens require a little more care to use, but the line quality varies as you draw from thick to thin and they're simply wonderful to … ah, sorry, I was getting carried away. Where were we?

When choosing a pen, you need to form your own relationships. Take a few out, wine and dine them (and draw on the napkins), but don't be afraid to dump them if they don't feel right. Eventually you'll meet the pen of your dreams.

As you advance, you might want something which has permanent, lightfast ink so that your drawings won't fade and will stand being framed and displayed, a joy for generations to come. For now, though, pick something you like using. I have heard tales of people who like to draw with a biro, but note that the lines don't scan easily and fade quickly in sunlight.

An eraser Buy a nice new one, then see how long you can keep it in its wrapper. We're going to try to do without using one for as long as possible. When looking to buy one, go into an art shop and find a Rowney art eraser. These are like malleable putty once warmed up (hold the eraser in the palm of your hand for a bit). They are great for erasing pencil without damaging the surface of the paper, as long as you don't rub away too hard. Another option, but not as kind to the paper, is a retractable eraser such as those made by Pentel or Rotring. The ones to avoid are the hard rubber type aimed at destroying creativity in school children.

Craft knife or scalpel For sharpening the pencils, not attacking art critics. Pencil sharpeners are sponsored by pencil manufacturers and are specifically designed to break pencil points so that you get through pencils at an inordinate rate! A small, retractable craft knife is indispensable. A scalpel is more specialized, although it allows fine control for cutting paper. The absolute best is the Swann Morton retractable scalpel, but they are fearfully sharp and replacing the blade can be tricky. The aim is to make it to the end of this book with all your fingers intact.

Tippex The ultimate eraser, good for covering up mistakes. To be honest, though, I never use the stuff any more. I hate the smell of it and if you put a drawing on the scanner before the Tippex is dry, you spend the rest of the day trying to get white blobs off the glass. The artist's alternative is Wite Out. It is more expensive, but if you are using a pen with indelible ink, you can draw over Wite Out once it is dry. If you use a technical pen (such as a Rotring), take care not to clog the nib.

Paper

This is immensely useful and saves having to wash your cartoons off the walls. Here are two types which cover most eventualities:

Cartridge paper Choose one which doesn't bleed or go all blotchy with your current favourite pen. If you are starting out, go for something inexpensive – good quality computer printer paper is nice to use. Buy it by the ream and don't worry when you have to scrap a drawing.

Layout paper This has a smooth finish and is considerably thinner than cartridge paper. This means you can almost – but not quite – see through it. It's very useful for tracing drawings if you don't have a light box handy (*see* below for more about light boxes). Layout paper is easier to use than proper tracing paper and less expensive. You can buy pads of layout paper in art shops.

Alternative papers When starting out, you can save money by investing in a ream of 80 or 100gsm printer paper. This will serve as both cartridge and layout paper – you can just about see through it to trace black lines and, if it is decent quality, it will take a black line without bleeding. As this paper is relatively inexpensive you won't be too worried about churning through tons of it whilst trying to perfect a drawing.

Printer paper is usually only available in A4 size. Cartridge and layout pads come in a variety of sizes. Start off with an A4 and A3 pad of each. A3 (and above) gives more freedom to manoeuvre.

A Format Paper Sizes

In case you are unfamiliar with them, here are the standard A sizes:

A6 – 105 × 148mm
A5 – 148 × 210mm
A4 – 210 × 297mm
A3 – 297 × 420mm
A2 – 420 × 594mm
A1 – 594 × 841mm
A0 – 841 × 1,189mm

The paper doubles in size each time you go up an A-size. So, conversely, chop an A3 pad across the middle and you get two pads of A4. All very logical. A1 is wonderful for large, sweeping, expressive artwork, but I usually reserve it for presentations and drawing in front of an audience. Most cartoonists are happy drawing much smaller than that. Bear in mind if you want to fax or scan a drawing, most machines will only take an A4 sheet.

Do I need to mention that white paper is best? By all means draw on coloured cartridge paper, but it won't scan or photocopy cleanly.

Other useful equipment

Drawing board Any table will do, or use a hardback book. I spent my formative years clutching pads of paper and a battered hardback copy of Hergé's *Destination Moon* as my drawing board. It is more comfortable to draw on a slope, but you can make one of these quite easily. Get an offcut of blockboard or MDF from your local timber merchant or DIY store and prop it on a few hardback books. Voilà, instant drawing surface.

Sketchbook A sketchbook is the cartoonist's absolute best friend. Indeed, depending what you've been cartooning recently, it might be your only friend. Carry one with you at all times and it will become a trusted companion. It's something to sketch in, doodle ideas, make reference drawings, or to keep yourself amused whilst sitting alone in a café. (For a longer eulogy on the joys of sketchbooks, *see* the Interlude at the end of Chapter 3.)

A hardback A6 sketchbook is ideal because it fits in a pocket or bag and has a stiff cover to rest on. Avoid wire-bound books, as the spiral bits get caught up in your clothes. My favourite sketchbooks are the Elson or Roberson's 'Bushey' ranges (*see* Appendix). The Daler ones are also very good. Wide sketchbooks which open landscape (widthways) are more versatile, but you will no doubt have your own preferences. You are *not* allowed to buy one with perforated pages as it would be too tempting to tear them out. You should always keep your drawings, otherwise how will you be able to see how much you have improved?

A window Handy for staring through when in search of inspiration. And very useful as an inexpensive light box – if you are trying to trace a drawing, particularly if using cartridge or printer paper, place your original against the glass, put another sheet over the top and you will be able to see through well enough to trace. A professional light box achieves the same thing but at somewhat higher cost. By the way, this particular cheat only works during the day unless your window happens to overlook a street light.

If you are just starting out, that's enough equipment for now. You are permitted to return to this chapter to read the section below only after you have completed the next four chapters.

The Professional Cartoonist's Studio

Once you've progressed beyond the basics and there's even the slightest chance you're going to draw cartoons regularly (or even for a living), it is time to get more adventurous, clear out the spare room and equip your studio. Make sure that everyone else in the house understands that this room is *yours* and no one can disturb you when you are in full creative flow. I also happen to think that it is just as important to have somewhere you can leave undisturbed at the end of the day without having to tidy up. If you are in mid-project, it's irritating to have to start each day by reassembling all the work from the day before.

Your studio will include everything from the Starter Kit, plus a range of more exciting pens and papers, specialized lighting and more besides.

Pens

Dip pens Basically a nib on a stick. Hugely archaic, but strangely satisfying as a drawing implement. Combine one with the right paper and you can gain immense pleasure from making tight, handbrake turns around a drawing. You can indulge in hours of delicate cross-hatch shading or splutter and splatter exuberantly across the page (and consequently replace the nib every two days). As systems go, they aren't very portable (you need a bottle of ink) and it can all get very, very messy (at least it can when I use them). But many cartoonists swear by them (and a few of us at them).

Fountain pens The regular handwriting fountain pen isn't suitable for drawing with as it's not designed to use Indian ink (*see* below). They clog up with Indian ink, but regular ink fades. However, you can get fountain pens designed specifically for drawing, which can take lightfast ink. The Rotring ArtPens are a brilliant example. They come with ink cartridges (plus a spare in the barrel), or you can fit a reservoir. Rotring makes a range for calligraphy, but two are specifically for drawing. These are great to carry around with you and produce strong, expressive lines capable of varying thickness, just like dip pens.

Technical drawing pens Traditionally referred to as a Rotring (they are different to the ArtPens), although others make them too. These are cartridge pens with thin, tubular nibs, available in a range of specific thicknesses. They are intended for technical drawing and, in theory, produce a fixed-width line (you can vary it, but the pens break down sooner). Their big drawback – apart from producing a rather sterile line – is that they clog if left unattended for more than five minutes (I'm exaggerating) and you spend half your time

cleaning them instead of using them. Good displacement activity, however.

Brush pens These are available in many sizes, shapes and makes. As mentioned earlier, I like these and use them a lot. Much easier than using a proper brush. But make sure you get a professional variety with lightfast ink.

Pantone pens These are produced by Letraset and are felt tips much used in design and advertising studios. They are keyed to very specific colours across a wide range of media, enabling consistent colour matching for work in print. Expensive and rather specialized, they are, however, excellent for providing quick washes of colour and shading. They used to be chemical-based and rather smelly – a few hours in an enclosed space and your drawings got more and more random. The modern ones are much better. Many of them now come with a broad nib at one end of the pen and a fine nib at the other.

Other pens Depending on the scale you draw, any size or shape of felt pen could prove suitable. Biro is also fun to use, although rather frowned on in professional circles because it does not photocopy well and the ink is not lightfast.

Inks Indian ink is the best for dip pens. It is a strong black which won't fade over time.

Brushes and other media

A number of cartoonists use brushes for line work, including Giles and Bill Watterson (*Calvin and Hobbes*). It gives the line a varied width and a lively, organic feel. I find them a little uncontrollable for fast work but brush pens are a good compromise.

Pencils, charcoal, pastels and crayons These are all highly usable if they reproduce well. Softer pencils – 3B and beyond – are darker and so reproduce more easily for black and white work. The broken line is attractive to view and fun to produce. Charcoal is notoriously prone to smudging, so it is advisable to use a spray fixative; you never know how the person receiving your artwork is going to treat it. Ditto pastels.

Crayon is more specialized and more appropriate for colour work. A word of warning: some crayons look great on the paper, but, because they are made up of multiple pigments, are difficult to reproduce for print. Anything with a hint of luminosity (bright green) may simply reproduce as a dull green. If you are using crayons and can speak directly to your printer first, it is worth making up a sheet of colours and asking him/her to scan and test them.

Process white An opaque white paint, used for covering those embarrassing mistakes. Similar to Tippex, but easier to ink over when dry.

Protractors, rulers and French curves All very useful for precise drawing and handy to have around the studio. Nine times out of ten I can't find mine under piles of paper, so I cheat and generate the required shape on the computer, print it off and trace that.

Paper

The wonderful world of paper is ever-evolving, with new varieties coming on to the market all the time. Here are a few of the regulars you may encounter with suggestions for why you might need them.

Acid-free art board and paper Acid-free means that the paper will last without going yellow, without the ink fading and, should you hit the big time, museums will be able to display your work for generations to come. Combine with lightfast inks and you need never fear hanging your work on the wall. (It's still better to keep it out of direct sunlight, however.)

Paper is graded by weight – the heavier the thicker, in general. 120gsm or more is good. Too heavy and you stray onto board. This is good for working in wash and watercolour as you don't need to stretch the paper first. However, there's a big BUT: you can't fit board on a professional drum scanner (which requires the artwork to be wrapped around a drum), so artwork on board creates problems if it is going into print. (Some boards can have the top surface peeled away to put on the drum – but do you fancy doing that with your precious artwork?)

Bristol board A fine grade watercolour board that is expensive but great to use for colour washes.

Polydraw Nothing to do with artistically-inclined parrots, this is a plastic film, rather than a paper. You can buy it in pads or by the roll. It will take ink, but is a draughting medium rather than fine art. It's translucent, so good for tracing, but its big advantage is that if you use a scalpel very, very carefully, you can scratch out erroneous lines. If you are a masochist, you can also cover a large area with black ink, then use a scalpel to make fine scratches and emulate a woodcut. (I have actually done this and, rather like banging your head on a wall, it is *so* nice when you stop.)

Some art shops will sell you paper by the sheet, which is a good way to experiment without going to a lot of expense. Some papers have a good 'bite', that is, a rough surface which creates friction as you draw. You may like that. Or you may prefer working on a surface which is super smooth. I find that paper surface has almost as much influence on line quality as the type of pen you use. By all means try them all but don't get too neurotic about finding the perfect paper.

Other accessories for the perfect studio

Light box Another companion the cartoonist shouldn't be without. These are brilliant for Almost Tracing (*see* below). In case you don't know, they are a bulb in a box, the top surface of which is translucent. Place your drawing on the illuminated surface and you can trace through almost anything. They come in a variety of sizes (usually A sizes) and a range of prices. You probably will never need a colour-corrected light box (used more by photographers and designers), so check when buying that you aren't paying for more than you need. I recommend A3 or larger to give some elbow room. You can always mask off the part of the box you are not using, but it's a nuisance if you have to trace something that is bigger than your light box. You can buy cheapish ones from craft and art shops. Go to a specialist graphic design or photographic dealer to get one of the larger, more robust variety. Searching online is a good starting point.

When you are starting out, if you can't afford a light box you can cheat by taping your drawing to an outside window and putting your paper over that, though, as noted above, it only works during the day unless your window faces a bright street lamp. Alternatively, find a glass coffee table and put an anglepoise lamp under it.

Anglepoise lamp Very handy for illuminating your creations. Go for the most manoeuvrable you can find and you'll never have to suffer shadows on your paper as you work. The traditional sort that take normal bulbs are the best as you can substitute the household bulb with a daylight bulb. This is simply a colour-corrected light source which mimics the wavelength of natural light. Much more pleasant to work under and good for judging colour work.

An additional bonus of a good anglepoise lamp is that if you have a small mannequin or similar object you are drawing, you can manoeuvre the lamp around to get the shadows right, should you wish to draw them. So I'd better mention …

Mannequin A wooden, fully-jointed model of a human figure, which is usually about 30cm high and found in expensive art shops. However, you may be able to pick them up cheaply in charity shops or those multi-branch discount book places like The Works. When I was but a simple youth, I used an Action ManA, which was half the price and had an unrealistic beard.

Drawing board Not essential, but better for your back than crouching over the kitchen table. The bigger the better. As I work, I tend to stick notes, sketches and reference drawings all round my drawing board. It can become a thing of beauty in its own right. A desktop drawing board is fine, although you can't vary the height (a facility which can be surprisingly useful). A good, floor-standing drawing board (such as the Italian make, Bieffe) is expensive to buy new, but as everyone is moving over to working on computer, they crop up cheaply second-hand – have a look on eBay.

Chair This may sound silly, but find a decent chair. If you're sitting at the drawing board all day, waiting for inspiration, you don't want a bad back at the end of it. Most office shops only sell glorified typist's chairs, so find a specialist. You want something with lots of movement. A stool works well at a drawing board and encourages you to leap up now and again (and pace about to get ideas). Visit one of the specialist back shops, tell them how you work and see what they recommend. There is one which is quite wacky and allows you to sit on it backwards (cowboy style) and use the backrest to support your chest as you lean over the drawing board. Great for fine, detailed work. Note that some illustrators prefer to work standing up. It's cheaper.

Music Not to be under estimated. Feeling dull? Ideas refusing to come out of their cave? Put on some energetic, uplifting music and see where it takes you.

A note about tracing drawings

We all do this, either to redraw a rough preliminary for final artwork, or because something has gone wrong and it's quicker to start again. Take a tip from Quentin Blake and Tony Ross, two artists whose illustrations have a marvellous spontaneous feel to them: when you trace, don't try to be too accurate. Arrange your tracing so that you can see the general shape of what's underneath, but not too much detail – then do Almost Tracing. If you try to copy too closely, you'll lose the spontaneity. Quentin Blake uses thick paper on a light box, but tracing with layout paper has much the same part-revealing, part-obscuring effect. (No cheating and peering under the top sheet.)

FACES

Unless you are a hermit, you are surrounded by faces. They come in all shapes and sizes – fat, thin, long, squat and so on … Some of them are supremely beautiful, whilst others appear to have been formed by throwing putty at a wall. It is a kaleidoscope of geometry and the cartoonist's stock-in-trade.

In this chapter, we're going to examine what lies at the heart of being a cartoonist – capturing faces, expression and character. Using a few simple techniques, we can change a bland drawing into something which immediately captures the reader's attention and pulls them in. Once you've mastered the basics, you can enliven any drawing by giving it emotion and personality, for example transforming a simple drawing of two fish into something much more interesting.

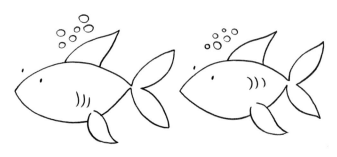

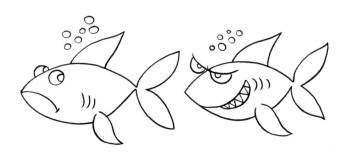

It's what separates a whimsical little doodle from a cartoon that has a character and a life all of its own.

Recognizing Faces

The human brain is hard-wired to recognize faces. We can all do it from birth. All it takes is a circle, a line and a couple of dots and our innate face-recognition software does the rest.

The tendency is so strong, we can even represent faces with three strokes of a keyboard:

<div align="center">

:-) ;-) :-(

</div>

Our ability to make a face from such rudimentary bits of information is all down to evolutionary programming. After all, if you're wandering through the jungle at night and you see a couple of circles, your imagination will fill in the gaps.

It could be something innocuous.

Or you could be about to become something's dinner!

This handy evolutionary trick makes life a lot easier for cartoonists. We can get away with drawing very little to arrive at something which is instantly recognizable. Our reader is going to do most of the work for us. The man shown here is identifiable even though the drawing lacks a forehead and back of the neck, and we know it's a woman even though the poor lady consists only of a few features and a hairdo. How *much* you want to draw depends on the *style* you choose to draw in.

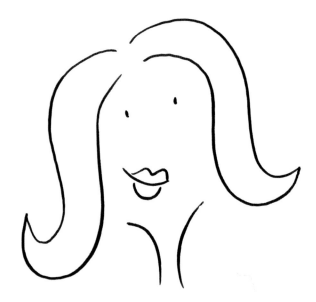

As you start off, there is an enormous temptation to fill in every last detail. Don't. Hang back. Deliberately leave details out. See if it works without all the extras. The trick is not to get in the way of your cartoon. We'll come across this idea again and again as we progress. The more complicated, intricate and realistic you make the drawing, the easier it is for it to go wrong. A realistic drawing of a face needs only one small detail out of place for the whole drawing to look wrong. A much simpler drawing, on the other hand, can be missing any amount of detail, but the reader will still be quite happy.

First Expressions

We will start off with something very basic. We're not looking for precision here, just a few wobbly marks on the paper. Relax, draw large and enjoy yourself. First, sketch a series of four circles. Large, small, distorted or perfect, it doesn't matter.

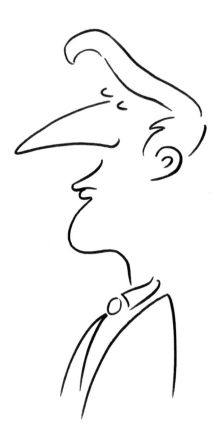

Now practise smileys. A couple of dots for the eyes and a line or curve for the mouth is all you are allowed.

Not bad. Now take a blank sheet and draw as many circles as you can fit onto the page. At least twelve. Now do some more smileys, but speed up a little. Throw the dots and lines down as though you hadn't a care in the world. You scorn precision and symmetry. You laugh in the face of a world paper shortage. Use a pencil if it feels faster – the twelve I've drawn here took forty-five seconds.

You'll quickly discover that the less symmetrical the drawings become, the more quirky and interesting they are. There should be at least a couple there that stand out as being more interesting than all the others. So with just a circle, two dots and a line, you're already on the way to drawing a face with character.

Now the whole gamut of human expression lies before us. Just so we don't get too boggled, let's see how simple we can draw them. There are three basic expressions: happy, sad, angry.

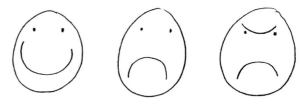

We've all these with just a couple of dots and a line. In fact, for angry we can start with just two lines.

Add some steam and he's livid.

We can also vary the happy face and make it rather more ecstatic by replacing the dots with two little curves.

Or we can make him look rather pleased with himself by turning those 'eyes' through 180 degrees to create a 'smug smiley'.

We can take our sad face and add some eyebrows to make him look forlorn.

Finally, a black cloud hovering overhead makes him look really gloomy.

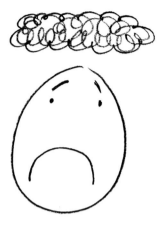

It's amazing what we can do with a few little lines. However, to do anything more sophisticated, we need at least one essential addition – a nose. At this stage we can portray this in a number of ways – a line, a circle, a somewhat stretched u-shape or a v-shape lying on its side.

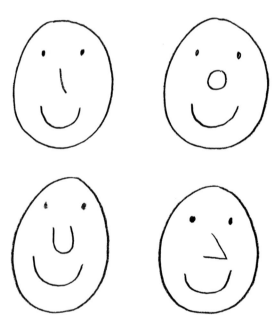

The u-shape is simplest and quickest, at least for a male nose, whereas the v-shape can represent a female nose, which, as we all know, is a slim, delicate thing. We'll play more with noses later in this chapter, but now it's time to work on the eyes.

The Eyes Have It

The real key to portraying a face that has character and personality lies in the eyes. Although there are cartoonists who always render eyes with a couple of dots (Hergé's *Tintin* for example), drawing the full eye with a pupil gives you more scope for expression. In some ways it makes things easier. For instance, to show a character looking to the side we no longer have to revolve the whole head. Here we've shown the eyes as white circles with a couple of dots for pupils.

Important tip If you leave a small area of white in each pupil, it makes the eyes look alive and interesting. Don't believe me? Try inking them in once you've drawn them. I usually put the white dot as an indication of where the character is looking. Technically, I suppose, it's reflecting the available light source, but I'd leave that to the 3-D enthusiasts otherwise it gets complicated and distracting.

Now that we have pupils, the eyes can roam about. Place two faces on the page next to each other and they can suggest some kind of interaction without anything else being shown.

All cartoonists should have a collection of DVDs of films for inspiration and reference. The true masters of drawing eyes are Chuck Jones and Pixar Studios. The *Road Runner* cartoons, *Finding Nemo* and *Cars* constitute a mini-masterclass in drawing expressive eyes. *Cars* achieves a wide range of expressions despite the fact that the eyes are windscreens. The first time I saw the film I thought, wait, how did they do those expressions? The pause button on a DVD player is an essential bit of kit.

Stern Instructional Note About Eyes

This is a very personal quirk, but this is my book so here is one of the few rules of cartooning I think you should follow. You are *not* allowed to give your characters crossed eyes just because it looks wacky. This is a cheap trick reserved for rank amateurs and rubbish cartoonists. Unless there is a compelling reason to do otherwise, cartoon eyes look best if they operate in a realistic fashion. This might seem ridiculous when we're still working at a very basic level, but we are trying to get across the idea of expression and character. Reducing everything to wacky faces destroys the effect. It also gets monotonous for the reader after a while. (The same goes for relentless use of goofy teeth.) The Cartoonist's Prime Directive is: don't get in the way of what you're trying to portray.

ugh. double ugh.

For a good example of this rule in action, study *The Simpsons* animated TV series. Yes, their faces are yellow, the top of Bart's head ends in an unrealistic scribble and no one could possibly have a gravity-defying hairdo like Marge, but watch their eyes and you'll see they always obey the realistic

rule. This was set down in the series' bible by the show's creator, Matt Groening, and the characters are stronger for it. It helps the viewer to forget the fact that they are watching a sitcom in which the actors are drawings rather than real people.

You are allowed the occasional exception; for instance, if a character is dizzy, drunk or on drugs. The effect will have more impact for having been used sparingly.

As a general rule, cartoon eyes look more interesting when the pupils are off-centre. Staring straight ahead gives them a somewhat bewildered, glassy expression, whereas moving them slightly away from centre immediately gives the face more character.

Exercise

Take a single sheet of A4 paper and draw a face shape on it. Add a nose and a mouth, then two circles for the eyes, but without the pupils.

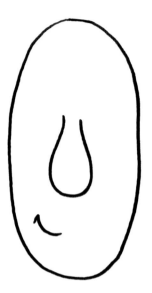

Add two circles for the eyes, without the pupils.

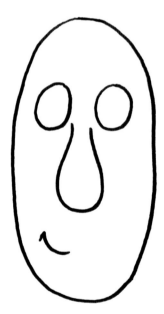

Next, get out the cartoon kit and dig out a craft knife or scalpel. Cut out the circles in the face shape, leaving the black line. Cut a strip from a new sheet of paper and place it below the cut-out circles in your first drawing. Draw two dots lined up so that they are roughly central to the eye holes.

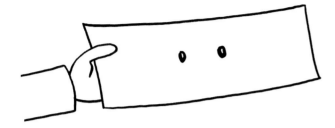

Now take the strip and place behind the first sheet and complete the eyes. You can now play around with this, moving the eyes from right to left, seeing how it changes the character of the face. Just a small move can achieve quite a different effect.

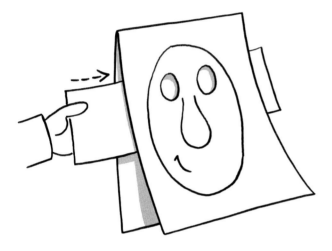

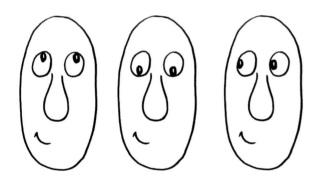

I freely admit this is quite childish but it's also good fun, especially if you take it one step further and do it to celebrity photographs on magazine covers. It's a useful trick if you're having trouble getting the eyes right. Move the pupils around until they are in just the right place, then pop a sheet of layout paper over the whole face and sketch in the final drawing. It's quicker than constantly drawing and redrawing.

Heads From All Angles

Looking at a face straight on is okay, but it's not terribly interesting.

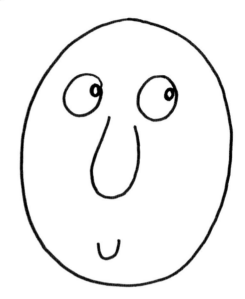

It's time to dig out the blue pencil and get technical. It will allow us to sketch away without feeling tense – we're not working on the final drawing so it doesn't matter if it goes wrong. We could also use a soft black pencil (2B or softer) and rub out the lines later, but all that rubbing out is a waste of time and might damage the paper. Besides it's good to look back later and see the underlying sketch.

We'll start by stretching our original circle into an oval and adding some guidelines. They are about one-third down and one-third up the face. Don't get hung up on precision. It's not architecture. We're drawing guidelines, not must-get-right lines.

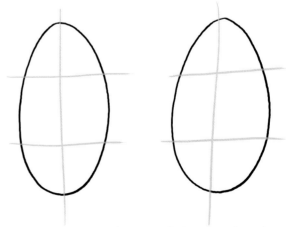

This will give us an indication of where to place the eyes, mouth and nose.

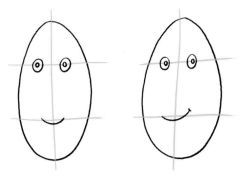

Add the eyes and mouth in ink.

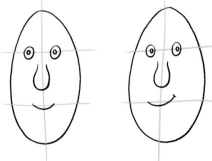

The nose is usually somewhere in the centre (unless our character has had an accident).

Having got our oval, we can imagine it as a three-dimensional shape simply by curving the lines a little and moving them off-centre, or by moving them up and down.

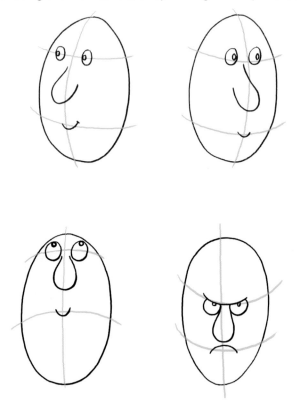

To help picture this, we can draw the guidelines on an egg

(preferably a hard boiled one or things can get terribly messy) and twiddle it about.

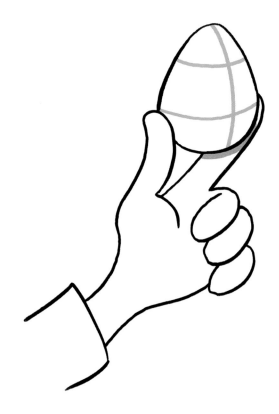

Add the eyes, mouth and nose. Take the horizontal lines right round the 'head' and add ears, which sit between the two horizontal lines. Notice that our nose has also gone three-dimensional. But remember – the guidelines are just that. If you are happy without them, sketch away.

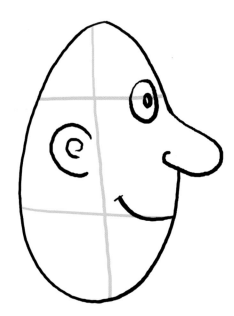

Now we can make faces that are rather more interesting.

Two faces viewed side on can be confrontational ...

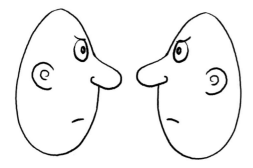

… or perhaps they've stopped speaking to each other.

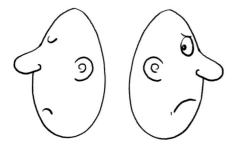

Drawing a face straight on or in profile isn't very interesting, in the main, especially if it is one face on its own. Turning it slightly is much better.

Bit tricky fitting in that other eye, isn't it? But it's a cartoon – rules of anatomy are there to be broken …

This is more interesting. Notice that it doesn't really matter that we've cheated and left an eye floating in mid-air. In fact, it gives the drawing character. Cover the floating eye with one finger and see if you prefer the face with or without it. Whichever you prefer, that's the way you can draw. There's no rule about this.

This is something we'll come across a lot as we draw a wider range of figures and objects. Nine times out of ten you are drawing what feels right, not what is technically right. We're trying to depict, engage and amuse, not necessarily in that order. After all, it didn't harm Picasso's career.

If you want your style to be more realistic, you'll have to forgo this technique. I use it a lot and it's fun to see how far you can push it. Obviously it's better if the eye stays on the same page.

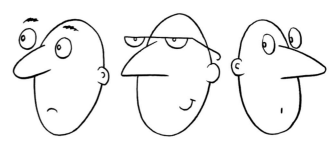

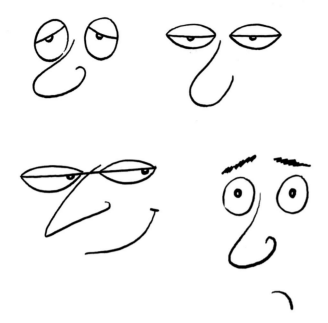

Eyes can vary a lot. By modifying the eyelids and shape of the eye, we can achieve various different expressions.

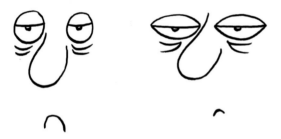

If we want the eyes squeezed shut, in a sneeze or in pain, we can do it with three little lines.

Expressions

Now that we have a more realistic set of eyes, we can make our expressions more sophisticated. We'll also add some

eyebrows now and again. First let's go back to our first set of three expressions.

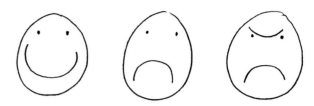

We can push these to extremes by adding tears, a really heavy brow for angry and going overboard with the happy face.

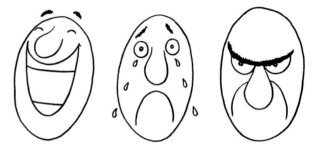

When drawing the happy face, keep the curves expansive and bold. You'll notice the eyebrows have levitated off the top of the head and the eyes have become curves. Oh, and if you add a little device formed from an 'm' and a 'u' in the centre of the mouth it suggests a tongue, which somehow indicates the mouth is wider, the laughter is louder. That's aided by the tears of joy. It's all little stuff, but it helps get the impression across in the minimum of time.

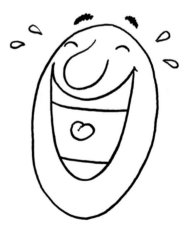

Time to try a few more expressions. When you are confronted with having to draw a particular expression, there are a number of approaches you can take:

- Draw from a photograph or from life – possible but

difficult. As usual, you've got the problem of capturing the expression, making it obvious and turning it into a cartoon all in one go.

- Go and see how someone else has drawn it. A very good idea, particularly if you look at comics, like *The Beano*. They are very good at big, bold cartoon expressions. Don't just copy the drawing; try to work out what the artist has done to suggest that expression.

- Pull faces in the mirror, in order to familiarize yourself with how expressions look.

- Draw the *feel* of the expression. I admit this is a personal quirk, but I find it easier to get into the *feel* of an expression or a pose than to draw what's in front of me. This usually involves pulling the expression as I draw it.

- Think of the clichés. Which phrases or descriptions are associated with particular emotions? For example:
 ⇒ **Frightened** My hair stood on end, my skin came up in goosebumps, I was trembling all over, I went white as a sheet.
 ⇒ **Happy** He was grinning from ear to ear.
 ⇒ **Sad** Why the long face?
 ⇒ **Angry** Heavy brow, glowering, steaming mad.

As usual, exaggerate – so if we're drawing a sad face (a long face), make it reeeeaaallly long, while the frightened face can pull out all the cartoon effects – wobbly lines (shaking), hair standing on end, eyes wide and those peculiar perspiration marks European cartoonists use to denote shock or surprise.

Quick exercise

Here is a selection of emotions. Take a fresh piece of paper and, as simply as possible, have a go at illustrating each of them:

- amused
- arrogant
- bashful
- bemused
- nervous
- piqued
- resentful
- smug
- sneaky
- superior/aloof.

Small changes

Because our drawings are so simple, we can change an expression by just a slight shift of one of the elements.

Moving the mouth off-centre makes it quirkier and more interesting. Try this for yourself by taking a sheet of layout paper and drawing a face without the mouth.

Now draw a small u-shaped mouth on a separate sheet of paper. Place it under the layout sheet and move it around. See what it does to the expression when you vary its position. Again you can use this as a trick to get the mouth just right. Once you like what you see, trace the mouth on the layout paper and no one will ever know that you cheated.

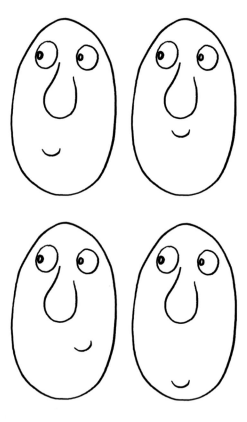

A final point (for now). Sometimes you try really hard to get an expression and it doesn't come out the way you wanted. Occasionally, if you're lucky, it suggests a different expression entirely. When that happens, if you can't use it for the project at hand, label the drawing and pop it in a scrapbook or reference file so you have something to look at when you want to draw that expression in the future.

Exercise

Take a blank sheet of paper, the bigger the better (A3 is ideal for this sort of exercise). Take your fastest sketching pen, the one which enables you to draw quickest without spluttering or breaking a nib. Now draw twenty quick faces, all with DIFFERENT EXPRESSIONS without thinking about it.

STOP! You were thinking about it, weren't you? Put a watch next to the paper. You now have *five minutes* to do all twenty faces, starting … NOW!

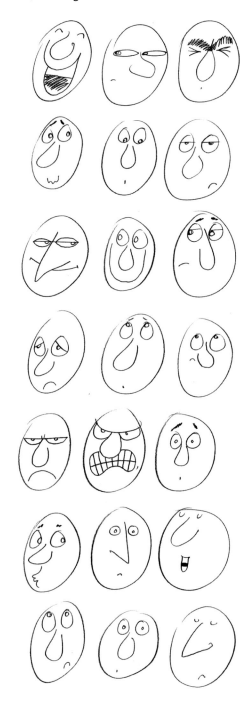

Very good. Go and make a cup of coffee, you've had a hard chapter so far. Leave the pad where it is. Go on, off you go. Don't worry about me, I'll amuse myself while you're gone, maybe by doing a cartoon …

There was a stranger in town and they didn't come much stranger than the Unicycle Kid.

Back again? Where's my coffee? Never mind. The point is, you've had a break. Now look at the faces you drew a few minutes ago and answer the following:

- Which emotions are they displaying?
- Do any of them suggest a different expression to the one you intended?

Because that's the important thing. Sometimes we'll doodle away and something quite unexpected will pop onto the page. You look at it and think, that's a really good bemused face, how did I do that? Don't worry how you did it – label it, put it away in your reference file and next time you're required to do a bemused face, copy that one.

As a longer-term exercise, keep a sketch pad handy whilst watching TV or staring out the window in reflective mood – any time you're *not* primed and ready to draw. Doodle away at expressions, don't pay attention to what you're doing and see what happens. Don't label anything. When it's time to do something else, go through them and see what the faces suggest. Which ones leap out at you and shout FRIGHTENED, ANGRY or FILLED WITH EXISTENTIAL DOUBT? The ones that work, or simply amuse you, paste into a scrapbook and use for reference.

Noses

Time for a few noses. They come in a rich variety of shapes and sizes. It's tempting to draw them all the same – and some cartoonists do this; I'm guilty of it myself when pushed for time. But it is much more fun to try and capture real life noses in the wild. Let's look at a few examples …

… and the faces they fit on.

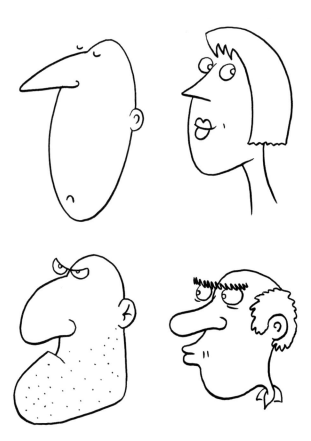

Of course you can go against stereotype – although the results are a little weird.

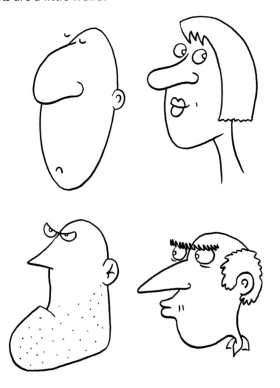

Match the nose to the character – for example a sneaky character could have a long, thin, devious nose.

A member of the aristocracy may have a more snooty appendage.

Noses can be long, small, short, stubby, snubby, fat, hairy, bulbous, pert, turned-up, turned-down, misshapen, broken, Roman, pointed, wide, flaring, hooked, pudgy, snout-like, spotty, prominent, retroussé, snooty, Grecian, flattened, sharp, dripping, distinctive, red, pinched, aristocratic, aquiline, venous, tuberous and running. How many of those can you illustrate?

When you're out and about and see a nose you like, jot it down in your sketchbook. In fact, why not keep a page exclusively for noses – then you have a handy reference for later. (And a bizarre page to show your friends.)

Exercise

Here is a selection of noses. Pick a nose, any nose. Copy it, then add the appropriate face and expression.

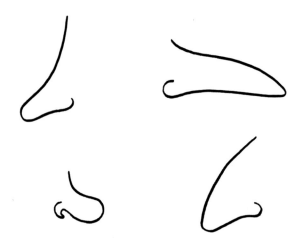

Face Shapes

So far I've stuck to a basic oval shape for the face. Just by modifying the nose and the expression we're getting some variety.

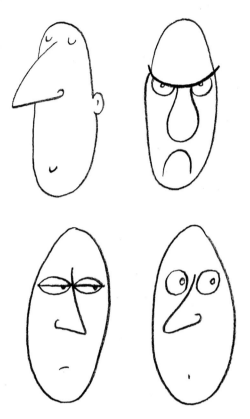

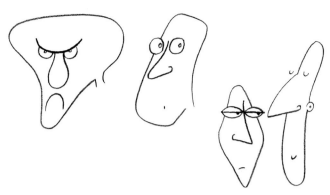

The triangle could be a child. Turn it the other way up and it becomes a tough guy.

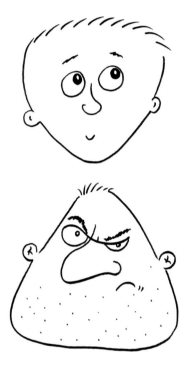

However, real people aren't like that. If you want to keep your cartoons simple, there is no reason why you can't pick a shape and stick with it. If that's your style, that's fine, but think what you might be missing out on by not experimenting with other face shapes. Each of them should suggest a different character.

Take the faces we drew in our ovals and put them in the appropriate shapes and we get four completely different characters.

We need to modify the face shapes when we draw different sexes. The male face on the left (overleaf) can be chunkier, beefier, more manly by simply squaring off the top and bottom of the face. The woman's face can be given a more pointed chin and rounded top of face. The forehead can be a little larger too.

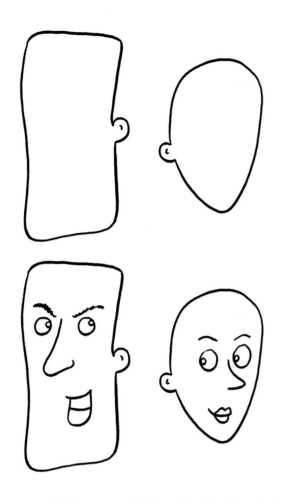

We can apply the same principles when drawing the faces in profile. Round things off a little, make them smaller and you go from a man's face to a woman's.

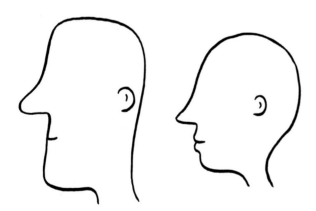

We will come back to explore this further in Chapter 6.

Facial Accessories

There is a great range of facial accessories available in all good cartoon stores. We're only just starting. Hair is a good one to begin with. We'll start with the stuff on top of the head. Generally, hairstyles are a good indicator of character, especially in a cartoon.

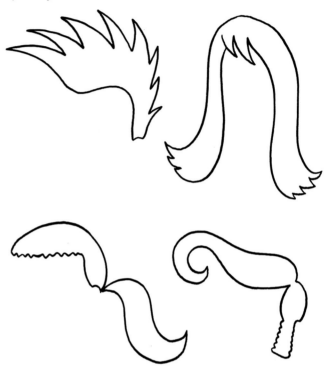

If you want to keep things simple, you can vary a face by adding any of those styles to the same face.

Here's a fairly anodyne face …

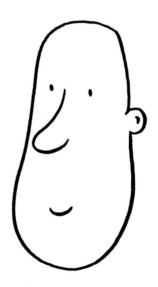

... now let's jazz it up a little.

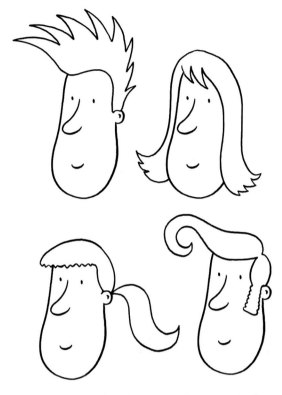

But it's much more fun if you vary the nose, the face shape, and the expression ...

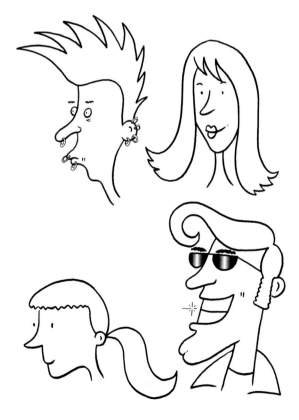

... and that's without considering facial hair.

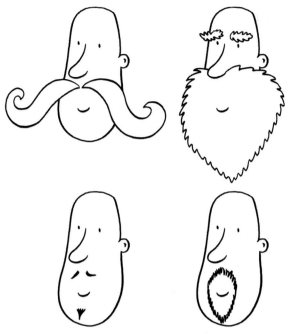

We can also define characters by the glasses they choose.

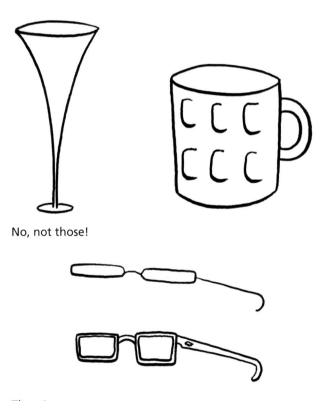

No, not those!

These!

At times, it may seem appropriate to leave the glasses blank, so that you can't see the eyes. It gives the face an impassive look which might be useful. It also means you leave the reader to read the character into the face. A good

example of this is the Scott Adams' Dilbert cartoon, where few of the faces have eyes. Or mouths, come to that.

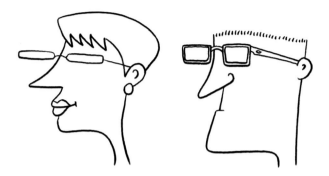

Glasses are great fun to draw because, by and large, a person chooses a pair of specs to fit their face and personality. Fashion comes into it too, with the modern trend being for very small glasses. Get the glasses right and you have one more small indicator of who your cartoon character is, their age, their relationship to modern trends … so keep another page in your sketchbook for glasses. Once you've drawn a few, you'll soon be able to imagine the faces that go with them.

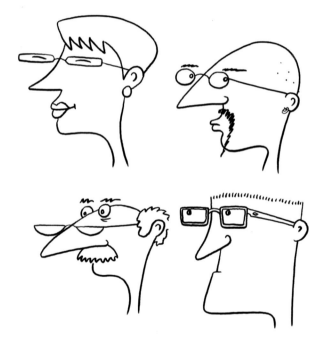

These glasses hint at the personalities behind them.

Exercise

Once you have got the hang of drawing faces – even if they all look the same – you can start to put them on anything. A personal quirk of mine (okay, one of many personal quirks) is to illustrate my shopping list. I usually do this by the highly sophisticated process of scribbling a face on a drawing of whatever it is I am supposed to be buying. They usually end up as bad puns. (For some reason, Loo Rolls always sounds like a soul singer.)

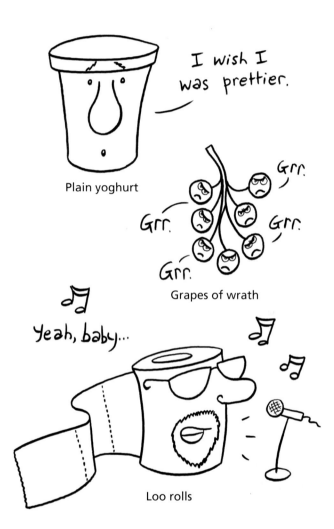

Plain yoghurt

Grapes of wrath

Loo rolls

Your mission is to do the same with the following household grocery items. I've included one or two clues to get you started.

- apples (lots of varieties to draw – for example, Granny Smith, French golden delicious)
- bananas
- cereal (think serial killers perhaps)
- coffee (arabica, Colombian, fair trade, unfair trade)
- crackers (easy …)

- cucumber (cool as)
- dishwasher tablets
- French loaf
- honey
- jam
- lettuce (lettuce pray)
- meat (chicken, lamb, hot dogs – come on, I don't need to tell you all this)
- mushrooms
- pet food
- potatoes (King Edward's, new, Maris Piper, baking)
- tea (think of the varieties again – Earl Grey, jasmine, assam, Tetley's, teabags)
- washing-up liquid.

That's enough prowling in my kitchen cupboard. The next time you go shopping, illustrate at least *half* the items on your list.

Field Work

When drawing faces it's useful to have one or two to work from. This gives you two choices – use pictures or draw from life. Pictures and photos are fine when you are working away in the dead of night, or rushing to meet a deadline. But nothing beats the variety of drawing from life, simply sketching whatever comes into view. You can, of course, try to persuade friends and family to model for you, but I find that the better you know someone, the harder it is to draw them. Plus they are more inclined to ask to see the drawing and get upset if it's unflattering or gone wrong. What you need is a good supply of strangers and unless you're rich enough to hire them from a professional model agency, you're going to have to capture them in the wild.

So first step, find your strangers. Park yourself at a window, in a café, in a boring meeting … take a sketchbook or a pad and a pencil. If it's inconvenient to suddenly get up and find a café or if it's wet, the middle of the night or you're housebound, you're allowed to cheat (we're cartoonists); find a glossy magazine or use the TV.

Don't get too involved, particularly the first few times you try this. Concentrate on one aspect of the faces you see. Try sketching expressions with just a few lines (as we did with the smileys, earlier in this chapter), sketch a few noses, some specs, hairstyles. Once you've got the hang of drawing in public, have a go at a complete face. But don't stare too hard, you'll frighten people. (It is possible to take in a fair amount of information using your peripheral vision.)

If you find yourself getting stuck or bogged down, choose a different victim or switch what you are trying to draw. Or perhaps it's time to have another coffee and wonder why the café proprietor is staring at you suspiciously.

Exercise

Here are a few face shapes. Trace them off and add your own expressions, characters and accessories. Trace one shape and use it several times with a different new expression each time. Use the same expression on different shapes.

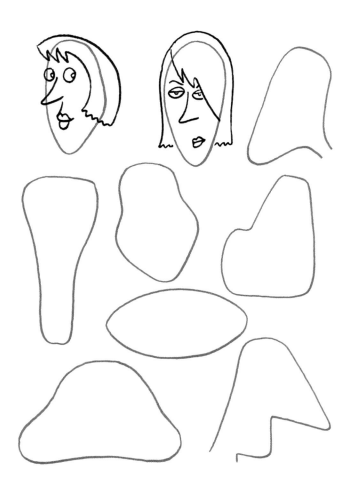

Facial Finale

We've covered a lot in this chapter, all the way from the simple smiley to sophisticated characters with expensive haircuts and trendy sunglasses. Don't expect to get there all at once. If you get so far and you are struggling, go back a step. Drawing faces can be tricky, frustrating, irritating, amusing and vastly entertaining. Don't feel that you have to be the world's best caricaturist. Simple is good and it doesn't have

to look like the person you are drawing. Go out of your way to *not* make it look like them. Stretch, pull and push those features around. Have a good look at how other cartoonists and comic book illustrators are drawing faces. You may even

find you're trying too hard and are happiest when you keep things simple. If that's the case, you'll like the next chapter. These faces might need something to carry them around. It's time for some stick men.

Interlude – A Sketchbook Is for Life

When you first start using a sketchbook in public, it is difficult to avoid feeling self-conscious. But you'd be surprised at how little attention comes your way. Unless you set up an easel and wave brushes about, the chances are you won't attract attention. Most people will assume you're writing a shopping list or you're a repressed poet, and will studiously ignore you. At least, that's the case in Britain where we're far too polite to inquire into ab-errant social behaviour. If you sketch abroad, things are a little different.

A few years ago, I was sketching in a French mountain restaurant. I got involved in the drawing and when I looked up, my models had disappeared. I heard some Gallic muttering at my shoulder and discovered they were all behind me, passing artistic judgment. From the shaking of heads, I gathered it was the general consensus that I wasn't going to be any competition for Toulouse-Lautrec.

Similarly, in America you have to beat them off with a Rotring, as everyone wants to see what you've drawn. Given what a number of Americans look like – and the cartoonist's stock-in-trade is exaggeration – it can be dangerous to show them the final results, unless you've been extraordinarily diplomatic.

You do get the occasional remark in the UK. These can be a little dispiriting: 'What's that meant to be?'; 'Have you ever thought of being an artist?'; or 'You could be quite good if you practised.' My favourite was uttered by a waitress after she had watched me scribbling away for several minutes. 'That's quite good,' she said, 'did you do that?'

A major danger is that your subject will see your drawing. I don't do caricatures and my cartoons don't necessarily resemble my victim. And drawings go wrong. You try telling that to someone who has just spotted you're sketching them. 'You've given me a huge nose! My ears don't stick out! What are you playing at? You can't draw me looking like that, I'll sue!'

Sketchbooks are a vital refresher for your drawing style; when you feel you're getting a bit stale, there's nothing better than looking through pages you've drawn from real life to pep up your imagination. Don't get precious about the drawings. If it goes wrong, turn the page and start again. If it goes wrong a second time, perhaps you're not really in the mood. I use the famous blue pencil when I'm sketching because I can scribble away without making an obvious mess, then come back to it later and ink it in. You may prefer the spontaneity of black pencil or pen right from the start.

You can also treat it as a research exercise. Charles Peattie – the cartoonist behind Alex in *The Daily Telegraph* – uses index cards which he then files away under subject matter. This is a bit too organized for me, but a browse through the sketchbooks does wonders when I'm stuck on a drawing.

I've been carrying sketchbooks for more than twenty years and they have gradually built up into a record of where I've been, what ideas I've had, people and things I've observed. They are also a reminder of how my drawing style has changed and, hopefully, improved. A sketchbook can become a diary of your life and travels. In which case, don't forget to date the drawings and note where you drew them. Future art historians will thank you for it.

STICK FIGURES

It may seem a very basic way of drawing, but there is a surprising amount you can achieve with a good stick figure. They are very quick to draw, so without expending a lot of artistic time and effort you can:

- get the proportions right
- capture movement
- show basic posture
- demonstrate your stick character's attitude
- tell a story.

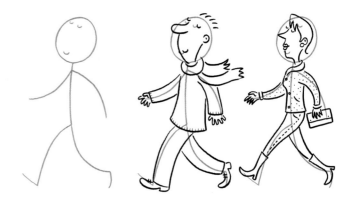

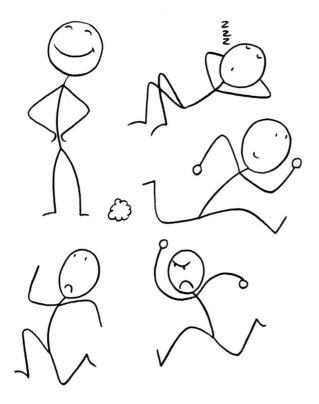

This elegant figure can provide the underlying skeleton for any number of characters, all of which have the same basic posture and proportions.

The simplicity of the drawing lends itself to animation. There are numerous examples on the web, including the splendidly bad taste Stick Figure Theatre of Death – www.sfdt.com. (Warning: unsuitable viewing for anyone over the age of twenty-five.) We don't have to worry about perspective, which limb is in front and which is behind the body, so we can concentrate on the basics. For example, even without an expression we can see that this is not a happy chap.

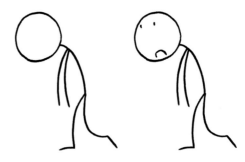

In drawing our pipe-cleaner person we are laying everything bare; you can see what works, whether you've got the limbs the right size, in the right place, where you've gone wrong – all in a few strokes. In this chapter we are going to use stick figures to look at body proportion, movement and posture. By the end we will have established a foundation from which to build up more rounded cartoons in the next chapter.

We'll start by establishing the basics.

Proportions

In traditional figure drawing, there are a number of rules. As cartoonists, we can cheerfully ignore rules, but it's useful to be aware of a few of them. One of these relates to the proportions of an adult figure. This is usually stated by saying that for an adult figure, the size of the head fits into the total height seven times, which gives a set of proportions that are fairly realistic.

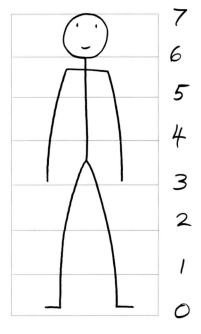

If we vary the proportions slightly so that the head fits five and then four times, we have a semi-realistic cartoon drawing, perhaps along the lines of Hergé's Tintin.

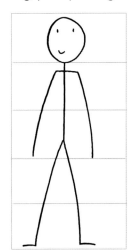

Alter the ratio further and we have something which starts to look much more like a cartoon. This is around the ratio I usually use, although that can vary according to subject matter, mood and what pen I'm using that day.

We can take the ratio even further and it starts to look quite cute. It could also be used as the proportions for a cartoon child.

Go one more and you have something similar to a Mel Calman character.

Very simple to draw but it's hard to get away with this ratio unless you are drawing something very simple and sketchy, or a highly stylized character.

For instance, I was once asked to provide some characters for an advertisement which had a very gender-neutral, 1950s feel to them and came up with this simple one-head character.

We can even vary the ratio the other way, to draw a nine-head ratio character, which would suit something like a superhero or general, all-round tough guy.

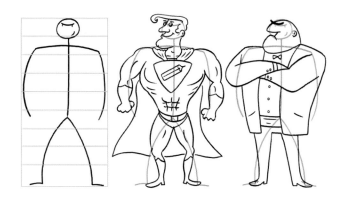

Which set of proportions you choose comes down to style. Do you want your cartoons to be cute and tubby? Go for three. If you want something more realistic and flexible, capable of portraying a wider range of characters, go for four or five. It doesn't matter which of these sets of proportions you choose. Different cartoonists have different styles. Pick the one which you like drawing – or simply the one which emerges most readily from your pen.

For the time being, I'll hover around three or four, an elegant, flowing creature with bendy arms … Don't feel that you have to do the same. You are attempting to draw *your* cartoon figures, not mine. But don't make the heads too small, or you'll have trouble later on when they acquire expressions.

Exercise

I run a cartoon workshop with adults and when we start drawing stick figures, something odd happens. Everyone tightens up and produces incredibly precise little figures. Even practised artists rarely draw stick men, so they suffer just as badly from this initial freeze as everyone else. To get over it as quickly as possible, take a blank sheet of paper (or several) and draw twenty stick figures. It doesn't matter what they are doing. Draw the first one quite carefully and then gradually speed up. Bend the arms occasionally. Let yourself go.

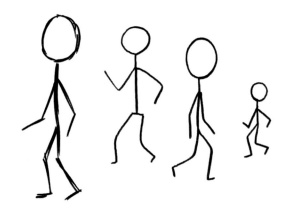

How do they look? Now have another go but this time a little more carefully, trying to:

- keep to the same proportions throughout (three- or four-head ratio)
- keep the arms and legs roughly in proportion (longer is usually better than shorter)
- don't let the head get too small or too large for the body
- vary the poses.

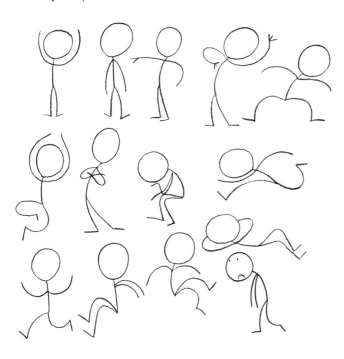

You'll notice that I do my stick figures with curvy lines. Traditional stick figures tend to be angular, for example the famous 'The Saint' stick figure from the television programme of the same name.

There's nothing wrong with straight-line stick men, but curvy lines give them more bounce and elasticity – a more organic feel. They're more fun to draw; you can swoosh the pen across the paper with tremendous style and generally not worry if things go a bit wonky. Try both and see which you prefer.

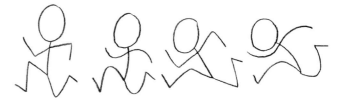

Try not to draw the head too small or the legs too short. If in doubt, use the blue pencil and sketch in the boxes first.

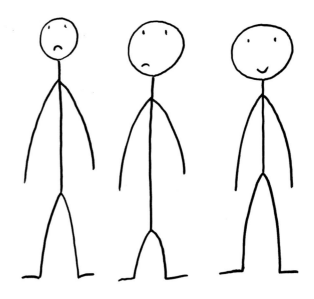

Head too small; Legs too short; Boxes and stick
 figure just right.

Practise the stick figures until you're happy you've got the hang of it. Then it's time to give them some movement and attitude. But first, we're going to draw something even simpler.

Posture Lines

You're in a pub or cafe. You have your sketchbook handy and you see someone in an interesting pose. You start to draw them and … they move. They might even get up and leave. People can be so selfish. If you've tried to do a detailed drawing, you'll probably have got as far as one elbow.

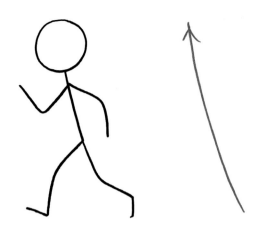

I sometimes also add a scribbled circle, as an indication of where the ground lies.

On the other hand, if you had drawn a stick figure, then you could have captured the whole pose in just a few seconds. This time we've caught the pose rather than the whole thing. What we miss doesn't matter too much. If our subject is still around, we can flesh it out into a complete cartoon. Whatever pose she adopts, we'll still be able to capture the face and clothes. Even if she has left, we can always pick someone else and build up the cartoon using that person's details. No one will ever know.

It's also about getting our eye in, working out what we're seeing. Look at the illustration of the posture line in the wrong position. You can see instantly that it's gone wrong before you start anything. But once we're happy with it, we can add the stick figure.

But even with a stick figure, there is something more we can do to simplify the procedure and make it easy for ourselves. If we go back to our original character, we can trace a line through the general angle the body is taking. It gives us an indication of whether or not we're going to get the overall posture about right.

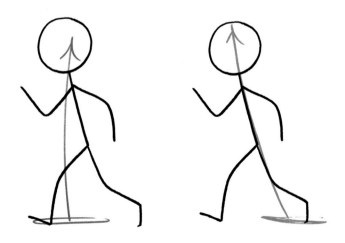

Here are some further examples:

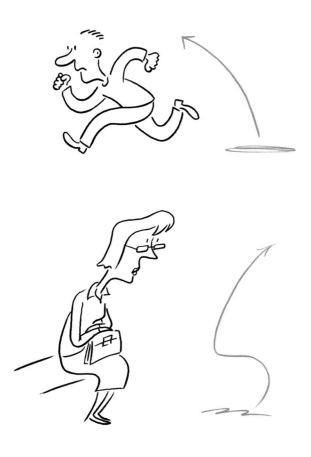

Taking the first posture line, we can use that to give the start of our stick figure. We can start off by sketching the head and build up from there. The original posture line is the basis for the stick figure's body, following the general curve of the spine.

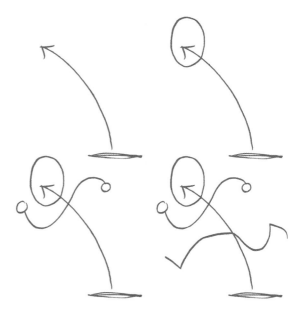

A posture line is not strictly necessary when drawing a figure. Sometimes I use it, other times I dive straight in without it. But it helps to set things up and provides a foundation for everything else, especially when we come to movement.

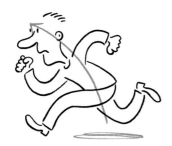

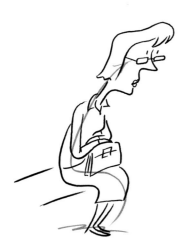

Movement

We are going to draw a figure in four stages of movement, from a sedate walk to running for his life. Four swift posture lines give the general idea.

In the distance, he hears a church clock chime; it's later than he thought.

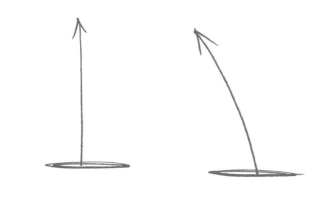

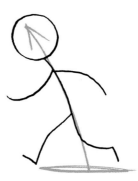

Then he spots the bus coming round the corner, he's going to miss it!

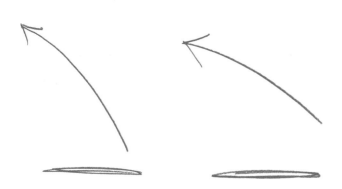

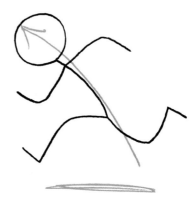

Finally, he sees the bus pulling into the bus stop ahead of him.

As before, the scribbled circle is the ground. The first posture line is barely leaning over. It's a lovely morning and he's walking to the bus stop.

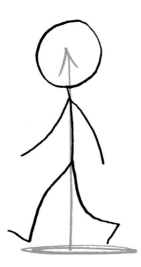

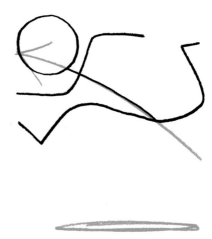

All from four little lines. The posture lines make it easy to see the differences between the four positions, and to adjust them to make the action more dramatic. For example, if we

had used a less extreme angle for the last posture line, the final stick figure would have been much less exciting. Yes, you could do it by drawing the stick figure's body first and fussing around with that, but somehow drawing the entire line, from ground to head, gives the full sweep of the action and makes it easier to see what needs to come next.

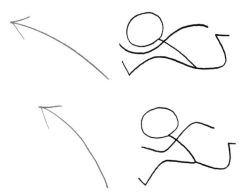

Stick Men with Attitude

If we go back to our original list of essential cartoon components, we'll recall that they are:

- the idea
- personality
- movement
- the joke.

We've established proportions, so we can now think of our little stick figure as giving the *idea* of a person. Thanks to the posture line, we're beginning to capture movement. Now it's time to give them some attitude. You may need to jump about for this next section, so clear a space and ban all pets from the room.

A stick figure can be surprisingly expressive. It's all down to body language, something most of us are fairly good at interpreting. For example, if you see someone who's feeling tired and down in the dumps, you immediately sympathize and know how they're feeling just from the way they are standing, without them having to say anything to you.

Try this for yourself whilst standing; the head slumps forward, the shoulders sag, the knees bend, the arms hang down listlessly. On the other hand, when someone's feeling on top of the world and full of bounce, their posture is completely different.

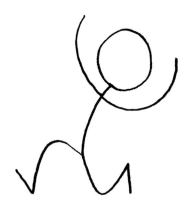

Even without the little faces, we recognize the mood from the attitude of the body. If you're trying to capture this and you don't have a model handy, the stick figure makes it easy to get the look and feel right.

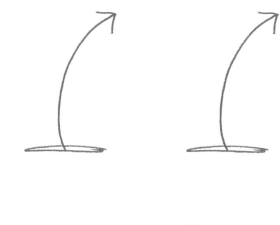

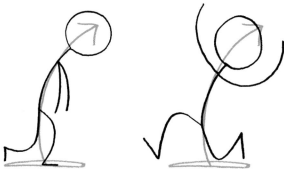

These two poses started off with the same posture lines.

Put the poses together with some minor additions and we can tell a story or a joke:

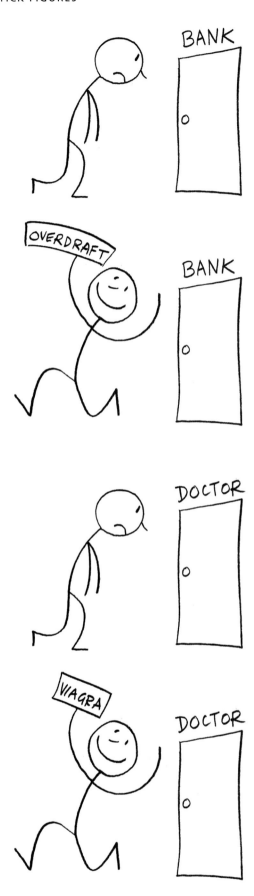

The posture line comes into its own when we move on to more complex poses. I've mentioned before about trying to capture the feel of a character rather than an accurate representation. Here's an example. Suppose we want to draw a character slumped in a chair. Look at the various posture lines we can work with.

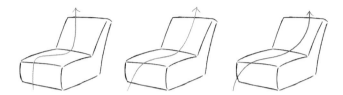

Each of these would give a different final position for our stick man and it's very easy to see which one looks the most relaxed. The last positively oozes over the chair in one flexible, flowing line. Even before we start we can see that this is going to be one relaxed stick man.

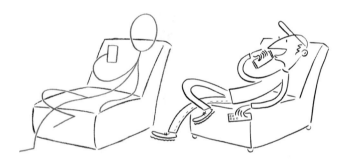

As a contrast, let's force our stick man to do some work by pushing a car uphill. We'll start with a simple box for the car (real cars come later, we're in two-dimensional stick world here). Depending which of these four posture lines we use, our stick man is either doing very little or really struggling.

Now we're upping the action, let's try a fight scene. We will study two stick men slugging it out.

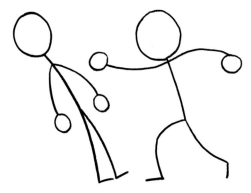

It's all right-ish but rather staid and boring. There's action going on but it lacks drama. If we look at the posture lines we can see why – they're barely waving in the breeze.

However, if one line leans in further and the other recoils at an extreme angle we have something with much greater pugilistic potential.

As cartoonists it is our duty to go over the top wherever possible, so next we'll have our protagonist knocking his opponent completely off his feet.

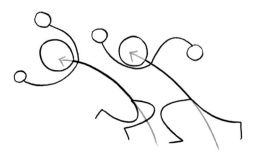

This is more satisfying. We can even add some cartoon effects, such as a contact explosion and a little shadow to show that the unfortunate victim has been lifted off the ground by the force of the punch.

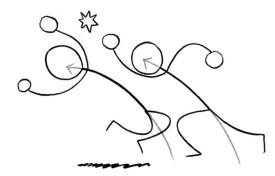

Here we're entering the realms of artistic composition (sorry to spring it on you like this), but we can cheat. If you find that you've placed the posture lines too close or too far apart and the final stick composition looks unsatisfactory take a sheet of layout paper and place it over the drawing. Now draw the figure you like best. When you've got him how you like him, move the paper around until he lines up with the other figure and the pair of them look right.

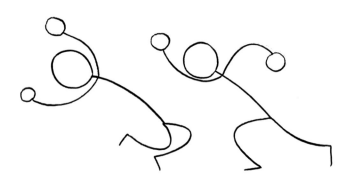

Stick boxers too far apart . . .

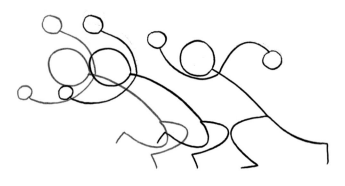

. . . moved closer together.

Advanced Stick Figures

There's more? Certainly. Stick figures really come into their own when we're trying to draw something unfamiliar – a cartoon golfer, a concert pianist, a javelin thrower, a pole vaulter, a ballet dancer ... The unfamiliar poses mean that we are grappling with unfamiliar shapes. If we launched right in, without the aid of our stick figure, unless we're pretty skilled, it could end up looking horrible and require several redraws to get right.

If you want to draw, for example, a concert pianist, there are two approaches. We either find a picture of one, or we clear the desk and adopt a pose. A quick hunt on Google Images (www.google.com and then click on the link for 'Images') will bring up a bewildering variety of drawings and photographs. Some may be useful, but most won't and it's possible to waste ages trawling through them. Instead, think of a classic pianist pose – hair flying, hands in the air, about to launch into the *forte*. We're after the feel of it rather than strict accuracy, so we can adopt this pose ourselves. Try it now. Feet flat on the floor, back usually pretty straight, perhaps leaning in from the hips in order to really drop those hands with some weight. Sketch a very rough piano and stool and then the posture line could be developed as shown in the illustration sequence.

The posture line provides the spine of the character.

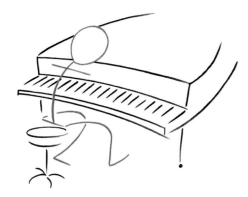

Add the head, shoulders, hips, legs and feet.

Finally, add the arms and hands.

Again, if it all goes wrong and he looks like he would need arms like a baboon to reach the keyboard, trace him (or the piano) onto a new layout sheet, then shuffle until you've got the relationship right and draw in the missing element.

If we had started with a photograph, we could have also used the layout paper to cheat. Place it over the photo and trace the posture line. However, there are still a couple of drawbacks with this, even assuming finding the right photo in the first place. Firstly, real life is never as exciting as a cartoon, so we will have to fiddle with the posture line, getting it more extreme than the pianist in the photo. Secondly, unless we're careful, we get tangled up with perspective. Now, there's not a lot of this in 2-D stick world. When we encounter it, we have to be a bit clever, as shown here. Someone sitting in a chair facing you with his legs and arms crossed and you decide to sketch them.

The stick figure version goes well until we come to the legs. Now what do we do? The top part of the leg will be a point

and the rest just a vertical line. It's going to look a bit rubbish, but remember we're after the *idea* of someone sitting down, not the reality. So simply move the legs off to one side so you can see what is happening in the pose.

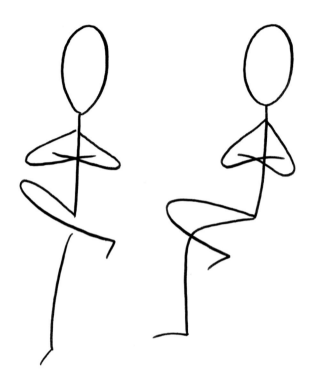

Field Work

The posture line is optional for this but try to remember to sketch it in when you're out and about with your sketch pad. Your mission is now to go forth and sketch as many people as you can as stick figures. Don't worry about speed; concentrate on feeling relaxed and comfortable doing a drawing which captures the posture, attitude and movement of the figure you are drawing. Try to capture the following:

- a person sitting in an armchair
- someone sitting at a table, working or eating
- someone walking
- a group of three people standing talking to each other
- someone standing in a queue, bored out of their mind
- someone leaping about on stage, performing.

You won't find all of these in the street, so you have my permission to draw *some* of them in the comfort of your own home, in front of the television. You do have to be quick though. Television directors have short attention spans and love to change camera angles every five nanoseconds.

Spread this exercise over several sessions and you'll be surprised how much your efforts improve. In addition to improving your stick figures, it makes you more confident at drawing from real life. They're only stick figures, after all. How difficult can it be?

CHAPTER 5

FULLER FIGURES

It's time to move from stick figures to fuller cartoon characters. We'll fatten up our stick men and women and give them some tasteful accessories – clothes, for instance. By the end of this chapter we'll have all we need to launch out into the world with a bewildering range of cartoon characters. But don't panic – we're still going to keep it simple. You may find that the stylized approach we take in this chapter is all you will ever need.

Rectangles and Circles

Let's start with something very basic. Bodies come in all shapes and sizes, but, as we discovered in Chapter 1, to draw almost anything we can get away with using just four shapes. In fact, you could argue that is only three with one of them stretched somewhat but we're not getting into advanced topological arguments here (they come in Chapter 7).

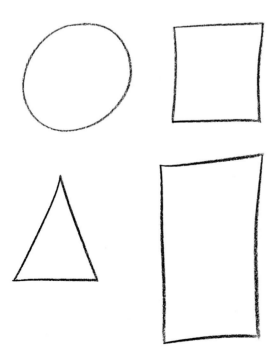

Body basics – circle, square, triangle and rectangle. Let's go back to our famous stick figure.

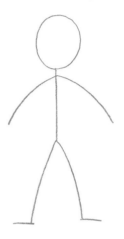

The easiest way to make him bulk out is to use a selection of rectangles and circles. Now that we've all practised what we learnt in the last chapter (you have been practising, haven't you?), we know how to get the proportions right by using the head/box ratio. I've chosen a three-head proportion here. A posture line establishes the stick figure's general position, so off we go with our box man, starting with the body.

Keep the rectangle nice and wide, otherwise you end up with a beanpole character.

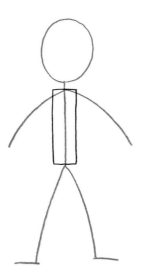

If we have the proportions right with the stick figure, this should work fine. We're trying to keep the rectangles a pleasant, balanced shape. Too skinny and you've got a super-model; too boxy and you have a Lego Man.

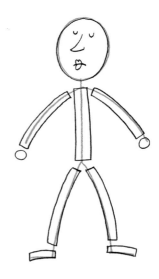

We can draw the arms and legs as more rectangles, thinner this time. It doesn't particularly matter that the arms should be bent, just curve them. However, if you prefer to keep the arms more realistic, split the arms and legs into two sections.

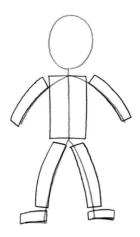

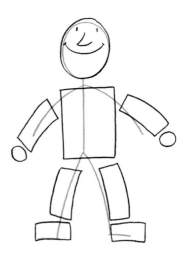

It's worth practising this. I know it seems very basic, but when running workshops I sometimes see my budding cartoonists get the box figures too thin or the wrong proportions. It's usually because they haven't got the underlying structures correct, or they've rushed in straight to the box figure. Then the final cartoon goes wrong and it is very discouraging for them.

We ought to add some hands and feet as rough shapes. At this stage, don't worry where the shoulders have gone or what has happened to the neck. These are intermediate stages. In fact, although I'm drawing these in black, feel free to use the blue pencil.

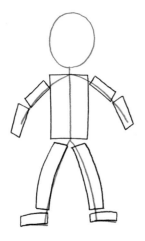

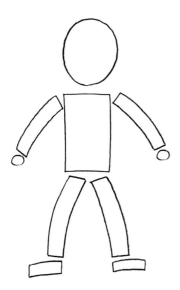

Now it is decision time and you can see where the boxes are coming into their own. They let you show which limb is in front of the body and which is obscured by it. It's easiest to start with the arm in front, then we know which leg is behind (it's the opposite one when you're walking, unless you're doing something weird).

Boxed In

Let's have a go at the man walking for the bus from Chapter 4. Take the walking stick and add the body.

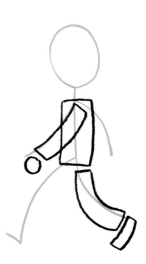

Finally, we can complete our running figure using boxes.

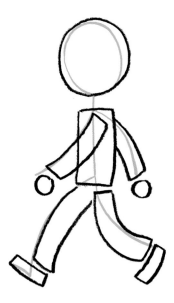

It's rough and scribbly, which is what we want. If the first line doesn't look right, scribble a few more; you can pick out the line you want later.

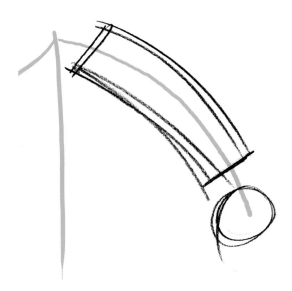

Exercise

We have done the walking figure from the last chapter. Now it is time to add the other three drawings of our stick man running for the bus. If the stick figures underneath are correct, then the box figures should look the same from drawing to drawing (it's meant to be the same character, remember).

The Tricky Stuff

The boxes come into their own when you have to draw something really difficult – someone with their arms crossed, for example. (If you haven't got a photo or a model, go find a mirror.)

This is not too difficult with a stick figure – the arms form a triangle, a bit like a coat hanger. The illustrations explain the sequence.

Box in the body first.

Then do the arm on top.

And the arm below.

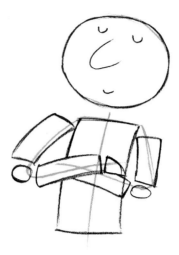

To make it easier to follow, ink in the lines.

We can extend this to our stick figure with the legs crossed from Chapter 4. Follow this through with the boxed figure. As usual, draw the limbs on top or closest to the eye first. Use blue pencil and it doesn't matter if anything goes onto the page in the wrong order. Then ink in those lines we want to keep.

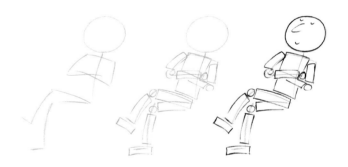

Body Shapes

Having established that we don't want our box figures too fat or too thin … now it's time to make them too fat or too thin. Let's start by throwing out all the stuff about arms and legs. We'll keep those the same as the stick figures for the moment. Then we simply play with the body boxes, making them wider, thinner, rounder, circular, tapered … just have fun with them!

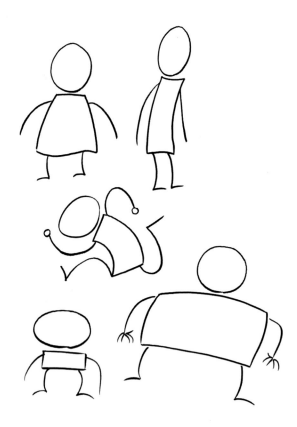

We can develop our characters a little by departing from the stick figure and joining the arms and legs at different points on the body – usually the corners – or by changing the faces. The possibilities are endless.

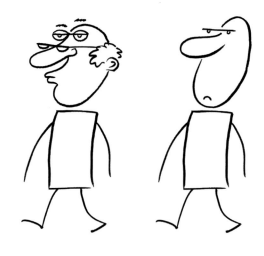

As our people develop ...

Whilst we're at it, let's add some simple faces and expressions. Now they can spring into action and start to jump around. Keep all the elements simple. If the face is too detailed it is going to look out of place on a sparsely drawn body.

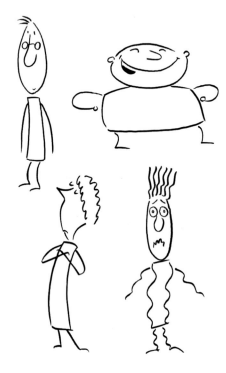

... we have the beginnings of a cast of thousands here.

This may be as far as you want your cartooning to take you. It would be perfectly acceptable to stop at this level of characterization. You might be limited in scope, but you could

still do a lot with them. Because they can be drawn so simply, they are ideal for animation. They come in handy when you have to draw a crowd, but don't want to get bogged down with too much detail. Or you want to populate a drawing with figures without the characters themselves becoming dominant. I used this trick recently when I produced a cartoon map for a visitor centre. The client wanted to show the centre being used, but the scale dictated tiny figures. These little characters were ideal.

Exercise

Without adding too much detail, how many different characters can you create from this combination of two shapes – a rectangle and an oval – and some sticks for limbs?

Add some characterization.

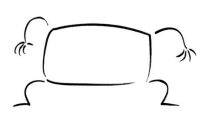

Start off with a basic body shape.

Don't do too much with the hair, features or costume. How much can you suggest with as few lines as possible? Are they better drawn large or small? How small can you make them? How many can you get on an A4 sheet?

Fougasse-style Characters

One of my favourite cartoonists is Kenneth Bird, who drew under the name Fougasse. His cartoons appeared in *Punch* magazine throughout the 1930s to 1950s and he was responsible for a number of famous wartime poster campaigns. His drawing style was distinctive, spare and supremely elegant. Of all the cartoonists working in the twentieth century, you very rarely see anyone mimic his style. But actually – some of his little figures are not far from what we have been drawing here. Here's my take on one of them. All I've done is replace the stick limbs with curved rectangles. The feet and hands have become lines and circles. The face has become more like a smiley and the nose is a single line.

We can try some variations on the Fougasse style.

We can make a suggestion of a slightly lighter build by tapering the arms and legs a little, maybe curving the body.

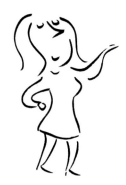

Or we can go to extremes, making the body a lot rounder.

We can even dispense with a separate head altogether.

It all depends how you want your cartoon style to develop. For now, let's get back on track with more finished-looking figures.

The Finished Figure

Let's have another look at our walking figure. Here is how he has evolved so far:

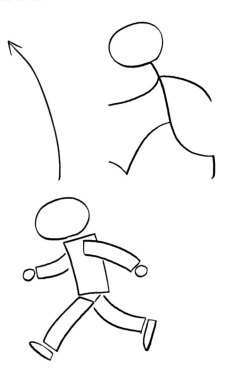

Now comes the fun part. Place a sheet of layout paper over the final figure and he becomes a template for a range of different characters. Tracing the bare outlines of the boxes gives someone in trousers and a jumper, or someone in a business suit …

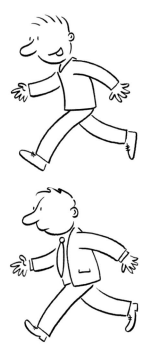

… you get the idea. And with a little gender reassignment he becomes:

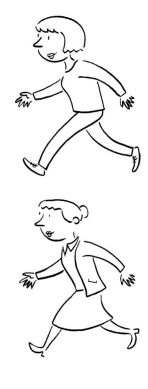

Similarly, if we go back to our famous chap running for the bus, it could be any number of different people, for example:

It's all down to the shape you make your characters and how you dress them. Which brings me on to the next section – clothes.

Clothes

Clothes are always good to have. They stop you getting arrested in the street, for one thing. But they are also fun to draw. Quite apart from preventing your cartoons from contravening any obscenity laws, there are two very good reasons why it's worth becoming an expert at drawing clothes:

- They are a shortcut. They flag up stereotypes and give our readers an immediate indication of context. Look at a range of single-panel cartoon jokes and you'll see what I mean. Scraggy beards and ragged trousers for desert island castaways, masks and striped jumpers for burglars, pyjamas with arrows for prisoners (where *does* that one come from?). You can vary it, of course, but if you are drawing a single-panel gag, which gets a few seconds' attention, woe-betide your poor cartoon if you wander too far from the stereotype or get too inventive.
 Tip: In addition to a small sketchbook, I recommend keeping an A4 hardback book as a reference scrapbook. Use it to keep drawings you've made yourself (some of the happiest doodles occur on things such as a telephone pad or a menu), photocopies, pictures from magazines. Anything you might want to use as reference material. It's a good place for all those noses, too.
- Clothes are a good way to make your cartoons look up-to-the-minute. Fashions change so fast that capturing the latest can make your work more contemporary. And that means more saleable. A good source of reference material are clothing catalogues. *Boden* is representative of the upwardly mobile and political classes, *Rohan* for the trendy mountaineers, *Next* for the urbanites. Newspaper colour supplements are a useful source, although they may be so trendy you'll never see anyone wearing the clothes in real life. Most of these are more up-to-date and easier to use than Google Images and all of them have their own websites. As a first resort, of course, you could sketch from real life, although this can sometimes be difficult and possibly socially unacceptable (children or teenagers, for example). Your scrapbook should include clothing accessories such as shoes, hats, gloves, handbags, overcoats, briefcases. Even things like rucksacks and shoulder bags. They have changed a huge amount over the past ten years and are now part of every city street scene.

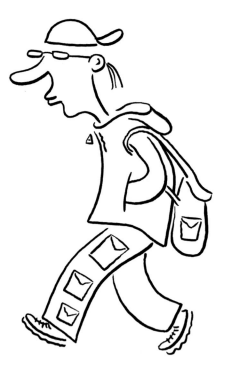

If you are keen, drawing clothes can be great fun. They tell you so much about the character: their age, social background, profession, historical period, how tidy they are, how they view themselves and even how fast they got dressed this morning.

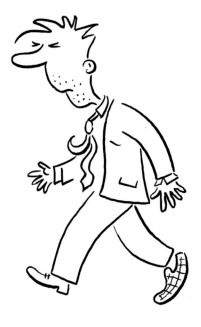

We will be exploring clothing in greater depth in the next chapter. At this stage, it's important to remember that our

characters are quite sketchy and minimalist. When we add clothes, we don't need to get bogged down by including too much detail. The characters themselves aren't sufficiently fully formed to require it. Look for shorthand ways to represent clothing. It is very tempting to go too far and draw every last button, but does the drawing need it? And will too much detail make it look fussy and spoil it?

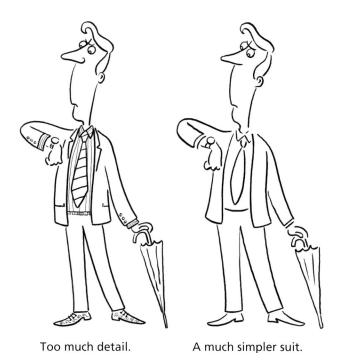

Too much detail. A much simpler suit.

This is actually quite hard, knowing what to leave out and forcing yourself to do it. So here is one way to practise it. Let's go back to the stick figure at the end of the last chapter and build him up into a finished character.

That last character has gone a bit too far. So take a sheet of layout paper, pop it over the top and redraw. Have a couple of attempts, varying what you omit from the drawing. Which looks best to you? Which do you prefer drawing?

Hands and Feet

A good example of knowing when to leave out detail is when we come to draw hands and feet. With these simple cartoons, it is not worth trying to do anything too realistic; as with the clothing, it will be too distracting.

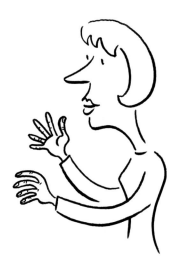

So once again we have to leave out anything which gets in the way. Shoes are relatively straightforward and a number of shapes will work. Feet are more complicated and I would recommend keeping them sketchy, or our characters will suddenly look as though they are walking round on sea anemones.

If in doubt, hide your feet in anything handy.

Hands don't have to be difficult. The trick is to use simple shapes and don't get overambitious, or we may end up with what appears to be a bunch of bananas on the end of a sleeve.

Let's look at the shapes we can use. One of the most versatile is a circle. Sketch it at the end of the arm (a good place for hands) and we have a starting point for a number of variations, from a Fougasse-style set of lines, a more ornate set of curves which follows the shape of a hand, and back to a squiggle. They all work if they match the style to the rest of the character.

If we want the hand to be more expressive or dextrous, we can modify the existing shapes. Sketch the whole hand in blue first, then modify the hand, keeping in character.

The chances are that at this stage you won't need to get too ambitious with hands. We'll save that for Chapter 7.

There is an interesting quirk about cartoon hands – most of them are deformed. In 1928 when Mickey Mouse made his first successful appearance in *Steamboat Willie*, Walt Disney established a tradition which many cartoonists have followed to this day. Instead of the full complement of thumb and four fingers, he reduced Mickey's digits to three fingers.

Notice how, in the next set of drawings, we have suggested that the hand is holding something. It's actually barely touching it, but once again the cartoonist is master of the physical universe and the constraints of gravity do not apply. What does apply, though, is matching the hand to the style.

Disney obviously figured that the extra finger got in the way, made the hand look ungainly and no one would notice if it wasn't there. The tradition continues and is made the subject of a glorious in-joke on *The Simpsons* whenever a character counts on their fingers. Nick Park's *Wallace & Gromit* animations have eschewed the idea to give Wallace

a full set of digits. As a result, his plasticine hands look enormous. Whether you choose to show four or three fingers on your characters is entirely up to you. I have tried both and come to the conclusion that, for me, without the correct number, the hands look wrong.

There is another consideration, although it is probably urban legend. It has been reported that BBC TV's *Postman Pat* could not be exported to Japan because of Pat's three fingers. A missing digit is the sign of belonging to the Yakuza criminal organization. It certainly illuminates Greendale in an exciting new light.

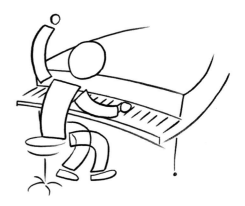

Pianissimo

By now our cartoon characters have evolved from a posture line to full cartoon figures. Let's go back to a stick figure from Chapter 4 and flesh out the pianist. Use layout paper to trace what we've done so far or a blue pencil to sketch it out new and we can progress him to the boxes. We then add some suitable clothes, flying hair and we have a splendid cartoon concert pianist.

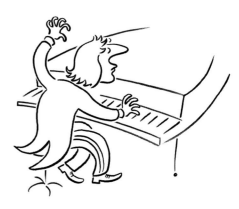

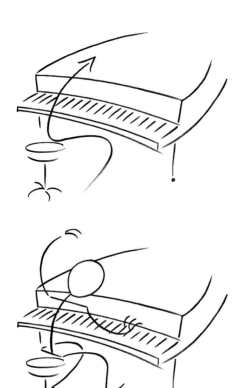

We could tackle any of the stick figures from the last chapter. And we can take them much further – but we'll leave that for Chapter 7, when we'll be drawing the figures in more detail, making them 3-D and exploring how to develop a cartoon style. We'll finish with a fun exercise.

Exercise

This requires several blank sheets of paper. Without thinking too much (or perhaps even without looking at the sheet), sketch a random squiggle on each sheet. Throw your whole arm into it, keep them loose and don't worry about how they turn out. (**Tip** Try holding the pen or pencil at arm's length and hold it like a sword, so you don't have too much control.)

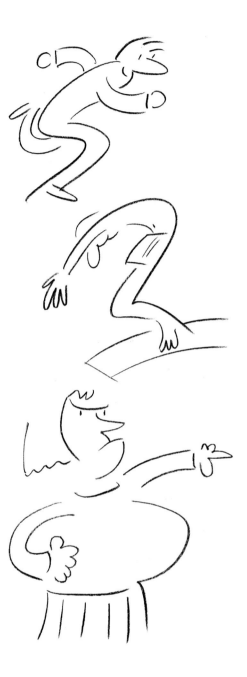

Now your task is to use those squiggles as the basis for a simple cartoon, either a face or a full figure. When you've done a few, get someone else to do the squiggles and set you a challenge. Have fun.

ANIMAL MAGIC

The wonderful world of animals, a source of joy and inspiration for generations of cartoonists. Once you have a few animal characters in your repertoire you can amuse your friends, keep children entertained for hours and maybe even establish a whole career.

In this chapter, we are going to explore the animal kingdom, from fish to insects, mammals to mythical beasts. Take it slowly, don't get frustrated and if all else fails, we can fall back on drawing wacky amoebas.

Shapes and Basics

We're all Darwinians here, so animal cartoons don't arrive fully formed on the page but are made up of basic shapes. Our four favourite shapes, in fact, but we'll add some variations to make things easier for ourselves. To the square, circle, triangle and rectangle, we'll add an L-shape for legs and a part-curve for tails, plus a squished circle comes in useful for various other anatomical parts.

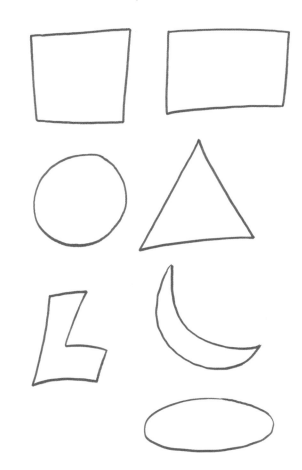

Exercise

Before we start, have a play by drawing some of these shapes. Yes, I know they look easy and this seems very, very basic, but

unless you get the shapes right, your animal is going to look wrong – although as you loosen up, it won't matter so much if your shapes come out wonky ('idiosyncratic and stylistic' in artist-speak). The perfectionists might want to practise the shapes so they get something aesthetically pleasing to work with.

Now you've got some good shapes, you can either:
• use them as templates to trace by placing layout paper over them and moving the top sheet, or
• cut them out and move them around under the layout paper.

Dogs

We'll go back to the dog we drew way back at the beginning of the book and jazz it up a little. As usual, we'll sketch it out first in blue pencil, then use ink or black pencil. If you recall, we start with two rectangular boxes. Make them roughly the same size. If you find the upper one is a bit too small, try

again. If you scrap and start again at this stage, you're not wasting too much time. Alternatively, use one of the boxes we've just drawn and trace and move. The illustration sequence shows how to create our dog.

Start with two boxes.

Now add the nose.

Another slim rectangle for the collar to make sure that no one thinks we've drawn a cat.

Add triangles for the ears.

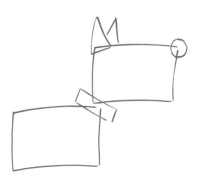

Add a circle for the eye that we can see.

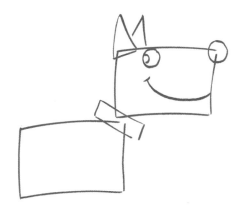

Add L-shapes for the legs and finally the tail.

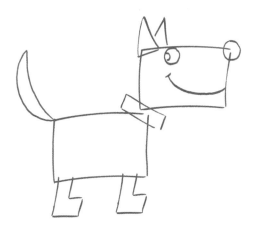

This looks okay – a little boxy, but then we did start with some little boxes so no surprise there. Originally we went round and roughened up the outline to give an impression of fur. We'll be doing this again, but first let's make the shape a little more organic by sketching some curves. That one around the chest is particularly good for getting across the *feel* of a dog.

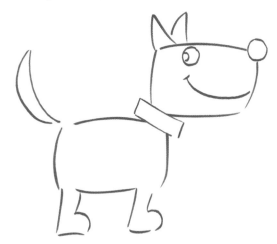

If you like the look of your dog, we can now finish him or her off in a number of ways. Rather than draw directly onto the blue line, pop the sheet under a blank sheet of layout paper and draw onto that. (If it isn't showing through, either place the two sheets against a window or a light box, or go over the blue pencil lines with a 2B or 4B pencil.)

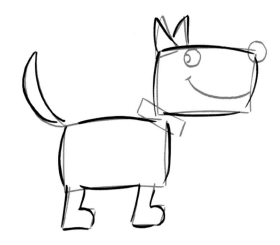

We'll have several goes at tracing this dog. First off, go round as we did last time, roughening up the outline, colouring in the nose and eyes. Once again, we've left white patches in the eyes and a similar bit of shine on the nose. It all helps to make a healthy, interested-looking beast.

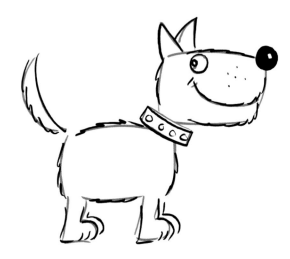

Now we'll try a second dog. This time give it a smooth coat. We will vary the ears by replacing the triangles with a U-shape, giving us something resembling a Labrador.

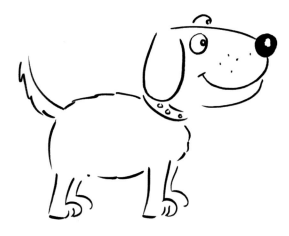

Next, let's make it really sketchy. We'll follow the underlying shape of the boxes, but leave out some of the outline, instead sketching in a mass of hair. And if we take this to extremes, we end up with an Old English Sheepdog.

But how about some action? For example, if our dog is running, we begin by tracing the head and body – adjusting the ears and tail to flow backwards, indicating speed. The legs are then rotated through 90 degrees and traced off and voilà, running dog.

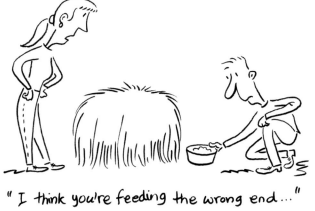

"I think you're feeding the wrong end..."

This type of dog is always a favourite for cartoonists.

Our original boxes can be quite versatile. Obviously there is not much involved in getting the dog to face the opposite direction.

Sitting down is more tricky. Begin by practising the number 2, drawn in a loose, devil-may-care fashion.

Now retrace the box terrier, this time moving the body down.

Add the number 2 for the back legs and we now have a sitting dog. For once, the back legs almost look anatomically correct. Well done. Finish with the L-shape for the front legs and the curve for the tail.

To show the dog from other angles, pick your point of view and sketch the original boxes as 3-D cubes, for instance, from slightly above.

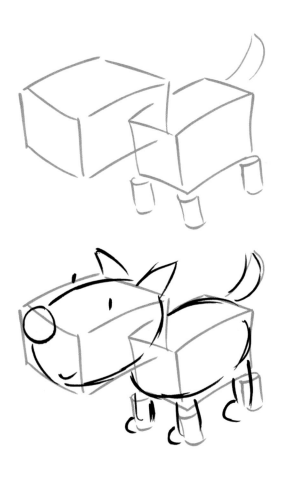

Work up your dog from this, rounding off as you go.

Frankly, I wouldn't get too complicated. Dogs are great, but everyone has a preconception about them and you can keep them as simple as you like. A good example is the current mascot for that driving force in British politics, the Apathy Party (www.apathyparty.co.uk). Not terrifically versatile, a little limiting in what we can do with him and not very expressive, but give him some speech bubbles or a bit of animation, and he can carry most jokes.

Animal Expressions

Animals, particularly dogs, can exhibit a variety of subtle expressions. But that needn't concern us here – we're after the over-the-top, obvious expressions and we're going to steal them from the people we drew earlier. If we go back to our sneaky face and compare it to a sneaky dog … all we've done is copy across the eyes and mouth and modify the dog's pose a little. We can do the same for almost all the faces we drew earlier.

Exercise

Draw a few blank dogs on layout or tracing paper – bodies and heads, but no expression. You may also wish to leave off the ears and tail and add them later. Then take a series of expressions drawn on a separate sheet. Now try putting the two together by placing the expression under the sheet with the dogs. You should be able to move them around to fit the face. When you have something which works, ink it in on the top sheet, then add the ears and tail as the final touch.

A dog's ears and tail are highly expressive: ears down for fearful or aggressive, forward for interested, upright for alert or listening, the tail up for happy, curled right under for sad or distressed, down for aggressive. And don't forget the hackles, if your dog is feeling put out. If you have decided that your standard style of dog is the one-box terrier we did earlier, it is going to limit you on the amount of body language you can have him display. But don't worry – do it all in the face instead. If you want to emphasize the emotion, add some eyebrows and special effects.

Boxer.

Breeding Puns

Dogs lend themselves to an awful lot of visual puns, always a good mainstay if you're stuck for an idea. There are at least 155 registered breeds of dog, many of which have names that lend themselves to bad puns. Here are a few names of breeds and types of dog – see if you can come up with a cartoon for six of them. To give you an idea of the level of sophisticated wit we're aiming for, I've done a couple of easy ones first.

Some breeds and types of dogs:
- Afghan Hound
- Basset Hound
- Beagle
- Bearded Collie
- Boxer
- Bulldog
- Bull Terrier
- Cavalier King Charles Spaniel
- cross-breed
- Dalmatian
- Dandy Dinmont
- Deerhound
- Dingo
- French Mastiff
- German Shepherd
- Greyhound
- guard dog
- hot dog (okay I'm cheating here)
- Husky
- Irish Wolfhound
- Italian Spinone
- Labradoodle (yes, really – it's a cross)
- Manchester Terrier
- Miniature Poodle
- Otterhound
- Pekingese
- police dog
- Pomeranian
- Poodle
- Pug
- Red Setter
- Retriever
- Rhodesian Ridgeback
- Rottweiler
- sausage dog
- search and rescue dog

Scottie.

- Sheepdog
- Siberian Laika
- Springer Spaniel
- St Bernard
- Toy Poodle
- West Highland Terrier
- Whippet
- Yorkshire Terrier.

And you can go against the breed description. Meet Brian, the non-retriever:

One of the best jokes – and also the more complicated – cropped up in a children's workshop I ran. A nine-year-old girl was busy drawing a dog in a bun.

'Is that a hot dog?' I asked.

'No, silly,' she replied, as if it was obvious, 'It's a Burger King Charles Spaniel.'

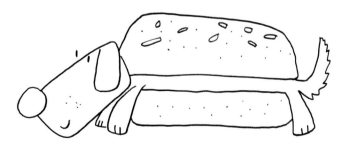

Cats

Tricky creatures, cats. Not only do they appear to possess no morals, they have also evolved without an internal skeleton. At least that's how it feels when you pick one up. So keep all the lines loose, flexible and use as many curves as you can. One of the world's best cartoonists, Ronald Searle, has developed a way of drawing the feline form which does away with all the difficult body posture bit. They end up looking remarkably like malignant tea cosies.

I'm rather fond of these. You can have them sitting about the place, making comments like a baleful Greek chorus.

You can't get much action out of them, so for that I always turn to another source of inspiration, Bill Watterson. If you haven't already seen his strip, *Calvin and Hobbes*, seek it out as soon as you've finished this chapter. His drawings of the tiger are simply wonderful. Here we'll have a go at our own version of a cat springing through the air:

First, sketch out the arc of the cat as it flies through the air.

Draw a circle for the head and a flexible rectangle for the body.

Add legs and a tail; note that the tail follows the arc very closely.

Add a suitable prey, a ball of wool in this case, then a shadow to give a sense of height.

Pencil it in, making sure the eyes are looking directly at the ball of wool – and we're done.

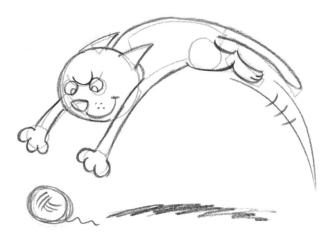

You can use these shapes to build up other poses, some realistic, some not.

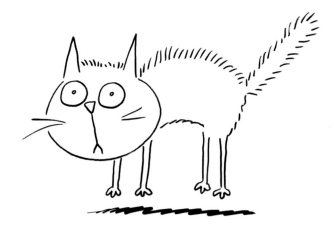

Most of the time, if a cat is still enough to draw from life it's either sitting up or asleep, curled up somewhere. Do a sketch whilst you can.

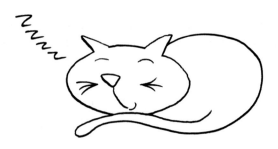

Birds

At the start of the book we explored how to draw a very simple cartoon bird. Start with a circle, add a triangle pointing left and then two more circles. Add a squiggly bit in the middle and another on the back. Two quick lines underneath, a couple more at the bottom and we are done.

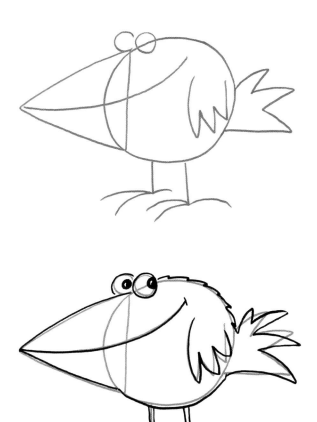

Clearly this has restrictions. We're not going to get away with claiming that this is an American Bald Eagle. It will do for smaller varieties though. One famous cartoonist, Harry Hargreaves, drew a long running cartoon strip for *Punch* called 'It's a Bird's Life'. The bird was not dissimilar to the one above, although with slightly more detail.

Other Mammals

When we're drawing animals, the blue pencil shapes we put down first help to get the overall proportions and look right. But they serve an additional purpose – they stop us drawing anything too realistic. If you are copying a photo or sketching

from life, there is a big difference between producing a drawing and a cartoon. Sometimes I have to go through the 'realistic drawing' stage in order to find the shorthand for producing the cartoon version of what I'm trying to draw. And then I have to modify it further so it bears some resemblance to my usual style. The shapes help. They remind me to keep it simple.

How simple you keep it depends on your style. There are times when it is fun keeping it really simple, almost childlike, such as the elephant shown here.

The tale of a camel

One of the problems with drawing animals is that sometimes even a reference photograph doesn't help. Take, for instance, the humble camel. Even a real one doesn't look particularly realistic. This is a case where someone else's drawing may provide inspiration. If another cartoonist or illustrator has done all the work of simplifying and has already decided what to leave out and what to include, then I think it is valid to see how they have done it. As it happens, when I had to draw a camel for a Christmas card a few years ago, I remembered that Hergé had portrayed some particularly fine camels in one of the Tintin adventures. I didn't copy them, but I did use them as a starting point. (Hergé's original is in *The Crab with the Golden Claws*.)

Another disadvantage with drawing from a photo is that you end up with … a drawing from a photo. It might be quite realistic, but it sure ain't a cartoon. You have to draw and redraw and redraw, changing, modifying and simplifying as you go along. Don't despair, regard it as a fun exercise. Keep at it and you'll come up with something which certainly isn't a drawing, but looks just enough like the idea of the animal to make it a cartoon. Don't put too much pressure on yourself. You may find the best cartoon comes when you're tired of concentrating and you stare blankly out the window and doodle. Or you may get mad and just let rip and surprise yourself. There are no set rules and whereas some artists can take a very disciplined approach to coming up with a new drawing, some of us have to flail around a bit, head off down

several dead-ends and get a certain amount of scribbling out of the way before the brain, exhausted from all the work, delivers what was always in there in the first place.

Exercise

Get yourself a huge stack of paper, several different pens, a lot of space and make sure that friends, family and breakable objects are out of the room. Get drawing. Stop after you've done a few. Get up, walk around. Do the next drawing standing up. Lean over the table and put your whole arm into it, not just a controlled drawing from the wrist. Find larger sheets of paper. Use the walls. No, on second thoughts don't use the walls, go get a coffee instead.

Go mad and try out things you wouldn't think might work. And *don't* rub anything out or throw it away. Wait until you've finished for the day and then go back over it all. Something may surprise you, either a complete drawing, or a bit of one. That head looks good, hmm, trace it off and add a tracing of that body and those legs and we're getting somewhere …

Play around and see what amuses you. If you laugh at it, chances are someone else might.

Fish

Fish are wonderful creatures for the cartoonist. They are basically balloons with expressions. Furthermore, it doesn't really matter how bizarre you get with the drawing, because the chances are that somewhere in the ocean is something which looks just like the fish you've drawn.

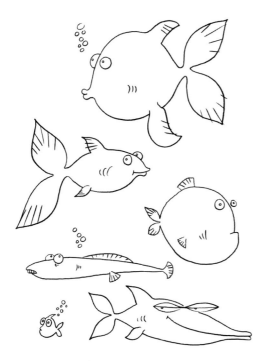

See what you can come up with for the rest:

- angler fish
- barracuda
- basking shark
- blue whale
- catfish
- clown fish
- conger eel (conga)
- dogfish
- electric eel
- flat fish
- flying fish
- hammerhead shark
- gibberfish (yes, there really is one called this)
- great white shark
- jellyfish (trifle fish, Angel Delight fish)
- lanternfish
- man-of-war
- manta ray
- marlin
- minnow
- monk fish
- mullet
- octopus
- parrotfish
- perch
- pike
- piranha
- plaice
- rainbow trout
- ray
- red snapper
- sardine
- sawfish
- seahorse
- shark
- siamese fighting fish
- skate
- sole
- stingray
- sturgeon
- tadpole
- tiger shark.

The other reason they're so terrific is that they open the door to a whole undersea world of bad puns. I've drawn a starfish and an angel fish.

Exercise

This exercise consists of word association rather than drawing. Think of an animal and what is the word which you most associate with it? Here are a few:

- brown bear – lumbering
- camel – haughty
- chimpanzee – mischievous
- cow – passive
- deer – graceful
- elephant – plodding
- polar bear – tough
- sheep – clueless
- vulture – brooding.

Now try and capture those characteristics in your drawing.

Anthropomorphism

Drawing against type can also be fun, particularly if you engage in the great cartoonist standby of anthropomorphism – giving animals human characteristics.

A good route to a joke is to put two animals together that you wouldn't expect to see in the same place at the same time. A penguin and a giraffe? A polar bear and a camel? What are they doing? Why are they in the same place and what on earth are they saying to each other? Cast your ideas net even farther: Do animals have hobbies? What are their interests? What music do they like listening to?

The other fun trick is to think of a distinctly human situation and put an animal in it. Animals can talk, everyone knows that. They can also wear uniforms and indeed do anything a human can do, sometimes with considerably more style. There are certain jobs which are just crying out to be done by animals. Polar bears would make superb nightclub bouncers, for example:

Play around, experiment and see what you can do with anthropomorphism. I would make only one rule – I think it is a huge and not particularly pleasant-looking cheat to plop an animal head on a human body. That's an anthropomorphism too far.

Dinosaurs

According to the list of the Natural History Museum, there are 325 types of dinosaur. And here are a few with names which may appeal to the cartoonist in you, only ten of which are invented. The one I've drawn is a Tricerocops. Of course.

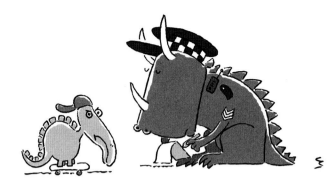

Triceracops.

- Alamosaurus
- Albertosaurus
- Alectrosaurus
- Ammosaurus
- Antarctopelta
- Antarctosaurus
- Archaeoceratops
- Archaeopteryx
- Argentinosaurus
- Atlascopcosaurus
- Austrosaurus
- Bagaceratops
- Bambiraptor
- Barapasaurus
- Brachyceratops
- Camptosaurus
- Chasmosaurus
- Confuciusornis
- Dinersaur
- Doyouthinkhesaurus
- Gargoyleosaurus
- Gasosaurus
- Giganotosaurus
- Gobisaurus
- Harpymimus
- Iguanodon
- Irritator
- Lambeosaurus
- Megalosaurus
- Microraptor
- Montydon
- Nanotyrannus
- Nipponosaurus
- Opthalmadon
- Oviraptor
- Pelicanimimus
- Pinacosaurus
- Pisanosaurus

- Plateosaurus
- Punkadon
- Rugops
- Seesaurus
- Seismosaurus
- Shamosaurus
- Shantungosaurus
- Shunosaurus
- Sinraptor
- Snorosaurus
- Spinosaurus
- Stegoceras
- Triceracops
- Triceratops
- Tyrannosaurus Mex
- Tyrannosaurus Rex
- Velociraptor
- Vulcanodon
- Wannanosaurus
- Zephyrosaurus.

For a generic dinosaur, we can use the same approach that we used for other animals.

Draw a set of shapes.

Put them together.

Ink them in and we have a dinosaur.

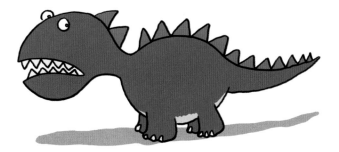

For the more heavily armoured varieties, make the initial shapes more angular, blocky and macho.

Greeks Bearing Gifts

Mythology is a great place for mish-mash animals, such as the head of one thing, the body of another. Take the Centaur, for example – head and upper body of a man, lower body and legs of a horse. Entirely demented but interesting to draw.

Or a mermaid...

Then there is a vast range of science fiction, alien, horror animals and monsters to try. And no one can tell you it's wrong if it's your own invention.

No matter how many animals you've drawn, it's a big, wide world and there will always be something lurking in the trees that you have never drawn before. Keep a sketchbook handy and if it is too difficult to catch in the first go, analyse the shape and work out how you can construct it, bit by bit. Failing that, go and see how someone else has done it.

And above all … go wild.

Interlude – Freeing Up

When working on a drawing, it is all too easy to get caught up in it, to the extent that it goes wrong or becomes overworked. If you are nervous about the subject matter (can I draw a gorilla on top of the Eiffel Tower with a lawnmower?), or the client, perhaps (this is the most prestigious commission I will ever, ever have, I must make it my absolute best drawing), I can almost guarantee your drawing will suffer. It may become stiff or formal and it will be very hard to make it look fresh. Someone described it to me as drawing with your suit on and that sums it up perfectly.

It is a common problem amongst cartoonists and illustrators generally. To prove it, I threw the question open to the US wisenheimer.com cartoonists' forum on the Internet. So here are some suggestions for getting back into jeans and a sloppy jumper:

• Go do something else for twenty minutes. If you're working late at night, stop and come back to look at it in the morning. It is astonishing how I can do thirty attempts at a drawing late at night and the following morning the one I draw second seems perfectly fine. (Perhaps the brain's critical faculties go to bed first.)

• Grab a biro and draw with that. Art editors (and indeed everyone else in the art world) seem to look down their noses at the humble biro. I suppose they don't reproduce terribly well (the drawings, I mean, not art editors), but a quick blast through Photoshop can sort that out. Biros are robust (though will fade with time), unpretentious and you can scribble away happily for hours until they run out.

• Scribble around the drawing. Go mad, go all over it, see what happens. Then pick out the line you like best and trace that.

• Draw with your eyes closed.

• Draw standing up. You have more freedom to move, get up, pace about, attack the drawing from a different angle. In fact …

• Trace it upside down (the drawing, not you).

• Trace on a light box, but make sure you can't quite see all the drawing underneath – this gives you freedom to wander and loosen up. It's the technique Quentin Blake uses for his wonderful children's book illustrations.

• Loud music. Something energetic and boppy.

• Pretend the deadline was yesterday. You've got to do this NOW!

• Ask yourself: How would your favourite cartoonist do it? What would it look like from a different angle (bird's eye, worm's eye, anybody's eye)? If it was tiny, what would you leave out? If it was big but you only had a large brush, how would you do it? You're only allowed a dozen lines, can you do it?

• Take a piece of paper and scribble on it, without letting your pen lift off the paper. Keep going at varying pace, until the paper is completely full. Let your mind wander whilst you're doing it – but you can't stop and can't take your pencil off the paper. Eventually some of the scribbles start to group and do interesting things.

• You have ten minutes. Do the drawing. It *is* going to come out too tight and stiff. But you have nine minutes left to do nine more!

MOVING ON

In theory, you now have most of the skills necessary to become a cartoonist. We have looked at the basics of faces, expression, character, figures and movement. We have generated a few ideas. But there is more that we can do with cartooning and in this chapter we are going to look again at figures. This time we'll be building them up into more realistic cartoons and making them more three-dimensional. We'll then look at simplifying the drawings and exploring how to develop your own style of cartoons.

When I run workshops this is always the hardest part. It requires a lot of practice. You may find you can do without it, in which case feel free to skip to Chapter 8. Once you have gone, we promise not to talk about you. Much.

Back to Basics

We are going to be working with our four shapes again, but this time we're going 3-D (sadly, the funky glasses would have blown the publisher's budget). So our shapes have now become a cylinder, a cube, a cone and a sphere.

Let's go back to our running stick character and build him up again using these shapes. We can use either the cylinder or extended cube for the body, but as we're talking organic, I think the cylinder works best. We can use the same for the arms, but this time we'll add a quick circle for the elbow and knee joints. This helps to establish a reference point for them. The hands we can also represent with circles for now and the feet as extended cubes. This results in cylinder man.

Cylinder man looks rather similar to the wooden mannequins sold in art shops. These are used by artists the world over to get proportions and positioning accurate. Here's a photo of mine. Say hello to Herman ... as in Woody Herman, of course. It's possible to buy these in a variety of sizes and you can even get wooden models of the hand, feet and animals. They are quite expensive to buy, but useful.

Great for getting proportions right (should you want to do such a thing) and for showing how light falls on a body; put a torch or an Anglepoise lamp alongside and you're done. If you are put off by the cost, investigate charity shops (particularly in cities where there is an art college), or use an Action Man™.

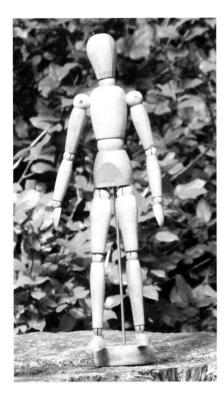

Eschewing the wooden mannequin, we are going to achieve the same process by placing the shapes around our superbly crafted stick figure. This gives us more freedom to exaggerate.

Beefy cylinder man; fat cylinder man.

We can see how useful cylinder man becomes if we go back to our seated figure from Chapter 4, the one with the crossed arms and legs. Either redraw the stick figure in blue pencil or use a layout sheet over the top and first sketch in the head and the body cylinder. (At each stage in this process, I've dimmed the previous stages to make it easier to see what has been added.)

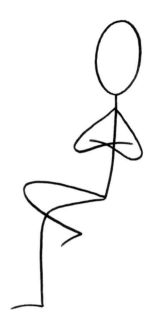

Add the head and body cylinder. That's the easy part complete.

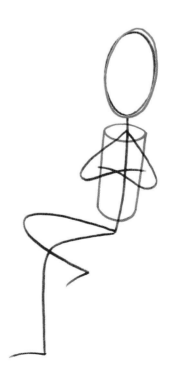

We're superimposing a frame on these characters to give a rough idea of the head shape. It's another useful technique to help build up our box figures and provide the basis for a finished character.

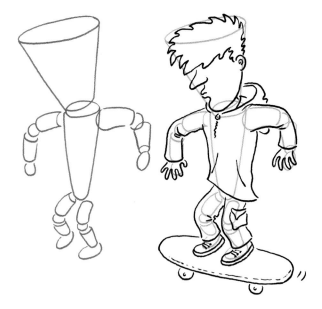

It's a fun exercise to restrict yourself to these head shapes when sketching from real life. We're now veering towards comic art, rather than cartoon art. The style is becoming more realistic. This means that the 'flying-eye' technique we adopted in Chapter 3 isn't going to work so well.

The odd thing is that the 'dots-for-eyes' technique, which a lot of cartoonists use, works perfectly well.

We can continue to build up the face using additional shapes, such as triangles for the nose, and so on. The illustration shows the general idea.

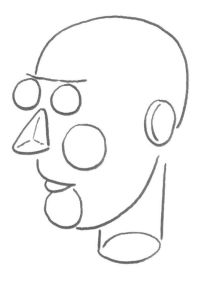

Exercise

Enough from me, time you did some work. Here are some random shapes. Your job is to fill each of them with a head – but the head has to connect to all four sides. Quiffs, noses and protruding ears are valid ways of achieving this. Adding a huge beard, luxuriant moustache or an Ascot hat is not allowed.

I've drawn the first two to give you the idea. Now copy the shapes and have a go.

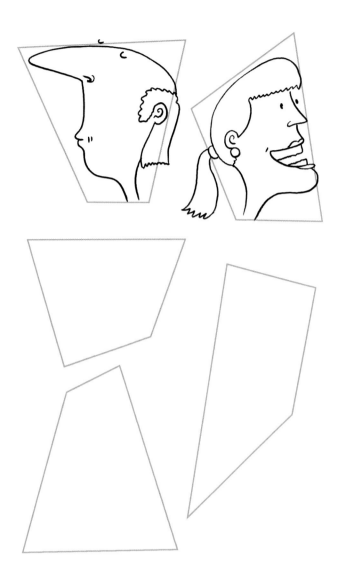

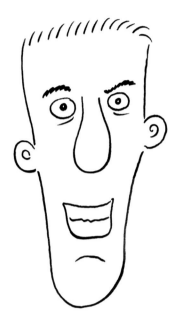

Original unsymmetrical face.

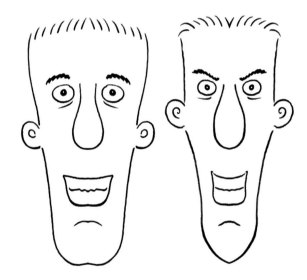

Symmetry

In a word, avoid. It is very tempting to want to draw a perfect character, the hero as ideal. Here, I've taken a regular cartoon character's face and made it symmetrical by copying the left half and flipping to the right, then vice versa. (I've done this in Photoshop, but you can try with a photocopier or simply by tracing onto thin layout paper.) The left-hand side suddenly becomes bland and a bit boring. Perfect for a super-hero, perhaps. The right-side, however, becomes much more menacing.

Left-hand symmetrical face. Right-hand symmetrical face.

Now I admit that when I started this drawing, I hoped both sides would be boring, but the right-hand side is rather inter-esting. But you get the idea: give your characters personality, quirks and identifiable characteristics. Few of us have perfect features in real life (without the aid of surgery) and you want your readers to respond to your cartoon characters. Make them *readable*. Show the emotion, show the personality in every way you can.

Igor – a face full of quirks and personality.

Exercise

Here are three half faces. Complete in whatever way you wish but do not make them symmetrical. If you're copying the half I've drawn, check by placing a small hand mirror along the centre line. Your half of the drawing should not look like the image you see in the mirror!

Avoiding Realism

As we build the body into a more three-dimensional structure, we're going to be making it look more realistic. Now, if we're drawing a comic book (a.k.a. graphic novel), this might be what we want. But we're going to have to study a lot of anatomy to get it right and it is gradually drifting away from what I would call a cartoon. We also have the problem that anything we've incorporated as a stylistic trick – for example, the bendy arms I sometimes use – is going to look increasingly out of place. And if we get something wrong, such as one of the proportions, it is going to stand out like a sore thumb. Although if it is a sore thumb, it's okay because we want it to stand out. I digress. We want our character to be more detailed and expressive than the figures in Chapter 5, but we still want it to look like a cartoon. So how do we drag it back? By exaggeration.

If we're drawing a face and we want to go for something more substantial than a few lines, then we have to learn to draw a face and stretch it about a bit. The first face is rather dull, but can be made more interesting by stretching it.

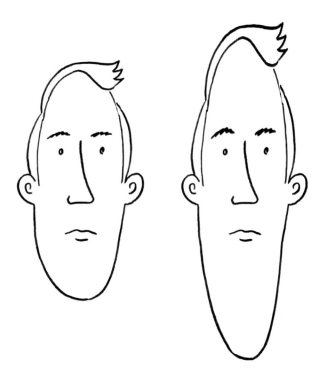

This is a trick I've seen done by a few caricaturists using a photocopier. We identify the part of the face we plan to exaggerate, copy the face twice, then from one copy we cut out the part we want to extend and paste it back into the other copy. It's easier if I show you in a sketch.

This does have limitations, however – unless we are prepared to mess around for ages, there's a limit to which facial features you can stretch with this technique. But once we've got in some practice, it's not too difficult to do by eye. You may have to accept you're going to have several goes at it until you get one which feels right. The trick is to loosen up, have fun and see where it takes you. Experiment a little …

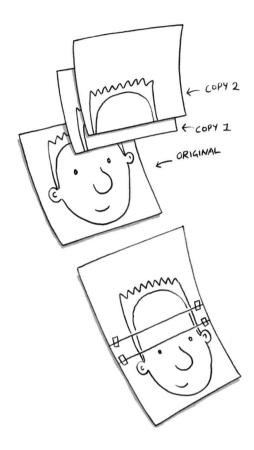

I've cheated and made the drawing fairly simple. We can also do this simply by tracing – make your drawing, place it underneath a layout sheet and as you trace over, move it about to double up the sections you want to stretch. However, the easiest method of all is to do this on a computer, especially using Photoshop's Scale or Distort tools. You can even make them go all wobbly.

Focus on the stuff you can exaggerate, for example eyebrows, moles, wrinkles, the hair. Go in close, pull out the details and go mad with them. If someone tells you that your face has character, you just know that what they really mean is … your face looks lived-in. So do the same with the cartoon. We want a face that's got facial ticks and flaws, a face that's about to do something, that's acting even when it's still.

As an aside, I once attended a wedding of a couple who were both deaf. Not surprisingly, a large number of their guests also came from the deaf community. They were a joy to watch – because they were used to lip-reading, their faces had more mobility, more expressiveness than you see in most people. I sat on my hands and wished I was allowed to sketch in church.

Actors are also useful to watch when they're in mid-flow. If you are serious about this, find your local theatre troupe and ask if you can take a sketchbook to rehearsals. Explain what you're doing and – especially if you don't feel confident – make it clear that it is just for your own practice, no

commercial intent, you're just starting out, and so on. Don't worry – they will love it; all actors like to be watched. It's usually a situation where you can feel relaxed, sitting in a corner and everybody else too busy to pay attention to you sketching. Furthermore, rehearsals mean repeats, so the same expressions will be gone over again and again, perhaps varying slightly each time, but, with a bit of luck, getting more animated. No pressure, but there's always a chance the director will commission you to supply drawings for the poster.

Part of the trick of getting in more character is to work on light and shade. This is especially good for menacing characters, but it's useful all round for lifting the character from the page.

A beautifully proportioned, realistic body is *not* what we are after. Nor do we want an uneasy mix of realism and cartoon. But we can take our three-dimensional body and start to squeeze and stretch it.

A common technique is to focus all the attention on the head and torso and reduce the limbs almost to sticks. They can then be shortened or lengthened as required.

This is another opportunity to take out the layout pad, do a drawing of head and torso and then use separate layout sheets to draw different types of limbs. Play around and see what strikes you as interesting, funny or appealing. Find your own rules and if you hit on something which *you* find amusing, pursue it, try the same technique on other figures and characters. Does it work on all of them, or do you need to vary it?

Losing Balance

Next, start to animate your characters in order to give them some motion. Never have them standing around, arms uselessly at their side, just talking to each other. That's dull. Think of someone you know who is always on the go, always gesticulating and in your face. And when you have two characters get them interacting, where possible. Leaning in or leaning out is good. Conflict always catches the reader's attention.

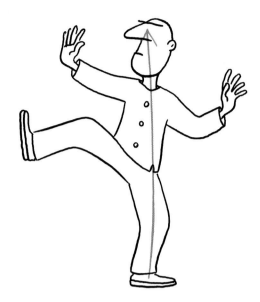

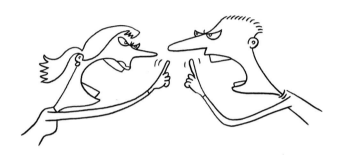

Push those posture lines to a more extreme position and the figure is unbalanced and more interesting.

When we stand and move around, if we are in balance, the rule I usually follow is that the head is (roughly speaking) over the foot that is taking the weight of the body. If standing, the centre of gravity goes down between the two. Here are some tai chi characters to demonstrate. If we drop a posture line down through them, we can see what is happening.

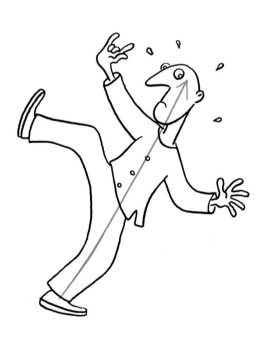

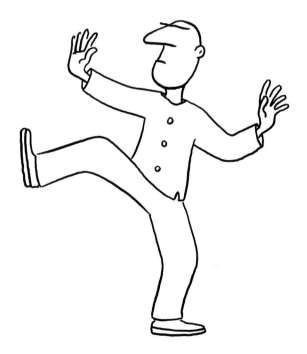

Throw your characters around a bit, make sure the limbs head off in opposite directions, make it look like something is HAPPENING!

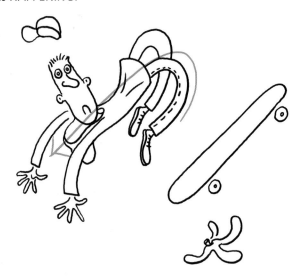

Balance can also apply to height. Watching some of the Pixar animated movies such as *The Incredibles*, I am always struck by how they manage to get characters of wildly different stature to work naturally alongside each other. This kind of imbalance is great for comic effect, especially if it is the little guy who is doing the bossing around.

The Supers

Visit any decent art or graphics shop and you will probably find books about anatomy. These reference works are intended to give artists an idea of what the body looks like,

how it is constructed, how it operates in motion, or the positions it can adopt when at rest. There will be a wide range of poses, some drawn, some photographed. It is all very realistic and, from a cartoonist's point of view, rather limiting. By all means use them to get a posture right, but once you've made that drawing don't forget to have another go and push it further.

If we want to study basic anatomy and also get an idea of how we can exaggerate it, there is an excellent alternative – the superhero comic. Before anyone gets dismissive of these, let me repeat something: cartoons appear everywhere. As cartoonists, we should always be on the look-out for sources of inspiration for our drawings. These can include children's books and comics, graphic novels, advertisements, animated features and the good old superhero comic.

All artists working on superhero comics have to be experts on anatomy; for a start, superheroes have far more anatomy than the rest of us. (They also tend to have tiny underpants worn on the outside of their tights – why is that? Sartorial dyslexia?) These artists have learnt how to show the extremes a body can stretch to (literally in the case of Mr Fantastic from the *Fantastic Four*). The better ones revel in illustrating wild angles, movie-like points of view, conflict and excitement. They are the doyens of exaggeration. Muscles will be bigger and better defined. Waists will be thinner. Biceps (men) and other bits (women) will be bulgier. Expressions will be angrier, hair will be more flowing, foreshortening will be more dramatic and poses will be off the wall (or up them for Spider-man). Everywhere there will be movement and action; a decent superhero *never* stands around talking without striking a dramatic pose first.

Find a good comic-book store such as Gosh! in London or one of the Forbidden Planet stores, force your way past the enthusiasts and have a good browse. Don't be shy. If you are female and want to blend in, take a man. If you are a man, take an anorak. Give yourself at least half an hour and don't forget the graphic novels section (all good comic books stores have them). If you get the chance to do this when you're in France or Holland, you'll find the comic books have a far wider range than just the superhero stuff, with many more of them demonstrating a cartoon approach – for example, *Asterix the Gaul* and *Lucky Luke*.

Superhero comic book artists all differ in their approach. Some are very commercial and, well, ordinary. These are okay for copying and working up your style. But the ones to look out for are the stylists, the sort of artists who surprise you and make you forget all about reading the plot. In recent years, some of the familiar comic book characters have been re-interpreted in styles which are very dark and edgy, with beautiful line work and composition. At the same time, there has been a trend towards very retro, 1950s-style comics, with

a distinctly cartoon look. I find that looking at these just makes me want to sit down and draw.

Do not anticipate that you will admire all of the comics or styles – frankly, there are a great number which are just churned out – but it is worth persisting until you hit the good ones. The best comic book artists are simply inspiring.

Exercise

Enough of me standing on my superhero soapbox and time for you to do some work again. Here are a few dramatic stick poses. Your mission is to work them up into finished cartoon superheroes. These should be bigger, badder, bolder and bulgier than anything you've ever drawn before! Go mad with the muscles, get creative with the costumes, have fun.

Let's develop this character further. Our superhero will need a special super power and a name to match. It also helps if the costume follows the theme of their super power. For instance, Spider-man has a groovy web motif on his costume (a set of threads which, you will note, is devoid of outside underpants). He got his powers by being bitten by a radio-active spider. Let's assume your hero has similarly acquired powers via the route of luminescent animal molestation and see where it takes us. For example, what if he or she was nibbled by one of the following – antelope, cockroach, elephant, badger, water vole, hedgehog, ant-eater …

'Looks like Moth Man is back again.'

Developing a Style

Once we are beginning to feel confident about our drawing, sooner or later the thought will crop up: What is my style? It's a tricky topic. Some cartoonists seem to evolve a style naturally, others have to work at it. In the same way a dog is supposed to resemble its owner (or vice versa), I maintain you can spot the cartoonist at a party if you're familiar with his or her style. At the early stage of cartooning, it isn't something to get obsessive about. Style happens in a number of ways. Here are ten:

1 You start out copying someone else's style. You stop copying directly, your drawings drift a little, you end up with your own style. This happened in the late 1950s and 1960s with the early work of a number of cartoonists showing distinct signs of having been influenced by Ronald Searle.

2 You draw, you have to meet particular requirements (time pressure, for instance), you take short cuts, they work, you stick with them. If they are distinctive, they become your trademark. Look at how many cartoonists use generic bulbous noses for their characters, for instance.

3 You happen upon a technique which amuses you or feels satisfying and you develop it. You feel comfortable with it. You adopt it.

4 The tools influence your technique. Mel Calman used a 5B pencil. He couldn't do a pocket cartoon with a ton of detail using something like that. Gerald Scarfe draws on huge sheets of paper whilst standing at the drawing board and uses broad sweeps of his arm, drawing from the shoulder. When a cartoon produced like that is reduced in size to fit a newspaper, it is going to look radically different from anything which has been worked on whilst crouching over an A4 pad. Technology also comes into it. If your drawing is going to be scanned and worked up in Photoshop, it has several implications. See Chapter 9 for more on this.

5 You can't draw very well. You decide not to try too hard, you hold back, stay in your comfort zone and accept any quirks or shortcomings. These eventually become a recognizable part of your style. For evidence, consider Scott Adams and the *Dilbert* strip. He freely admits he is not the world's best artist. Doesn't matter. The humour is dry, spare and clever, so is the style.

6 Subject matter may influence your style. Different topics or themes require differing approaches. ffolkes, the *Punch* cartoonist, was keen on mythological and Victorian jokes. His ornate, flowery line was ideal, whereas angry, edgy jokes may be better in an expressive, edgy style.

7 Client requirements – angry, expressive Ralph Steadman cartoons aren't going to be popular everywhere. Michael ffolkes once told me that if you can draw bland, you'll sell to magazines all over the world. *The New Yorker* has a number of cartoonists whose style fits that category, however funny or clever their gags.

8 You've progressed from copying (the first bullet point above) and then along comes a cartoonist or piece of artwork and you think, how did they do that? You pick up the technique (perhaps unconsciously) and absorb its distinctive character into your own, blending it in so that your style evolves in a slightly new direction.

9 You always draw when drunk and don't care what lands on the paper. (Not recommended.)

10 You consciously set out to develop a style which is different from everyone else's, which is yours alone. Unless you are prodigiously talented (or very lucky and stumble upon it by chance), this is the most difficult route.

My own style is a mixture of most of the above (except perhaps not drawing when drunk). Some of my most personally satisfying drawings happen when I am not really concentrating – talking on the telephone, perhaps, or doodling in front of the television. Capturing that relaxed quality of line is the Holy Grail of many cartoonists. Artists are legion who bemoan the time and effort it takes to get a finished piece of artwork to match the looseness and freshness of the original rough sketch. Some don't try; Larry (www.larrycartoonist.co.uk), the British cartoonist, was famously told by one of his editors to stop redrawing and send in the roughs. This became his style, which is quick, exuberant, happy and free. It makes me smile just to look at one of his drawings, before I've even read the gag. (Larry is the cartoonist equivalent of Tommy Cooper.)

Finding your own style sometimes comes down to *how* you want to draw. What technique do you enjoy the most? I used to revel in a lot of cross-hatching and fine pen work. Drawing more regularly for a newspaper taught me that wouldn't always work. Now I really enjoy using a brush pen and drawing with varying thicknesses of lines, ones which don't necessarily always join up. Here are two examples, drawn twenty years apart (these were drawn 200 per cent printed size and are usually 7.5cm wide).

26 May 1989 *29 May 2009*

" 'And who's been renting out my second home?' said Daddy Bear... "

" What people say about us could be worse... they could think we're MPs. "

Only you can decide what you want to do. The key is to *draw*. Draw whenever you can, in as many different places, with different pens and papers, practising different techniques. The more you draw, the faster your style will evolve. If you aren't doing this for a living, make sure you do A DRAWING A DAY. Doesn't matter how simple. Make sure it is one you're happy with, date it and stick it in a book (if it

isn't already). After a month of this, you will see a change.

If you can already draw several different ways and you're undecided which works best for you, try doing a whole load of styles for the same basic character. For example, here's a set I tried for a club door bouncer.

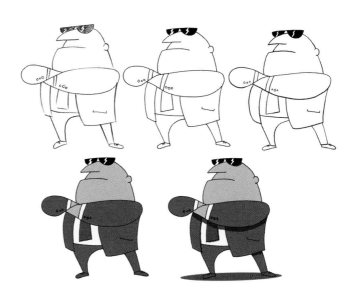

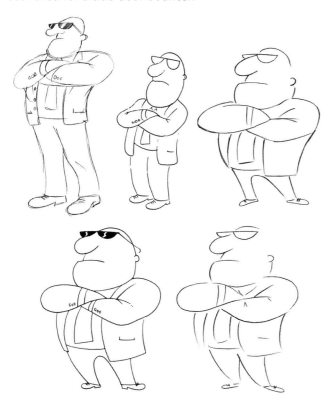

The first sketch was semi-realistic (as close as I get anyway). Then came a more cartoony version. Number three pushed it further, so I inked that one in – bouncer number four. Bouncer five was a further pencil tracing to see if I could reduce the lines and give it a more graphic feel. I then took the graphic look a stage further and produced one which was based more on the shapes and lines, rather than anything organic. The difference in these three is purely down to the drawing implements used – pencil, fine felt tip and brush pen. The graphic look was best served by the fine, felt-tip version, so I added some simple, flat colours and finally a few shadows. The red pumps were deliberate, by the way. They show his sensitive, caring side.

Warnings about Style

Just as a style identifies you and your work, it can also limit you. It may make it difficult to tackle certain topics. Or you may have to be more inventive to tackle them, which is a Good Thing. A bare, minimalist style might make it tricky to incorporate architectural detail into your cartoon – on the other hand, it will stop you getting bogged down in a lot of corbels, balustrades and palladian windows.

Be very, very wary of modifying your style to accommodate a client's wishes. Willingness to do this may get you the job, but *why* are they asking you to modify your style? Is it because they really wanted someone else and you were second choice? As a freelancer, working in an unfamiliar style is an unmitigated pain for three reasons:

• it is probably going to take longer, so your hourly rate goes down

• it is far less satisfying, often frustrating; it feels like someone else is driving your pen and you may end up wanting to murder the client

• it's not going to look like your style, so it may not get you any further work (that will probably go to the artist your client is asking you to imitate).

Exercise

Having said all this, playing around with different styles is fun to do when there is no client looking over your shoulder. Look at as many different cartoonists as you can. Now have a go at this chap in as many styles as you can.

MAKING A SCENE

The time has come to move beyond single figures and to encompass the world. In this chapter we will look at how much of it we can fit into a cartoon, what to leave out and some tips and tricks for assembling your actors on stage. This is a speedy canter through some of the principles of composing a drawing. Do not panic. This stuff is useful if you want to use it, but don't let it hold you back if you can't get a handle on it straightaway. You can still be a great cartoonist without it. You can even pick it up as you go along. But before we plunge right in, first let me introduce …

The Cartoonist's Best Friend

It's not your commissioning editor, bank manager or biggest fan, but a small cardboard window frame. (Mine are usually made from yellow card, so that I can find them easily.) With the aid of this frame we will set limits on our cartoons, keep our clients blissfully serene and have something to push against.

If you are in the happy position of having a commission, the art editor or client should supply dimensions for the artwork – the final size it will appear in print or on-line. There is no point in drawing any old size and hoping it will fit. Besides, if you give the art editor too much work to do resizing the drawing, you are not going to be top of the list when the next piece of artwork is urgently required. Art editors like cartoonists who make their lives easier. So upon receiving a commission, the first thing to do (after jumping around the studio and punching the air) is ask for final print size.

Let's assume the designer or commissioning editor has left a space 9cm wide by 15cm tall for the artwork. This is a typical size for a newspaper single column or pocket cartoon, but it is very small for a drawing, so we scale up. For my own news-paper cartoons, I usually draw the artwork at 200 per cent, that is, twice the size it is going to appear in the paper. That is larger than some cartoonists because I use a thicker brush pen rather than a fine-point felt pen. Matt, for example, scales up around 140 per cent. Gerald Scarfe scales up around 1,000,000 per cent (I am joking, but he draws huge). Steve Bell, on the other hand, is reputed to draw at the same size as his cartoon strip appears in print. He must have eyes like a laser.

The simple way to scale up is draw a box the same as the print size, extend one side to the size you want (we'll take the width), place a rule across the diagonals and complete the new box. This is one scaled up 150 per cent.

Scaling up.

The author's frame.

Manufacturing a frame like this is especially useful if you repeat work at the same size (as with a regular newspaper cartoon). It is also more flexible than measuring up each time, because if your cartoon has strayed outside the limits, you can quickly reposition the frame and redraw the box.

The bigger the print size, the less you may need to scale up. Sooner or later, you will find you are limited by paper or scanner size if you email your artwork. Incidentally, if you are mailing out your artwork or delivering to a printer to scan, don't go mad – bear in mind there are still limitations on scanner sizes. It is extremely irritating to get back a piece of artwork and discover some hamfisted scanner operator has sliced a chunk off so it will fit on his scanner. If in doubt ring the printer or art editor first.

Back to our new, larger-scale drawing box. You could simply ink it in and use it to trace over when you draw the artwork. Or you could draw a new box each time you draw the cartoon, but that's time-consuming. The best way is to make a frame the same size as the box. Thick paper or card is fine. Mark out the box and cut out with a sharp craft knife or scalpel. Voilà! An indispensable, customized piece of kit in no time at all. You now use this to sketch out a light blue box and get drawing. In the case of my newspaper cartoon, it becomes a hand-drawn frame to contain the cartoon and incorporates my initials to save cluttering up the drawing with a signature.

A couple of interesting things happen when we limit our artwork to a confined space like this. First, it makes us think about the image on the page: what it will look like; the composition; and how to achieve the most impact and draw the reader's eye to our little corner of the page. Second, depending on the size of artwork, it makes us aware of what we can cram into the space. It is the opposite of the business guru's mantra; we have to think inside the box. That means – simplify. It also means – get crafty. In the past, my little cartoon space in the newspaper has managed to encompass a canal boat, a motor launch, a stage set, a wind farm and a cast of thirty-seven. (Not all in the same cartoon, of course.) Some of this is achievable simply by altering the angle of view, as in this crowd scene from 1989.

" Nice to get away from it all, isn't it. "

And, of course, some of it is achieved by cheating. This scene depicts night-time road resurfacing work alongside a lake. It includes two workmen, a tarmac lorry, a digger, a workman's tent, several on-lookers and a small tawny owl. The editor threatened not to pay me that week until I pointed out I ought to charge more for the extra ink used. That week's cartoon certainly stood out on a busy front page.

" My bit of road has just gone 'splosh!' – I think we may be resurfacing the lake... "

Breaking the Box

As always, we should be aware of all the above rules, follow them faithfully and break them whenever we feel like it. One entertaining and visually striking way to do this is have a character burst out of the box. Comic books do this all the time (especially the American ones). Something which breaks out of the frame (even making a hole in it, if you have a rigid black frame as sometimes occurs with newspaper cartoons) instantly grabs the reader's attention. As shown in the cartoons here, it is more interesting to break the frame, even if only slightly.

Contained.

Break out.

"It's not a monster — it's just another fat kid jumping off the pier."

(There are periodic sightings of a monster in Lake Windermere. Often around tourist season. Funny, that.)

The Rule of Thirds

The compositional Rule of Thirds was conceived during the Renaissance and can be succinctly defined in six words:

- stuff in the middle is dullsville.

The European fine artists of the period may have been a trifle more long-winded about phrasing it, but this gives the general idea. If we divide our picture frame into thirds, we can use it as a handy aid to composition.

Rather than put the subject of the cartoon dead centre, moving it off to a third or two-thirds across the frame gives it more interest.

Okay, this is already quite interesting, given she appears to be juggling piranhas. However, move her over a bit and we

have room for a secondary subject, a sense of conflict. Moving the subject away from the centre creates a certain sense of tension. What's going to happen as she cycles off to the right? Will she trip and fall and be eaten by the piranhas? What happens next? Will I have to wait until the author's best-selling book appears in order to find out? (Yes.)

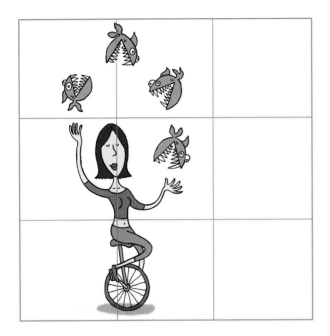

The ideal place for the subject is at the intersection of any two lines on the grid. If you have two conflicting characters, place them either side.

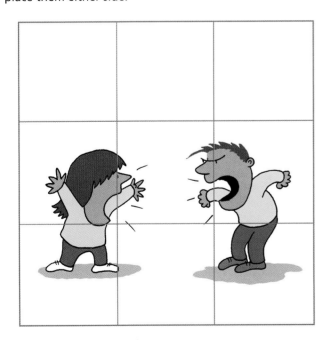

Placing the subject off-centre also helps to lead the viewer's eye into the picture, which is particularly helpful if

the main subject is in a scene and there is a lot going on or you want tension between two separate parts of the cartoon.

It is not always strictly necessary to follow this rule. After all, in many cases the whole point of the cartoon is the gag and no one is going to worry if the composition is a little off. However, it is something to strive for if you want the drawings themselves to have impact. Be aware of the rule, play with it, break it whenever necessary. If you aren't satisfied with a cartoon drawing, is it because it looks too central, too static? If so, draw it again, this time composing it strictly to the rule of thirds. Does it help? Does it make it more interesting? Does it re-energize your approach to the drawing?

Viewpoint and Perspective

A little knowledge of viewpoint and perspective can similarly improve your cartoons. There is a great temptation to have a couple of talking heads chatting away to each other, with a viewpoint that matches their eye level. Fine if you want the reader to dive in, get the joke and leave quickly. But it's always nice to encourage him or her to linger. You can lead the eye into the drawing, make the reader work at it a little and hopefully at the end of the joke, they'll sit back and look again at the drawing, appreciating its fine mastery and craftsmanship. Possibly.

Playing with perspective doesn't hurt and it can be quite good fun. We can summarize the basics with:

• at a distance, stuff goes to a point.

So roads get thinner in the distance, buildings get narrower at the top, and so on. All very straightforward, but quite a good, quick way to give an idea of a landscape lurking behind your characters. It also helps to place your characters in a context.

Now you can get away without much in the way of perspective (I've been trying for years), but it means your style is going to have to accommodate this and it may be difficult to maintain. I don't propose to go into the finer details here – there are authors out there who are far better at this than I am – but there is one aspect of perspective which is really useful – eye level. Depending upon the viewpoint of the drawing, we can see farther into the scene. Take a man standing on a road. There are three principal eye levels we can use for this.

Bird's eye view From a bird's eye point of view, we get an enigma. A man alone in a fierce, unforgiving landscape. A man who's gotta do what he's gotta do, and has gotta do it from a variety of different angles. Bird's eye views are good for showing how small a character is, for including a wide landscape in a small image area or for setting up a puzzle, as in this picture.

Person's eye view We can see everything about our character full on. We can see everything our character sees. This viewpoint puts the character on the same psychological level as the reader. It also makes all the characters in the scene roughly equal in stature and importance.

Worm's eye view Not literally of course, otherwise it might be dark, depending where the worm was in its daily burrowing routine. However, a low-angle view can be good if we want to make the main character seem bigger, more dramatic, with greater importance. It is also very good for hiding too much of the background, if we don't fancy drawing it, feel it would clutter up the image, or just aren't very good at drawing backgrounds.

A bird's eye view is ideal for incorporating a range of vistas, especially if you bend things a little.

Hiding Stuff

The basic principles of perspective are well worth learning and practising. But much of it is wasted in a tiny pocket cartoon or a small Web graphic. So learn to cheat. Suggest background with a few lines and modify the angle to avoid drawing things which you either can't draw, or can't afford the time to get right. And if in doubt, hide stuff: use close-ups, blacked-out shapes, anything you can to avoid too much detail which is either difficult, or would just plain distract the reader's eye. For instance, my most simple regular scene for my newspaper cartoon has a silhouette of houses in the background which gives enough of a suggestion of a town without going into a lot of unnecessary detail. If you can get the backgrounds right with an artist's eye for fine detail and accuracy (think of Thelwell and Giles), people may admire it, but the chances are the general public will give it hardly a glance. If you get something horribly wrong though, you can guarantee everyone will see it.

If you think all this talk of hiding things is wrong, consider Terry Gilliam. He was the animator on *Monty Python's Flying Circus* and in a later interview he admitted that he used to have great difficulty getting his characters to walk in a realistic manner. He couldn't figure out how to do it. So guess what? He cheated. He gave them long flowing robes so they glided across the ground, or they moved through tall grass. He even gave them wheels, or had them bouncing around as if on a hidden pogo stick. These bizarre techniques became his signature style, instantly recognizable. And they were funny. A bishop on wheels is much more memorable than a bishop who simply saunters about the place. If Gilliam had been able to animate a decent walk right from the start, *Monty Python* would have been a lot less visually distinctive. So if you need to cheat, do it blatantly, with panache and you may become world famous.

All the World's a Stage and All the Men and Women Are Merely Stick Figures

So how does all this help when we are composing our cartoon? Well, if we were trained fine artists with several years at art college and a grounding in drawing techniques, we'd be off and running. All the points about perspective, rule of thirds, would be second nature. We'd grab a pencil and a sheet of paper and begin sketching right away. For those of us without this training, it can take a little longer and seem more formidable to start drawing. We can try to have a clear picture in our head of what we want to get on paper, but from head to pencil point sometimes things get a little lost.

We could draw everything at the same eye level, assembling it as a flat, two-dimensional image – a bit like those cardboard theatre sets children used to play with before fun was invented. This is fair enough and may indeed become your style of drawing. Terry Gilliam's *Monty Python* animations were assembled from cut-outs and pieces of paper. (The US series *South Park* has a similar feel, but do not be fooled – they cheat and use computer graphics.) Knife and Packer's *Private Eye* strip, 'It's Grim Up North London', also goes for a flat, badly-assembled look. I am not being rude; there is considerable skill in getting cartoons to look consistently slightly gauche and unsophisticated. You have to limit yourself because as soon as you introduce a three-dimensional or realistically drawn element into that style, you have wrecked the illusion. If you can work within those limits, great. If not, and your drawing skills need some help, it is time to cheat. Enter the world of theatre, shoeboxes and the ever-useful condiment set.

Many chapters ago, I recommended a sophisticated filing system for reference photos and sketches. Now it is time to turf them out and make use of the shoebox. If we are trying to picture a scene, it is sometimes helpful to imagine it taking place on a stage. Not many of us have one of these in our back garden, but a shoebox will substitute rather well. Remove one side and we have the three-sided stage set. In fact, we can go further and have theatre in the round. Leave the side in place and then once your stage is populated, we can twiddle it around to see which view we think is the most suitable to draw (or which is the easiest to achieve).

In place of suitably miniaturized thespians, we'll make use of a few inhabitants of the kitchen cupboard. Salt and pepper pots are good, as are spice jars. We will go for a scene depicting two characters in a kitchen. Simply place your condiments where you think is most suitable, pop in something to represent bits of the kitchen (a bar of soap for an Aga, say). Exact scale doesn't matter as we have imagination to help. Move around to suit, twiddle box to get the best view, transfer to paper as rough sketch.

Most of the time, we won't need to actually get a shoebox to do this. It's a last resort if you're having a failure of imagination day (it usually lands around Wednesday lunchtime). You can also put your condiment characters out on a desk or coffee table and shuffle them around till you get something you are happy with.

Big disclaimer I know this seems excrutiatingly basic, but it can be extraordinarily helpful in setting a composition in place. It has a further benefit – play. Whilst we are happily moving things around and considering the composition, we're also occupying the spacial awareness cells of the brain, giving other cells time to freewheel a little and generate ideas. And once the characters are in place, we can take our cardboard frame again, hold it up in front of our eyes and move around until we have the scene we want. A one-handed sketch and we have the beginning of our shoebox scene committed to paper.

In fact, this very technique was used to compose the little scene involving a television engineer, a bath and a rubber duck. (The explanation for which will, I am afraid, have to wait for that forthcoming best-seller of mine.)

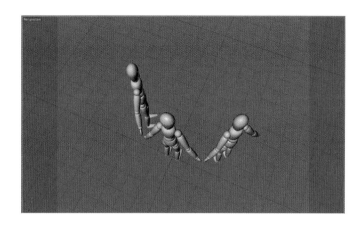

Those of us working at the cutting edge of digital technology (ahem) can achieve a similar result by using a high-end modelling program such as Cinema 4D. It is not that different. There is a gridline perspective on the floor and figures made up of cylinders and spheres.

And just as we can take our cardboard frame and move about to get the best angle, the computer viewpoint can fly round the scene and draw it from different angles. The main difference is that Cinema 4D costs a wee bit more than a shoebox and a pepper pot.

Body Space

Drawings of pepper pots and salt shakers are all very well, but as a cast of characters they do restrict us to a condiment-based milieu. We can, however, use those little sketches to box out personal space for our cartoon characters to inhabit. It's as easy as A – B – C:

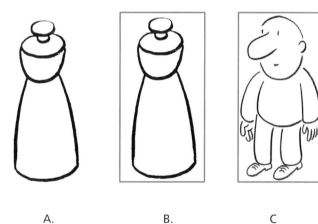

A. B. C

This is for a 3-D set of characters, but we can do the same in two dimensions. Even before sketching out characters as a set of posture lines or stick figures it is invaluable to draw a few boxes to show where they will be standing. This gives the following:

- relative positions
- whether any characters need to obscure others (foreground and background characters, in other words)
- relative sizes and shapes.

Let's have a go at a 2,000-year-old parade ground scene, with a short sergeant major at the left shouting at three Roman squaddies on the right. First I'll sketch it out as a set of boxes (shown here in red, but I would do this on a separate sheet or in blue pencil).

Now we can begin work on the characters. As a further cheat, I worked on each character separately, on a different sheet of paper. Putting them together again on a light box (or scanning and reassembling in Photoshop) gives me a final chance to adjust the positions. In this case, I made a final move and took all three squaddies higher in the frame so that it looks as though they have been blown off the ground by the force of the sergeant major's shouting.

Hmm ... okay, but a little regimented (I'm allowed one bad pun per chapter). Let's move them around a little so the squaddies aren't in size order.

That looks better and one amendment before we start with the stick figures – one of the characters could do with recoiling further.

Now we can use the boxes to sketch in our stick figures. In this case, I am going to use a combination of sticks and box figures.

And finally, the fully coloured version with a hint of background.

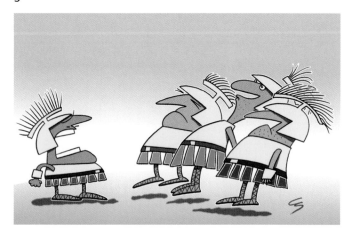

Exercise

Time for a quick exercise. To the right are four boxes to contain your characters. Copy them to a size that suits you and draw a character in each ... *but* the characters must touch each of the sides of the boxed-in space. No cheating and using an outrageously tall hat – although hairstyles and quiffs are allowed. This exercise should give you a feel for the technique and set your imagination going.

Of course, we don't have to restrict ourselves to characters who are perfectly symmetrical. So have a go at a few additional and slightly more bizarre shapes.

The World of the Shadow

Consider a few of our stick figures from earlier. The last two look immediately more interesting, now that they have shadows underneath them. They have acquired a landscape, or at least a sense that there is ground beneath them. And it has been achieved by adding a couple of very quick scribbles under the figures. Where there is a shadow, there is something for the light to throw the shadow onto. And we have added even more information by the distance the figure is above the shadow. The left one is running over the ground, but the right is positively flying over it.

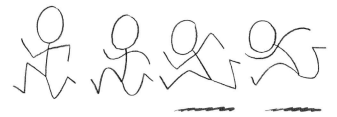

Adding shadows to any drawing immediately gives it weight and depth. But don't overdo it – if your style is simple and spare, a single scribbled line may suffice, as with the stick folk. As the style veers toward the more detailed, add a few touches here and there, falling on clothes or nearby objects.

This is one of those cases where being able to manipulate artwork on a computer is so invaluable. Let's take our shadowy mystery man character from page 94 and remove the shadows altogether. He looks a lot less threatening without them.

Drawing the shadows on a separate layer in Photoshop means that you can adjust the transparency of the layer and therefore how light the shadows appear. I draw the shadows

in black, so that is 100 per cent. Here is our mystery man again with the shadow layer reduced in 20 per cent increments from 80 per cent to 20 per cent. (The original was 66 per cent, which looked about right against the background of the wall.) Unless the lighting is dramatic (as in this case), I usually find 20 to 30 per cent is about right for adding depth without the shadows becoming distracting.

If you prefer to work on your cartoons by hand rather than using a computer, you can achieve the same effect with a light grey wash, either using watercolours or a light grey brush pen such as the Staedtler Pitt. If you are unsure about it – and excessive use of shadows is a very reliable way of over-working a drawing and mucking it up – use a sheet of layout or tracing paper over the top and sketch the shadows in first on the overlay. Or if the work is only going to be reproduced in black and white, use the famous blue pencil.

Inevitably, having told you all this, a quick tour through other cartoonists' work will demonstrate that some cartoons manage quite happily without any shadows at all!

Adding Tone

We can use grey tone to liven up a cartoon in a number of ways. We've already tried it with shadows. A little light colouring around the cartoon also helps to give it depth and interest. Matt, the *Daily Telegraph* cartoonist, uses a small box of grey watercolours to apply tone. It is then scanned to go into the paper. This gives it a delicacy of style which is very attractive. The same effect can be achieved in Photoshop.

The traditional, painstaking (i.e., hard work) method of adding tone and shadow to a black and white drawing is to use hatching. This involves laboriously sketching lines with a fine nib pen, spacing the lines to indicate greater depth of shadow, going back over them in the opposite direction (cross-hatching) to make it darker still or to add texture. (A similar effect can be achieved by peppering the drawing with dots, or stippling.) Here is a quick example based on our shadowy character.

Cross-hatching gives a lot of control, if handled correctly and if you have the time to devote to it. It has an old-fashioned, crafted look which can be very appealing. Chris Riddell uses this technique on his *Observer* newspaper cartoons and in the exquisitely detailed drawings in his children's books. I am full of admiration and the drawing looks gorgeous. It is also very satisfying to work like this but *very* time-consuming and requires a lot of concentration and skill, not least in knowing when to stop; it is easy to ruin a drawing by over-working it with cross-hatching. And it gets to your eyes after a while. I am not convinced it works well in modern newspapers or on the Web, unless the drawings are reproduced at a decent size. For impact and immediacy, a simpler approach can be better. This example from a children's book was to be reproduced quite small, so the computer shadows kept it simple and bold.

In Full Colour

Before launching into colour, there are a few questions to ask yourself:

- Does your cartoon need colour, or would it have more impact in black and white?
- What is the intended market for your cartoon? A colour cartoon may shine in the glossy pages of a magazine, but reproduced on newsprint it may look a soggy mess.
- Does your prospective editor want the artwork in colour? Always ask – you'd be surprised how many don't think to tell you.
- Even if the other images on the page are in colour – especially if they are *all* in colour – would my cartoon stand out better in B&W? My cartoons on the front of the newspaper I work for have always been B&W and I don't think putting colour into them would help – B&W seems to tie it closer to the newsprint and make it more immediate.
- You must also check to see how your cartoon is going to be reproduced and at what size. A piece of artwork that is reproduced over half a page in *The Oldie* in splendidly detailed colour, full of subtle variations and delicate rendition, may look a confusing little blob when used at 75 × 75 pixels on a Web page.

Beginning

Unless you are confident with using colour, keep it simple. Don't slosh colour about like a maniac in a paint factory, or you'll wish you hadn't started. The odd light wash can work wonders if applied to the main characters, to bring them into focus. If you have doubts about your ability, or simply want to experiment, then COPY your B&W cartoon first. Either scan and print, or put it through a photocopier and play around with the copies. Before he made the jump into Photoshop, Bob Staake, the renowned US illustrator, used to colour photocopies. That way, if anything went wrong or he changed his mind, he could just grab another copy and start over.

Brush pens and coloured felt pens are ideal for cartoon work because they are bold and easy to use. Progress to Kolinsky sable hair brushes and Bristol board when you've built up your confidence and skill (not to mention a decent bank balance). Crayons can work well – but be aware that they may contain pigments which are impossible to reproduce. Oh, the fun I had in the early days before I realized that, and the lovely, verdant forests on a map I was doing came out looking like a peat bog. As usual, cartoonists have an advantage over the fine artists because we are not afraid to cheat. They call it 'mixed media'; we call it 'whatever works'.

Live Example

To round up this chapter, here's an example of a Christmas card I produced a few years ago when *Harry Potter* mania was at its height. I knew the idea I wanted to put across – the fairly simple notion of Santa's sleigh being towed by broomsticks instead of reindeer. Here are a couple of the early sketches:

The first caught the angle and energy I wanted, the second begins to hint at a landscape underneath. Some further footling round with the pencil and it dawned on me that rotating the scene from landscape (wide) to portrait (tall) gave me a better angle on the landscape.

Now I just needed tp improve the landscape.

This is beginning to feel more like it, but Santa and his sleigh need more work. A blue pencil sketch got me closer so I pencilled that in, ready to trace off.

Time to put them together and see how the composition works. There are three ways I could have done this: cut out and paste; scan and position in Photoshop; or more tracing. On this occasion I was quite happy with the Santa drawing and knew if I kept tracing it, I was going to lose the feel of it. So this was the Photoshop composit.

This became the final sketch. It went onto the light box, a sheet of fine art paper went over it and I traced out the main elements in ink, leaving the background lines to pencil in in colour. Once this was done, it was off to the colouring box. The final artwork is a mix of a grey/blue Pantone felt pen for shadows, Caran d'Ache colouring pencils, red Pantone for Santa's suit and yellow watercolour for the outline around Santa and the sleigh (added to help lift these foreground elements away from the background). The snow is … the white paper.

Finally, the caption was added in felt tip. Here is the finished artwork as it came back from being scanned by the printer, complete with crop marks, instructions across the top and masking tape down the side applied by the scanner operator (*grr* – outside the crop marks but, nonetheless, *grr*). The artwork took about two days to complete and, as this was a personal card, there are a few in-jokes. That's my dog with the skiers – although my partner isn't blonde, which caused a few rumours. The snowman by the front door is from Calvin and Hobbes and I regularly produce Lap Maps … these were put in purely for my own entertainment, but they give it interest and achieved the Giles-like feel I was after.

BYTES AND PIECES

Today it is difficult – if not impossible – to be a professional cartoonist without using a computer and the Internet. They are vital for archiving, working on and sending out artwork. Whilst a few traditionalists may baulk at the idea, introducing a computer into your workflow opens up endless possibilities, makes your work more flexible and gives you access to new markets.

In this section, we'll look at techniques for drawing on computer. We'll examine how it affects your preparation and how not to let the computer get in the way. And we'll look at the one thing computers are really good for – cheating.

Why Bother?

I've been using a computer for artwork for twenty years so I've arrived at a few pros and cons.

Pros

- Once in the computer, I can manipulate the artwork a number of different ways. If I change my mind, I can go back to the original file. I don't have to scrap the whole drawing and start again. This also applies if the client requests change.
- I can assemble a drawing from a number of different elements without having to redraw. If I'm assembling a cast of thousands, I can draw them all separately, knowing that if I muck up number 999 the previous 998 aren't going to have to be redrawn.
- Using built-in filters or tricks I have developed myself, I can achieve effects which would take far longer using traditional artwork techniques. Artwork can therefore generally take less time to do.
- Artwork never need leave the building – no more worrying about when or if the editor is going to return my precious original.

- Storing your drawings is easier and takes up less room. I have multiple back-ups in case of accidents.

Cons

- Contrary to what's been said above, it can at times be easy to get bogged down in trying to achieve something on the computer when it would just be much quicker to redraw it on paper. Yes, really.
- When I'm drawing on screen, I lose the feel of pen on paper. My drawings look different.
- Unless I'm very careful, tints, shadows and effects can look mechanical and instantly shout, DONE ON COMPUTER!
- It's rather depressing to spend six months doing hundreds of drawings and then discover they all fit on a weedy silver beer mat. Or maybe that's just me.
- At the end of the process I no longer have an original piece of artwork to display or sell.

Having said all of this, if you are planning to work professionally, avoiding the computer isn't really an option. You need to be able to get the artwork to clients as quickly as possible and nothing beats 186,000mph. It also makes their life easier – the cartoon pops up on their screen, there is no scanning, it can go straight to page. Save the client work and you'll be nearer the top of the list when the next commission comes along.

Besides, computers are fun, the field is comparatively new and the opportunities are tremendous. But before we leap into methods, we'd better get a few technicalities out of the way. (For a cartoonist's overview of recommended equipment, see Appendix 1.)

Throughout this chapter I am going to assume we are all working in Photoshop or Illustrator, the two industry heavyweights. You may find you can do everything here in one of the smaller, cheaper programs. Most follow the same basic rules regarding tools, layers and how drawings can be manipulated. The main difference between home and pro software

is in the way files are saved. But we'll come to that later.

The main thing to remember is that cartoonists probably don't need all the facilities, filters and fiddle factor of the Big Gun programs. Or the expense. In ten or more years of using Photoshop, I've still barely explored more than 20 per cent of it. And Bob Staake, the brilliant American illustrator, is well known for using a version of Photoshop which is hundreds of years old (in computer terms). It does everything he wants, he hasn't wasted time learning new programs, he's comfortable with it and the drawings he creates in it are great. (See Appendix 2 for a link to a YouTube video of how he works.)

First some basics about line quality and then we will get back to being cartoonists.

Different Strokes

There are two fundamentally different ways of drawing a line on a computer screen, bitmap and vector.

Bitmap

This is like painting a line across a series of pixels on our screen. The computer stores information about each pixel's position and colour. This takes memory, so file sizes can be large. If we scale the drawing up, the computer makes it larger by inventing new pixels (called interpolating).

Computers aren't very good at inventing, so beyond 150 per cent or so the results can look fuzzy and rough (unless we use specialized – that is, expensive – software to do it). Shown here is a bitmap line at 100 per cent and then ten times the size. Bitmap drawings require 'anti-aliasing'. Alongside the solid colour pixels, the computer puts in a few translucent ones, so that the line fades off gradually and it looks less like it has been constructed of Lego.

Vector

Make two or more points on the page and the computer describes the route between them to make the line (direction, length, curve, thickness and colour). This might seem more complex, but in reality it's plotting two points rather than describing every pixel in-between. This requires less information so file sizes are smaller. When you scale up, it simply replots the information and the line stays sharp and clear. Shown here is a vector line at 100 per cent and then scaled up ten times.

This is very useful if your drawings are going to be blown up to life size. Meet Megan, the cartoon National Park Ranger (overleaf). She originally appeared in a book for Pembrokeshire National Park Authority and now stands one and a half metres tall in Tenby Information Centre.

can be fiddled with, tidied up, colour added, even extra characters included. Scanned images are bitmapped. This means we have to know the size it will appear in print before we start.

- Work entirely on screen. Some artists scan a rough sketch and trace it, but the final artwork is all computer-drawn. This artwork can be either bitmap or vector, or even a mixture of both. Most modern comic book artists work this way.

Much of the next section applies to Adobe Photoshop, but many of the techniques also work in Corel Painter, Photoshop Express and a number of the newer, smaller bitmap art programs. See Appendix 1 for more techie guidelines to programs.

The Paper Approach

We have the beginning of a cartoon in black and white, lovingly hand drawn in black ink on the very finest paper and we are about to commit it to computer. Now what? Well, let's assume we are going to add some grey tone to the cartoon. Let's dig out the scanner and … we are faced with questions: What resolution? Black and white or greyscale?

- Easy one first – resolution: most print publications work on 300 dots per inch (dpi), so scan at least as high as that. I usually work at 600dpi to be on the safe side.
- Black and white or greyscale (your scanner may call this Document or Photo): B&W reduces the image to two colours (guess which), whereas greyscale captures the subtleties of tone. I used to think B&W was fine. I scanned, converted to greyscale to add the tones and worked from there. But I have gradually realized that the whole image is softer and more hand drawn in appearance if I scan in greyscale.

Working like this may mean fiddling the exposure to get rid of any blue pencil lines, which can show up as faint grey lines. (You are using your blue pencil for this, I trust.) But we can always whizz round with the eraser tool afterwards.

Here's a cartoon man scanned as a greyscale image at 100 per cent. Once scanned, save the image as a Photoshop file or TIFF file. Avoid JPEG at this stage – this file type is designed to compress and lose information. Once it has gone you can never get it back, so save it for the final stage if using on the Web. Avoid using for print.

Personally, vector drawing feels more like technical drawing. It's possible to draw freehand and programs like Illustrator or Expression can make the lines resemble brush strokes or pencil lines. But once we go beyond simple lines, we have to construct the drawing from shapes, like a high-tech collage. I find it requires a different way of thinking and, for me, ruins any spontaneity in the drawing. For most of the rest of the chapter I'm therefore going to be dealing with bitmap drawing and we'll do a quick canter through vector drawing towards the end.

Paper or Pixels?

Some cartoonists prefer to draw and shade/colour on paper, then scan the artwork. Others work entirely in electrons, at most tracing a rough sketch which they have scanned in; the final artwork is created entirely on the computer. My method of working falls somewhere in between. Find the compromise that suits *you*. There are two basic approaches:

- Draw on paper and scan into the computer. The cartoon

Cartoon scanned as a greyscale image at 100 per cent.

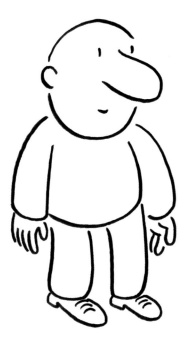

We could simply use the brush tool and add tone to the drawing straight away. But we would have to make sure we didn't go over any black lines or we would obliterate them, as shown in the illustration.

Oops. Why not use the fill tool, then?

Okay, not so clever. There was a gap in the line. But as it happens, line gaps are part of my style and I am not modifying it just to suit Photoshop. Even if you have closed the lines and can use the Fill tool, the tone will not butt up against the black line because of the anti-aliasing. There will be a little jaggedy white gap all round the colour fill. There is a better way to colour and one which allows us to change our mind if we don't like the final result.

Layering Up

Note the Layers palette. The key to adding tone and colour to a B&W cartoon resides in the use of layers. We can do this in several stages:

1 Duplicate the Background layer.
2 Pull the new layer to the top and give it a memorable name. We could delete the original background layer now, but I usually keep it – if I accidentally delete something from the Line layer, I can copy it again from the Background layer.
3 Create a new layer below that and call it Grey. If at this stage we draw on the Grey layer, we aren't going to see it. The Line layer is covering it up. But we can alter the properties of the Line layer with the little box on the top left of the Layers palette.

moment, we can see that the grey tone is on a transparent layer, that is, there is no white background.

4 Set the Line layer to Multiply. Now any shading we do on the Grey layer suddenly becomes visible. The Multiply setting effectively makes everything on the Line layer transparent except the black line areas. This is extremely useful because it means we can paint in our tone or colour without even touching the lines we drew earlier; they're on an entirely separate layer. If we stray too far over the line, we can rub it back without harming the line. And because we are not using the boring Fill command and simply pouring colour into an enclosed space, we can be more creative and treat it like a water-colour wash. For example, I like to leave the tone sketchy to liven up the look of the drawing.

This means that any further layers behind that will show up in the transparent areas – somewhat akin to fanning out playing cards. When we come to work on our little man in colour, we can have a separate layer for each colour. This allows us to build up a drawing step by step, adjust each layer's colour or tone and, most important of all, if we change our mind about something on a layer, we can dump the whole layer and start a new one without affecting any of the other work we have done. We will come back to working on a colour example of this in a short while.

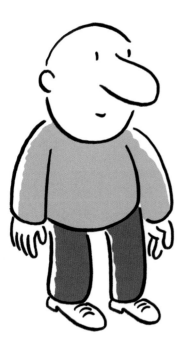

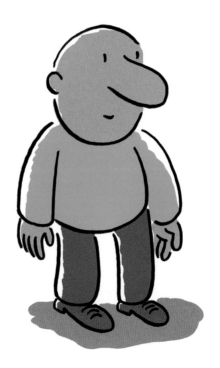

Using different layers makes life a great deal easier when working on colour artwork. If we turn off the Line layer a

Screen shot of layers.

Corel Painter is a program which excels at this sort of thing, offering a vast range of adjustments and possibilities, far greater than Photoshop (the clue is in the name). What this means is:

- by switching to a computer you are not going to lose all the techniques you've learned in traditional art
- there is room to develop your own style, without it looking like computer art.

Photoshop and Painter offer much more than pencil and brush tools. If you really want to explore it, there are excellent tutorials on the Web, many of which are produced by other cartoonists and illustrators who are doing it to simply enthuse about the possibilities.

Brush Work

The Brush and Pencil tools in Photoshop give two different effects. The Pencil is harder edged and works like ... um, a pencil. You can modify it to produce a line which resembles 2B, 5B, charcoal, graphite stick. It is great for drawing lines.

The Brush on the other hand is terrific for tone and colour. By adjusting the hardness and opacity of the brush, it's possible to produce very natural effects. For example, by fiddling with the opacity and flow, we can mimic the swoosh of watercolour as it splurges off the brush, the way colour gets denser as we go back over it. For example, this is the same colour brush – the density is either altered by changing the transparency of the brush, or by overlaying brush strokes. So this mimics watering down the colour and brushing watercolour in successive, overlaying strokes onto paper.

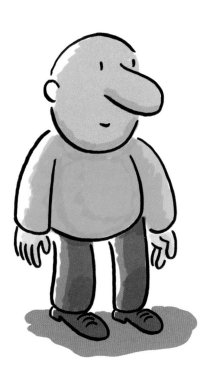

Bin the Mouse

I know I promised to leave the equipment until Appendix 1, but I lied. Here's a brief technical aside. Before you embark on any serious work on the computer, unplug the mouse and throw it into the bushes. Replace it with a Wacom graphics tablet. This enables you to work holding a pen, just like in real life. It feels natural, it doesn't give you repetitive strain injury, it's fun and it looks cool. By comparison, working with a mouse is like trying to draw with a house brick.

Colour Example

The principle of using layers with grey tone illustrations works even better when we move to colour. Let's look at a live example. This is an illustration for a birthday card, using relatively simple colour with a few tricks thrown in to jazz it up a bit. It makes use of layers because it was quicker than drawing the whole thing by hand, it gave me the opportunity to play around and because I wanted to be able to modify it for different uses at a later date.

Once it was scanned in, before I did any work on it, I copied it, renamed it and worked on the new copy. That way the untouched original is always available if I ruin the working copy. (You would be surprised how often this has saved me from missing a deadline.) Then I set it up in Layers, as I described earlier. (I have done this so many times that I use a Photoshop Action for this – a great timesaver.) The screen shot shows this stage.

This particular line drawing is pretty complete and doesn't require any tidying up, apart from moving the signature and

making it less prominent. So straight into the colour. Our little alien comes first and everyone knows Martians are green. We'll dot a few bits of colour into his eyes and accessories whilst we're at it.

We want to keep this layer separate – we might change our mind later as the colours build up – so we'll rename it Green to avoid confusion. By selecting the green colour of the Martian's body with the Wand tool, we can use the Paintbrush tool to splodge in some yellow spots without straying over the lines of his body or having to be too careful.

And then we continue building up the colour in sections, each on a separate layer. Some of the colours (sky and ground), I'll put in as a graduated tint, to give the image more depth. This is very easy in Photoshop but does have a computery-look to it, so don't overdo it. The mountain colour bleeds over the black line to make it more interesting.

Our Martian is looking okay, but we can jazz him further. The sky needs a few stars and we could do with some shadows.

Final birthday card.

He could now do with separating out from the background a touch. Normally I would paint a thin white line around the main character to achieve this. But Photoshop to the rescue: there is an outer edge glow filter we can use to achieve a similar effect. Again, a technique to use with restraint because everyone has access to it. But it suits the other-worldly nature of the character in this case. Finally, add the caption and pop a frame round the cartoon. This will go on to a long and happy career as a birthday card.

Vector Drawing

Some artists and illustrators achieve great things with vector drawing programs such as Illustrator and Corel Draw. The techniques are nothing like drawing freehand with a pen or a graphics tablet. The downside is that you have to plan your drawing very carefully. Filled areas (a jacket, for example) become discrete objects and you spend a lot of time juggling layers to make sure the right ones appear in front or behind … you are engaging in a three-dimensional jigsaw puzzle.

The upside is that it is easy to have a kit of parts on hand for regular characters. For example, meet Dave Dusk (over-leaf), a charming, charismatic photographer invented by myself and charming, charismatic photographer David Ward. Dave Dusk stars in a series of cartoon strips, along with a few other unlikely members of the professional photography undergrowth. In order to work up the look of the characters, I sketched them first, then scanned them into Illustrator.

(I defy anyone to sketch first in a vector program, unless they are a cartoonist called Spock.)

Then they were traced and assembled in Illustrator, giving a set of characters and body parts which could be used again and again.

Once assembled, Dave Dusk was easy to pop into a series of cartoon strip adventures.

Take a look at all the layers in the screen shot and it is apparent what is involved.

Dave Dusk could have been hand drawn, but in this case we wanted something which looked different from my usual style and which would have the flexibility to go onto a wide range of merchandising.

There are some projects where you have to work using a different technique so it is worth getting acquainted with vector programs, even if you don't plan to use them regularly – shown here is something which couldn't have been achieved any other way as a book for online publisher, Penwizard.co.uk.

Albert's Christmas Adventure was a book the reader could customize him or herself. On the site you could specify the main characters and they are inserted into the story, which was then digitally printed and sent to the recipient. It's been done before, but Penwizard went several stages further – the alterations were not just to the text, *all* the illustrations also changed. So the main character's hairstyle, skin colour, clothes, whether or not he/she wore glasses, age, height – all had to be drawn and accounted for in order that every single page could be adjusted by the software.

As each of the main characters had to be drawn in all their variations, on each of the pages, a simple sixteen-page book

had hundreds of drawings associated with it. It was an ambitious undertaking, the first of its kind in the UK and, to be frank, if we all had known what we were doing we would have never embarked on it. (Sometimes it is helpful not to know what's impossible because then you can go ahead and do it anyway.)

The results were fun, especially when you twiddle around the characters – something the end user doesn't usually see, of course.

Albert, by the way, was the son of one of the Penwizard founders. As a thank you, I received a copy of *Colin's Christmas Adventure*, in which the hero's present at the end of the story was the supermodel, Jordan.

These are just a few of the techniques and uses involved in cartooning on computer. Each cartoonist has his or her own approach. Prowl the Internet, see what others are up to, learn from the tutorials and play with the options. Becoming a pixel-driving cartoonist will keep you wonderfully versatile and infinitely desirable to a vast range of potential clients.

Interlude – Frequently Asked Questions (FAQs)

Once you expose yourself to the world as a cartoonist, you will find yourself having to answer a number of standard questions. Here are a few, together with suggested answers (and don't blame me for the consequences).

Q. What's it meant to be?

A. I haven't decided yet. (Or if in a metaphysical mood: It just *is*.)

Q. Who is it meant to be?

A. Who do you think it looks like? (Whoever they say, then that is who it's meant to be. Obviously.)

Q. How long did you take to draw that?

A. Time taken to do the drawing + time spent training and/or practising = time taken to do the drawing. This is useful if trying to persuade a client to pay you a sensible amount for something they think only takes thirty seconds to draw. In my case, that would be thirty seconds plus thirty-odd years and therefore whatever I'm about to charge them is going to be completely reasonable.

Q. What else do you do?

A. It varies. This is a particularly irritating question for professionals, the implications being: (a) it can't be a real job; and (b) it only took you five minutes so how else do you fill your time? *The Times* cartoonist Mel Calman was so plagued by this question that it became the title of his autobiography. I like to tell people I spend at least four days a week relaxing on my private yacht.

Q. Did you just draw that? (Often asked by someone who has just watched you draw it!)

A. No, I use an automatic pencil.

Q. Can you do proper drawings?

A. Yes, but I prefer to do improper ones.

Q. Have you always been able to draw?

A. Yes, I used to decorate my mother's womb with cartoons.

Q. That's really good – can I have it?

A. Tricky … If the drawing is in the middle of your sketchbook, the answer is always no. Never, never, never tear anything out of your sketchbook, otherwise you'll end up with a pile of old sketchbooks with all the pages missing. But even if it's a doodle on a paper napkin, you may not want to part with it, so practise saying, 'No, I'd like to keep this one, but I can send you a copy.' (By the way, Salvador Dalí used to get free meals in exchange for his paper napkin doodles. It's something to aspire to.)

Q. Do you get paid for drawing like that?

A. No, I get paid for answering questions. That will be £25 please.

Q. Have you thought of becoming an artist?

A. No, I don't like drinking.

Q. Can you do a drawing for my son/daughter/mum's birthday/wedding/graduation/celebration?

A. Of course … but beware this question. Although it may come from a friend, relative or work colleague, it has the potential to lumber you with a ton of hassle for zero payment, create arguments and lose friends. Set down the rules immediately. Are you going to charge? Do they realize what the going rate is? Do you? If charging a sensible amount is out of the question, are you happy to do it in return for a barter?

After grappling with this for a number of years, and building up burning resentment and blood feuds on all sides, I hit on the idea of making the fee a donation to a charity of my choice. But I still establish what is expected of me – and the minimum I expect them to donate.

Q. When are you going to get a proper job?

A. Never. (It is usually relatives who ask this.)

Q. Do you sell your originals?

A. It depends. This is another personal one. You may have some drawings you couldn't bear to part with for sentimental reasons. I kept my first *Private Eye* cartoon for that reason. You may have another use for the drawing, or it is too useful as a resource and a copy won't do (something which is printed regularly, for example, or used by several clients). Otherwise, feel free to sell your originals. Many cartoonists do and you can find them in cartoon shops and galleries. But please be aware of the market value of your work and check to see if it is increasing if you are getting better known. And remember that if someone thinks your originals are expensive – tough. They're your children and you don't have to sell them. Do remember to make a decent copy before it goes out the door. And make sure the buyer knows that you've only sold the original, not the copyright and they're not allowed to print it without your permission.

Q. How did you learn to draw like that?

A. I got this brilliant book on cartooning …

CARTOONS IN THE WILD

We are almost done, you are almost fully equipped to launch yourself upon an unsuspecting world as an ace cartoonist, brimming with wit and chock-full of drawing skills. But what is it like out there? What are the markets? How much can we earn and will anybody love us for what we do? This chapter will give you confidence to sally forth, pen at your side, as a buccaneering freelance cartoonist.

Where Do You Get Your Ideas From?

Ah, the worst question of all. The *Monty Python* team had a good answer to this – a goatherd in Greece. Those of us without access to Mediterranean bovid botherers are thrown back on our own resources. Of course, it is arguable that if you have to ask this question you're already doomed. Most potential cartoonists I have encountered have no problem with the ideas, they just need help translating them into drawings. But there are always tricks and techniques we can use. Here are some that work for me.

- Go for a walk, free-associate whilst you're on the move (and take a notepad).
- Pick a subject, making the constraints as tight as you can (two characters max or one character max but no caption) and then push and twist and wriggle against your self-imposed limits until something pops to the surface. The more freedom I have with something, the harder I find it to get started.
- Throw an animal into the equation; what would happen if one of the characters was a polar bear, a marmot or a gorilla? Take an extremely human situation (exam results, for instance) and give it to some animals to play with. What would they come up with?
- Go for the awful pun.

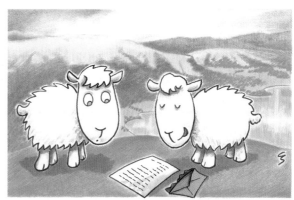

"I did really well in my exams - I got a B and two As."

- Keep your ears open for modern trends, fashion and technology. I once produced a book of cartoons on

walking and the outdoors. Once I realized how much technology was involved in walking gear, it suddenly got easier.

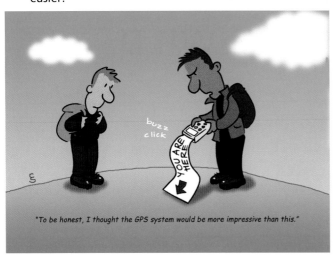

"To be honest, I thought the GPS system would be more impressive than this."

- Listen to what people *say*. A mildly amusing comment or wry remark can often translate into a good cartoon. And that includes listening to what *you* say when you're trying to be funny.
- Have a go at someone famous or in the media. Who or what gets you angry? What do you want to say about them? If it is something no one else has spotted about them, you may be onto a winner. (Steve Bell's cartoon of John Major with his underpants worn on the outside became an icon. It was the defining image of that prime minister.)

- Play word association. What words do you associate with a given subject? What words do you definitely *not* associate with it? Can you make up combinations or scenarios using some of the words?
- How would your favourite cartoonist tackle the subject? Warning: there's the chance he or she may have already done it. And if you take this approach too often you are going to look like you're simply following your favourite. Some cartoonists' signature style extends beyond just their drawing technique.
- Pick a subject, any subject. How many cartoons or ideas can you think of to do with that subject? Funny or not, throw them down on paper. Some may combine later to make something worthwhile. The cartoonist Larry famously mined the topic of Rodin's *The Thinker*, coming up with an apparently inexhaustible supply of alternatives.
- What do you fancy drawing today? What sort of subject, character or scene? Okay, do that. Really enjoy the drawing and see what your brain gets up to whilst you are doing it. You never know, it may have come up with a good joke by the time you're finished.
- On a given subject, what's the rudest, vilest, most obscene or most offensive cartoon you can think of? Draw it, draw several if you must. Get it out of your system. Then throw them away and do something funny.

"All this talk of gay vicars is making us look ridiculous."

Depending on your style, the news is a good source of material. You have to be aware of the danger with topic stuff … it's topical. If you don't hit your market at the right time,

the joke is dead. It is also less likely to get picked up and used in compilations. But just being aware of what is around you and what is concerning other people is worthwhile. Even signposts are a good source. I once spotted a roadside sign in Scotland which read simply: 'Beware sheep'. Why? What are they up to? What *could* they be up to? This duly resulted in a 'Beware sheep' postcard.

By contrast, the one of sheep dancing on the caravan roof is pure whimsy. As a postcard it sells well, though I'm still not sure I get the joke …

"Funny - I could have sworn I heard hailstones …"

What Else Do You Do?

Quite a lot. For example, you could moonlight as a clown.

Cartoonists are not restricted to print or the Web. Cartoonists appear on TV, the stage, in podcasts and sometimes on the radio (me, for instance – see www.radiocartoonist.co.uk). Take every opportunity to put your name and work about, to get exposure and try out new types of work. You never know, it could be fun. Amongst the jobs I have been asked to do are talks, slide shows, business presentations, mind maps and stage scenery. One of the more unusual was being asked to attend a business meeting in London. They didn't want my cartoonist's drawing skills, they wanted me to sit in on the meeting and throw in ideas. They wanted a cartoonist's perspective, an off-the-wall take on what they were discussing. They wanted, in short, someone who thought outside the box (and never is a phrase more calculated to indicate that people think inside the box).

and a video monitor displayed the drawing as I worked on it. A little nerve-wracking, but great for getting the adrenalin going. The cartoons were a little rough but made their points. Here are a few, snapped on the day with a digital camera (which is why the image quality is rough – the roughness of the cartoons is entirely down to the nerves of the cartoonist).

The Rolf Harris Effect

Never underestimate the effect of drawing live, in front of an audience. It is easy to forget that most people don't *know* how you do what you do. They haven't witnessed the magic of minimalist marks on paper becoming a character or a joke. If you get the chance to do this, seize it. Don't worry about making a mess of it, standing in front of an audience or freezing up … cartooning is what you do and after the first nervous ten seconds, you will love it. It's good for the ego and good for ideas too. Talking about something you love always feeds back into what you do and you go back to your lonely studio feeling fresh, invigorated and generally all-round brilliant.

There are a number of ways of getting to do this. If you have a talk worked out, you can contact local art societies or Women's Institute groups and offer to give talks. You could talk about other cartoonists, some of your favourites or ones the audience may recognize, and give a slide presentation. But nothing beats drawing on a flip chart in front of real people. Take your time, enjoy it. Whilst you are drawing, with your back to the audience, it can be a little unsettling if they go quiet. They haven't sneaked out, it means they are enthralled.

And be prepared for someone to put on an Australian accent and say, 'Can you tell what it is yet?'

One of the more interesting jobs I had to do was appearing on stage during a climate change conference. I was drawing cartoons at the side of the stage whilst the speakers addressed the audience. The audience could see the flip chart

Frame those Doodles

Do not throw away drawings. Even the ones you've scribbled on a telephone pad or sheet of lined paper torn from an exercise book. If the cartoon makes you smile, file it away for inspiration. Better yet, put it in a frame and hang it on the wall. Even the scruffiest of inspired scribbles looks more important when it has a nice frame round it (and the little ones from Ikea suit tiny doodles perfectly). As a random example, I scrawled the cartoon shown here on a beer mat during a boring pub conversation. I have no idea what I can use it for – but it amuses me and about 50 per cent of the people who visit. So it went in a frame and now looks almost respectable.

Who knows, one day that happy scribble you were about to discard may inspire a children's book, a joke or a thirteen-part children's animation series.

Going Pro

Now for the serious stuff. A lot of what I am about to say here also applies to illustrators, so don't be afraid to pick their brains or join their associations. You can safely ignore the fine artists, who inhabit a rarified, less practical world. You don't need to be a full-time cartoonist to submit cartoons to newspapers and magazines. Most cartoonists start off part-time and build up. Some always have another career on the

go (although personally I think this is cheating). At any given time, it is estimated that there are around 250 professional, full-time cartoonists working in the UK. (Source: Something I heard on the radio, although as it was said by Bill Tidy I assumed it was true and have been repeating it ever since.)

Markets are changing fast and it is your job to keep up. Newspapers were once the traditional stage for a cartoonist but their numbers are declining in the face of competition from the Web. On the other hand, there are now thousands of websites that require livening up with cartoons. Cartoons are ideal for the Web, being small, simple drawings which aren't file-hungry hogs and which are easily absorbed by those with a short attention span. The Web opens up the world.

So, apart from grim determination, an invulnerable ego and a rich sugar daddy, what do you need to go pro?

- A Place of Your Own – somewhere you can work and leave out stuff without it disappearing the next time Someone Tidies Up.
- A copy of *Writer's & Artist's Yearbook* or *The Writer's Handbook*, to tell you who is looking for cartoons, where they are and (sometimes) what they pay.
- A willingness to research your market. It's a waste of time sending cartoons to a publication which will never use them. But it is astonishing how many do use cartoons, particularly amongst the trade press.
- A business plan – what are you aiming to do with this new life? What else will you need to do to sustain it?
- A flexible attitude. If you're offered a job but it is not strictly a cartooning gig, do you take it? If it keeps you drawing, hell yes. Can you see an outlet for your cartoons which no one else has spotted? Go for it. If you need to do something else to get your work published and earn you money, do you do it? Yup. (I co-own a publishing business for this reason.)
- An idea of your *worth*. Repeat after me: a thirty-second drawing takes a lifetime of experience to achieve. You are not paid by the second. Which brings us to …

What Can I Earn?

Untold riches and the admiration of millions. If you happen to be Carl Giles. The rest of us have more flexible expectations. Illustration work is usually paid per job, not per hour. There are set rates (or guidelines) for a wide range of work and when you quote, you pitch within those limits. Living outside London and not terribly well-known? Pitch below the maximum.

How do you find out the rates? See *Writer's & Artist's Yearbook* or *The Writer's Handbook* for some guidance.

Magazines have set rates they will pay you. Other work is by negotiation. Joining the Association of Illustrators (*see* page 156) gives access to their advice service, which will suggest the usual rates for the more familiar jobs.

How much do you need to earn? That's down to you. As a rough rule, a professional illustrator or cartoonist generates income for about a thousand hours a year. That may seem low, but if you work out how many hours you want to work, take out holidays, remove office admin time, research time, marketing yourself time and *learning* time (including wrestling with the latest software), it's about a thousand hours. Want to earn £40,000 a year? You are going to need to earn £40 an hour. And that is without including all the professional expenses, such as materials, accommodation, software, computer gear, insurance, professional membership and subscriptions. Add it all up and the hourly rate goes up.

I am not saying all this to put you off, just to make you realize that if you undersell yourself and work for ten quid an hour, you are going to be in trouble unless you have another income. Your first responsibility is to your bank balance, otherwise the next time a client wants to use you, you may not be around.

There is always a lot of help out there if you want to start your own business. And there has never been more support available on the Web. Don't just visit cartoonist forums, look at small and home business sites too – someone else's experience in a totally unrelated field may turn out to be just what you need (*see* Appendix 2).

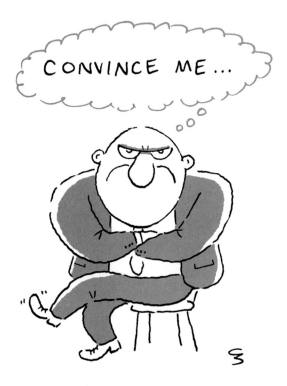

How Do I Submit Cartoons?

Assuming you have researched your market (you *have* researched your market, haven't you?) and know precisely the sort of cartoons a magazine, newspaper or website publishes, it's usually a case of ringing up to find out their submissions policy and then sending in your ideas. It's also useful to know who you are sending to, so get the name of the art editor. It used to be the case that you submitted half a dozen roughs and one finished cartoon (so they could see how well you can draw), together with a stamped self-addressed envelope for the return. Now many magazines accept submissions by fax (getting rarer) or email (on the up). If they don't like it, they usually don't bother to tell you and simply throw the stuff away. Don't worry – it's your copyright and they are extremely unlikely to hand it to their tame cartoonist, tell them to redraw it and then not pay you. Make sure you sign your work all the same and make it clear you are offering the rights to reproduce, not to buy outright.

If you are pitching for more general illustration work, you may have to put together a portfolio or series of sample packs to send out. Again, there is a lot of advice on the Web. Mine is simple – only send your very best work. Don't show them everything you've drawn since kindergarten.

Copyright

It's yours the moment you put pen to paper. You don't have to register it anywhere, deposit a copy with a bank, or get your doctor to sign it. When you submit a cartoon, ideally you should be offering the publisher the First British Serial Rights. They can publish it first. After that, if you can sell it elsewhere, it is no concern of theirs. Some magazines (*Private Eye*, for example) buy all the rights, but then if they sell it on, you receive a cut of the proceeds.

Some publishers and British Broadcasting organizations who will remain nameless issue jolly little contracts which claim all the copyright and all the use for anything they want for all eternity and no further money for you, so there. Refuse to sign contracts. Sometimes asking if they have a professional contract rather than an amateur one will produce a better deal. If not, walk away (unless you really don't care about the drawing and don't think you or they will get any further sales out of it). If this seems a little idealistic, remember: if they buy all the rights and can sell it on, how thrilled will you be to lose a job because you suddenly find you are competing with yourself? If a prospective client can buy one of your cartoons elsewhere for less, why wouldn't he/she?

Professional organizations (*see* page 156) can offer much more advice than I can here. They publish guidelines and often will even vet your contracts for you and warn you what to strike out. I sometimes think publishers just like trying it on. I did genuinely get a completely amateur contract once and when I rang up and laughed at it they sent a sensible one within seconds.

And there are always the ones who ask you to work for free because, well, think of the exposure! No thanks, I can get that standing in the Arctic in my underpants. Getting published is easy. Getting paid for it is the tricky part.

Do It Yourself

So why wait for someone else? Publish yourself. Print publishing is costly, but doing a small run of postcards or greetings cards isn't too expensive. You need to check out your market and be comfortable with selling them, but it is a start. And of course, there is the Web. A good website with compelling content (say, for instance, some good cartoons) will always draw visitors. Get yourself known, link to other sites, use the social websites (Facebook, MySpace, Twitter) to draw attention to yourself. I am on Twitter not because I want everyone to see how dull my life is, but because I want to build up a following, preferably fans rather than stalkers but I'll take who I can get.

Of course, you have to be aware that if you put a cartoon on a website, it's out there, vulnerable to being copied and used by someone else. Usually it's an amateur someone else, so it doesn't matter too much, but irritating nonetheless. There are ways to prevent this, for example chopping the cartoon into bits in Photoshop and then reassembling it on the website like a jigsaw, or putting on a watermark. All a bit of a fuss and I prefer to put up small, low-resolution images which won't reproduce anywhere except on the Web. Most – though not all – professional clients will come to you to buy the use of the original or commission something new.

Self-Promotion

You need to do more than simply sit around thinking, 'I'm great.' This is not a valid marketing strategy and the rest of the world may need a little convincing. There are a number of ways of getting exposure. The best is, of course, to get published. Let your work get seen around. Make sure you always sign your artwork. Many cartoonists use a pseudonym because they want something snappy and distinctive. (A

famous *Punch* cartoonist once told me my name was hopeless for a cartoonist, which annoyed me so much I stuck with it.)

You can pay to go in an annual illustrator's directory, such as *Contact Illustrators*. (The cartoon below is an example of one of my pages on the subject of communication.) An entry in a professional directory is not cheap and can cost anywhere from £600 upwards. It is sent out to thousands of art editors and design agencies. I have been told by clients that it is the first place they look when they need a new illustrator.

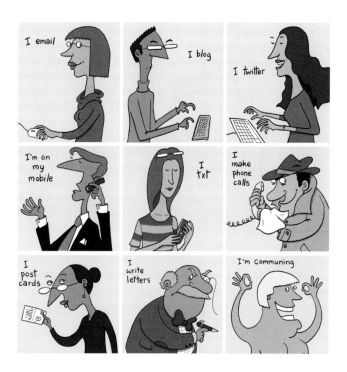

However, other clients say they simply Google 'cartoonist', so make sure you have a website. You're a cartoonist. You can produce something simple, fast-loading, snappy, amusing and fun to visit. Change the content regularly. Not only does that bring back visitors, it keeps Google interested (its little software robots visit your site more often as you alter stuff, up to two or three times a day).

Once you have a website, encourage people to link to it – perhaps by linking to them – and devise ways of getting it brought to the attention of surfers worldwide. Start a blog and link to it, or use some of the social media sites such as Facebook, MySpace and Twitter.

Greetings Cards and Postcards

You are, of course, producing your own birthday and greetings cards for friends, are you not? It's quick and easy to do a one-off that is professional in appearance and original in nature. There is also a constant demand for new, bright and original ideas in the greetings card market. An ideal opportunity for cartoonists.

Building a website is not rocket science, but I would recommend starting with something clean and simple. It makes it easier for you to build, you don't need the most sophisticated software and, to be frank, it is nicer for people to visit. The all-singing, all-dancing, jumping about website which behaves like it has eaten too many E numbers is painful to the eye, difficult to navigate and can be slow to load up. There are good books out there on Web design. There are also websites which will tell you the basics. You probably already have Web space available from your broadband provider, so use it.

And whilst you are at it, make sure you buy a distinctive domain name for yourself. They are cheap to buy (£10 or so a year) and it gives you a permanent home on the Web. (Before you look, c@rtoonist.com has already gone.) Make it easy to remember, avoid complicated hyphens or extra full stops and then put on everything – business cards, letterheads, email signature, car stickers, t-shirt.

When I first started as a cartoonist, I thought every drawing had to be work only from now on. After a year, this got boring, so now I have reverted to my old ways and draw on everything. A recent discovery is that Winsor & Newton make splendid 6 × 4in postcard pads, comprising fifteen pages of Cotman watercolour paper. Each sheet is blank one side and has the usual postcard format on the reverse. These

are great fun for drawing and sending your own, personalized messages to gloat about your holiday. Rather irritatingly, you may find that because you *are* on holiday, the drawings look more relaxed and exuberant than the ones you produce at the drawing board. If you've drawn one you're particularly pleased with, take a digital pic before you post it. Shown here is an example, sent by my dog whilst at the seaside last summer.

A card to a prospective client thanking him/her for seeing you after a portfolio visit is always worth doing – make it interesting enough and it may get pinned to a noticeboard where other potential clients may be drawn to it. Prospective clients are like moths and your work is the flame (Ancient Greek goat-herding proverb).

Positive Thinking

Repeat after me: 'I am *proud* to be a cartoonist.' You are not producing doodles just to amuse kids (well, you may be, but that's not all you do). Being a cartoonist is *not* kids' stuff. Cartoonists have brought down governments, undermined politicians, attacked dictators, annoyed major world religions, taunted tyrants and taken men to the moon. (I may have got carried away with the last one.) The point is, it is a valid art form with a strong tradition. If you don't believe me, visit The Cartoon Museum in London. Cartoonists, children's illustrators and comic book artists are, in my opinion, hugely undervalued in this country. Some produce work of far greater artistry than any of the contemporary Brit Art clowns.

Cartooning is a brilliant way to earn a living. You get paid to make people laugh, you're legitimately allowed to spend all day playing with ideas and you can use it to annoy politicians. What could be finer? I wouldn't swap jobs for the world. It has brought me untold wealth, fast cars, glamorous women and a jet-setting lifestyle*. (* Some or all of the last sentence may be untrue.) Laughing keeps you healthy and helps you live longer; there are a lot of seventy- and eighty-year-old cartoonists out there, still working away, having a good time.

Go out there, do your best work, draw what makes you laugh and hope it will also amuse your clients. With luck, you'll never have to return to the day job. Send me a postcard to let me know how you're getting on. In the meantime, here's to success and your very good 'elf.

INTERVIEWS

During the course of writing this book, I was lucky enough to speak to a number of cartoonists whose work I admire. The interviews which follow are in the cartoonists' own words. The introductory comments are my own.

Pugh – *The Times/Daily Mail*

Jonathan Pugh produced the pocket cartoon for *The Times* newspaper from 1996 to 2009. In 2010 he moved to *The Daily Mail*. He is a self-taught cartoonist and his work has appeared in *Punch*, *Private Eye* and *The Spectator*. His spare, elegant style is ideal for newspaper work. Pugh's 'Everyman' viewpoint and superb jokes give his work great appeal. He's one of my favourite cartoonists working today.

For nine years I worked in The Times *editorial office. Then I moved out of London and now work from home in Salisbury. With all the technology available now it's very easy to do that.*

I start the cartoon early afternoon, usually with a one- or two-minute briefing over the phone. I have all the online news in front of me but they let me know if there's any breaking stories I'm not aware of. I usually send them eight ideas, maybe more on some days. This is usually by about 6.00 p.m. I can never tell when I'm going to finish. My deadline is eight o'clock but sometimes it takes until 7.30 for them to get back to me. If stories are changing, I may not finish until 8.30.

The cartoon sketches are faxed to The Times, *which they like because they can pass them round the office and look at them. And using a fax machine dictates the paper I use. It's no use drawing on thick cartridge because it won't go through the fax machine. Just lately I have started sending the final artwork via email. This means I can do a little fine-tuning on the computer. I use an old eMac, which is not grand at all, together with a Canon scanner. I keep meaning to update, but there's the problem of intro-*

ducing a new machine into the workflow, which can always cause stress.

I draw on 100 gsm paper, which is thin enough for me to see my template underneath. I draw directly in ink; I don't use pencil. I find that if I use pencil and then draw in ink, it slows me down and the drawing looks stiffer. If I make a small mistake, I use Tippex. If I make a large mistake, I simply redraw it. The drawing itself can take between ten and thirty-five minutes. I like to draw quickly. The drawings are done 8 cm x 6 cm.

" SOMEHOW WE'VE GOT TO PERSUADE THEM TO ONLY EAT LOCAL PRODUCE "

Cartoon by Pugh © *The Times*.

It took me a long time to work out which pen I wanted to use. I was never comfortable with nibs. There is nothing wrong with them but they never felt quite right for me. Five or six years ago I discovered the Mitsubishi Uni Pin Fineline pens. The ink doesn't fade, the pen moves quickly over the paper and it feels good to use. I used to worry that I wasn't using the right pen but I think you have to find the one that you feel comfortable with.

If I'm working on the Saturday Times cartoon, I use a grey wash but I don't use it on the pocket cartoon. I like the crispness and immediacy of black and white. It occasionally makes it harder to portray depth but I quite like the challenge.

It's nice to be surrounded by all the paraphernalia of being a cartoonist. People imagine I work among lots of pens and inks but actually there's just my pen, a bottle of Tippex and my template. It looks like an accountant's desk, really. But you get used to working in a corner when you work in a newspaper office.

I'm not art school trained. I did try for art school but didn't get in, so I studied law and history of art instead. Looking back on it, if I'd got into art school I doubt I would be a cartoonist now. When I started sending stuff to Punch, the cartoon editor, Steve Way, would come back with pages of comments. He could be quite critical but with the very best intentions. He didn't shy away from being frank. When you're starting out it's very important to have someone out there showing enthusiasm and a willingness to provide feedback. It was an immeasurable benefit. I think the odds against making a living as a cartoonist are very high. But I've done that and proved a lot of family wrong. So that's good.

Am I proud of being a cartoonist? Definitely. It's something I always wanted to do. If it hadn't taken off professionally I would still be doing it. I just feel very happy when I'm doing drawing cartoons. I'm trying to raise a smile or a laugh in what can sometimes be a very serious world. I love it.

Mac – the *Daily Mail*

Stan McMurtry trained at Birmingham College of Art and became a freelance cartoonist in 1965. He began working for the *Daily Sketch* in 1969 and when it was absorbed by the *Daily Mail* continued as one of their regular political cartoonists, alternating with Emmwood. From 1975 he has produced four cartoons a week for the paper and regularly wins awards for his work.

His large, expansive cartoons display a wealth of semi-realistic detail and, like the great Carl Giles, the joy of his drawing is often found in examining the scene unfolding in the background.

My routine is to come in at about 10.30 in the morning and leaf through as many papers as I can, scanning the news for a subject to draw on. There's no point getting in terribly early because very often the news will change while I'm sitting here.

'Oh no! I don't think they're here to rescue us. They're here to join us!'

Cartoon by Pugh © *The Times*.

Cartoon by Mac © *The Daily Mail*.

Cartoon by Mac © *The Daily Mail.*

I make a list of little headings and then I think of a couple of ideas on each of them. I usually draw up four or five ideas each day. I rough them onto A2 layout paper, shuffle down to see the editor around midday and hope that he likes one. Usually he does. Then I draw the artwork in the afternoon. And that seems to take all day.

My deadline is around 6.30 or 7.00 at night. But I have been later than that, especially on Budget Day when you don't know what the story is until the Chancellor sits down at 4.00pm.

My drawings are rather large and I put a lot of background in them, so I can't just draw one figure talking. Well, I have done once or twice. But I always put my wife in the background and if I've only one figure in the drawing, it's very difficult to hide her anywhere. The readers always write in if I miss her out.

Very, very occasionally ideas are rejected if I've crossed the legal line and the editor will send me off to see the legal beagle. Occasionally I've done something which amused me, but doesn't amuse the editor.

I wouldn't dream of taking in anything to the editor that I wouldn't want to see in the paper the next day. Some days it's a bit of a squeeze. You think to yourself – I haven't got it today, I haven't quite hit the idea I'd really like to come up with. And then the editor says he loves one of them, which comes as a bit of a surprise. Sometimes I think of an idea and chuckle to myself as I draw it and it's always better when he picks one of those. If I have to explain an idea, it is the kiss of death.

Occasionally I like to put in a cartoon which I know will make the editor's hair stand on end, one which would be impossible to put in the paper. I just pop it in amongst the roughs. It keeps them on their toes.

The drawing itself is done in 4B pencil first and then I

go over it in brush and ink. The tone is painted in black on an overlay, to show the printers where to put the grey. I think I must be the only cartoonist doing that sort of overlay these days.

A lot of cartoonists have moved to colour but I've always resisted it. I can do colour, but I just have this Luddite feeling that cartoons should always be in black and white.

The lines are all brush work. I used to always draw in pen using a very flexible nib. It gave me a lovely, variable, loose line. But now I find that a brush gives you an even looser line. It is certainly quicker and I've got into the way of doing it now. Jak (on the Evening Standard) always drew with a brush and I could never understand it, being a pen and ink man. Then I started trying it and found I liked it, it gives a nice feel. My favourite brush is a Winsor & Newton 00. I've got the big, thick brush for putting the wodges of black in and it's all drawn on hard board. The cartoons are printed around a quarter size and the originals are about 33cm high by 50cm wide.

I'm not tempted to go the computer route. You don't have an original. I have thirty years' work piled up here in the studio, going back to 1970. If I hadn't sold a lot and had exhibitions, there would be twice as many. The Admiral Codrington, in Fulham [Chelsea] has a lot of my originals in an upstairs room. In fact, they call it the Mac Room.

As regards other cartoonists – I'm very fond of Matt. I think he's very clever, he does some very funny drawings. We sit next to each other at award ceremonies so we can throw buns at each other if the other wins. I'm quite fond of Steve Bell's stuff and Peter Brookes' work. I like people like Eddie McLachlan, Gary Larson of The Far Side. They're the people who make me laugh a lot.

Gerald Scarfe

For the past four decades, Gerald Scarfe has been the scourge of politicians and the establishment. He began working for *Private Eye* and his bold, acerbic style captured the mood of the 60s and 70s. His approach hasn't mellowed one jot and he continues to attack humbug, pomposity and stupidity in the pages of *The Sunday Times*. Whenever you look at his work – particularly if you are fortunate enough to see an original – it is impossible not to get swept up by the energy and passion in the drawing, the sheer life and exuberance of it.

I work at home, in a studio at the top of the house. I need room to work. I stand at my desk and work from the shoulder, unlike a lot of cartoonists who sit at their desks and work from the wrist or the elbow.

I do a very quick sketch sometimes, if I'm not at the drawing board. Nothing elaborate, just the main bones of the idea. Surprisingly enough I find those quick sketches have a lot of action and immediacy. It carries the spirit of it though it doesn't carry a lot of anatomical drawing.

That's the only kind of preliminary sketching I do. I don't sketch anything out in pencil because I feel that it dissipates the energy of the drawing. If I have to ink in over a sketch that I've done earlier then (a) I'd be bored and (b) I would want to depart from the drawing underneath. It is a bit hit-and-miss but I go straight into it, bash it down onto the paper, try and get the bare bones of the idea down, the main movement of the thing. These cartoon characters are like a little actor on the paper, trying to convey a movement or sentiment – you have to think of the simplest way to do it. It is the immediacy that counts, particularly in a newspaper where you have to get the message across as quickly as you can.

I correct mistakes as I go. First of all I'll put the whole thing down in basic form and then if any of the lines overlap or have gone too far, then I'll white those out. Possibly at the same stage I might colour it in first. I put down the main structure of the drawing and often at that point I can tell it's going in the wrong direction and I'll abandon it and start again.

Once I've got something I'm fairly happy with, I'll go in and add the details. When all that ink is dry I then watercolour the colour into it, painting on top of it. I try not to colour in areas, I try to give the face some shape within the line drawing, adding shadows and extra details with the watercolour.

To get the cartoon to The Times, the artwork is scanned on a very big scanner. The artwork is 76 cm high and 50 cm wide. The scanner will take them and then I'll send them in electronically. I used to take them in personally but this cuts down on those awful confrontations with an editor who doesn't know what you are presenting them with. Editors are not necessarily very visual. They live in a literal world.

I'm lucky in that I don't have to discuss the ideas with

Cartoon © Gerald Scarfe

Cartoon © Gerald Scarfe

them before I send them in. Occassionally there might be some alteration if the editor thinks it's too extreme or there's too much blood. There's no political tampering. If I drew anything too sexually overt it wouldn't get in The Sunday Times, but I have my own parameters and don't waste my time doing something unacceptable.

I take five or six newspapers on the run up to The Sunday Times. I'm aware of the news all through the week, so I've always got a vague idea of the political background. I'm not in any way a political creature. I'm not that interested in politics, only in the broadest sense. I've pushed myself into other areas to broaden my field – stage, books and sculpture. I think I would go crazy if I just did political stuff. I don't even like politicians, as must be patently obvious.

I start thinking of ideas on Friday or Saturday morning. It has to be delivered by midday on Saturday. If there's a real drama you could alter it up to 4.00 or 6.00 p.m.

Just recently, I've started using the computer more to correct drawings. I am not computer literate but I have a wife who is brilliantly computer literate. Once I've done the drawing, we scan it and then I might add sky or a figure in the background. Which means my originals now may not be true originals any more. It makes it a lot easier. In the old days I would do four figures and I might get one wrong. I would have to cut one out, paste another in or start again. Now, of course, I could do four completely separate figures and scan them in. I don't tend to do that because I think when you're working on a drawing, it should come together as an entity. Doing them separately wouldn't come together in the same way.

I never draw directly onto the computer. When I was a production designer on Disney's Hercules, the Hydra was perfect for computerization. All I had to do was make the model for the Hydra. They then took that into the computer to work on. When they finished it – and it took ten to twelve weeks – it just looked computerised, like a computer game. So I have a prejudice that the artist touching the paper is the magic bit. The computer work becomes another entity entirely. It's not something that I've ever employed. I feel you can't beat the old business of the artist touching the paper or canvas.

I use hard steel nibs in ordinary holders. I get through a lot of them, standing as I do at my desk and putting a lot of pressure on the paper. I used to use Mitchell nibs. I work on 200 gsm cartridge paper, as white as possible. The difficulty is that some papers will take pen but it won't take watercolour very well. And if I work on watercolour paper it is difficult to get a crisp pen line. In my work I'm known for a hard, caustic approach and the hard line is important.

I used to keep a sketchbook but these days I don't. I would encourage anyone to do it. Those briefest of notes can summon up what you saw much better than your memory, even if it is just three or four lines.

When I was growing up, Walt Disney was a huge influence, though it may not be apparent. Whenever a new Disney film came out, as a child I would wait for it with bated breath. Pinocchio was a big influence on me – I drew all the characters. I can see within my work a slight Disney approach. So it's ironic that when I went to Disney I was trying to make them draw unlike Disney.

And then after that, influences included Ronald Searle and André François – he did quite a lot of work for Punch. I admired François because he seemed to be a complete anarchic; he didn't follow any of the cartoonists who were around at the time – the Thelwells, the Illingworths and the Cummings. He just drew in a way that almost looked like bad drawing but it wasn't, it was original, unique, it was his style. He broke the boundaries of what was accepted. Cartooning can be a very tightly bound thing. Partly because it has to appear in publication where it has to be got quickly, you can't do concept cartooning.

There is a sort of stigma attached to the word 'cartoonist' as opposed to a fine artist. I am self-taught though I did, finally, later in life go to the Royal Collage of Art. I stayed about two weeks – I just wanted to know that I was good enough to be accepted. And as soon as they accepted me, I lost interest. I thought it was too hard going back to school. I think there was some teacher or professor there who got me to carry his books. I thought, 'Bloody hell, I'm not going for this sort of thing', so partly because of him – and also I was already making quite a good living at the time – I left.

I am proud of being a cartoonist but I always wonder what would have happened if I had continued at the Royal College of Art and taken up painting, as I always intended to do. The fact that I work so very large and in a flamboyant way leads me to think that with a flick of fate I would have stayed on at the Royal College and turned out very different.

Being labelled a cartoonist doesn't worry me as such but I am sad that, for some people, it means an inferior art form. It doesn't have to be. If anything I try to raise the level of it and raise the commercial aspects of it, as well. I do sell my drawings for quite a lot of money. I don't see why Hockney or Tracy Emin can get £30,000 for a quick sketch and a cartoonist's work should sell for £300.

Matt – *The Daily Telegraph*

Matt Pritchett has been drawing a pocket cartoon for *The Daily Telegraph* for over twenty years. His spindly little characters, with their exquisitely drawn expressions, capture the attitude of a bewildered public faced with political events of the day. He is probably the most popular newspaper cartoonist working in Britain today, his audience having taken him to their hearts in the same way they did Giles, a generation earlier. His cartoons are always on the nail, never cruel and quite often, simply brilliant.

Most of my day is spent thinking of ideas. I get in at about 9.00am, read the papers, see what's on the internet, see what the other cartoonists have done. The editorial conference happens at 10.00 and I get the list of what the news editor wants to discuss in morning conference. These are the things he thinks are going to be the big stories for tomorrow. It gives me a very good idea of what's going to be in the paper. But you can't categorically say what's going to be on the front page, and a lot of the stories which look great at 10.00 have collapsed by lunchtime.

I write down different subjects for cartoons and then try and think of as many ideas on each subject as I can. I am working to have six presentable ideas by 3.00 or 4.00pm. I use an A4 piece of paper and sketch out – very roughly – six drawings with the captions written in pen underneath. I take those to the night editor, who is in charge of the front page, and he narrows it down to two or three. And then I go and see the editor with these. He picks his favourite, which always based on which he finds funny.

People think, being on a right wing paper, the editor is going to choose the most right wing, the one which attacks Labour. That's never been my experience. They're happy with the leader writers to do all the political stuff.

And then I draw the cartoon. I was talking to Charles Peattie recently and he said the drawing goes right either the very first time or the fiftieth time. You have days when it's the simple ones which go wrong – two people walking along don't look like they're on the ground, for example. So I always start with the faces. Quite often there will be a page with two or three floating heads talking. If they're not right, I abandon it straight away. I can have pages and pages of these floating heads and if I show them to someone they can't see anything wrong with them. But the heads – although I'm not a caricaturist – have to convey the right atmosphere of pathos or anger or delight. Quite often I think, that person doesn't look sufficiently miserable.

When I have my two faces, which I draw immediately in ink straight away, then I sketch the rest of the scene in pencil. I've found with faces you can't trace them, you can't draw in pencil and then ink them in, it seems to kill the expression. I feel faces and the movement have to be just right. Someone coming to the paper doesn't know what the cartoon is going to be about, so from a standing start you have to say this is inside, these people are talking about their pensions – you have such a lot to convey instantly.

One advantage of being in an office is I spend a lot of time walking round asking ludicrous questions like, do these people look like they're in a restaurant, or does this person look like he's fallen off his chair? Although I know what I'm trying to draw, someone else may not see it. It's extraordinary how many clues you have to give in a

'I know you're excited, but the sooner you go to sleep, the sooner it will be bin day'

Matt cartoons © *The Daily Telegraph.*

drawing. I have had the experience of doing a drawing that I thought was perfectly obvious but wasn't to anyone else.

Most days, the cartoon goes to bed between 6.00 and 7.00. I have until then from 4.00 to do the final artwork. 9.00pm is the latest I've done one. It's always when some major sporting tournament is going on; I've held on to see what the result is in case I can do a joke on it. Even if you do a joke for each way a match will go, something unexpected happens, there's an earthquake at Wimbledon or something like that.

I'm quite often half a day or a day behind breaking news. Being on the front, people often say they look at my cartoon first. So I can't do a joke where they have to read the story. I can't put, 'Read page 4 before looking at this joke.' I need a subject that is around, that people are talking about. So in a way I'm not terribly interested in breaking news, unless the headline is going to set up the joke for me.

Occasionally a rough gets picked which is my least favourite. If my editor picks one I hate, I would say, 'I really don't want to do that one.' I do feel that I'm drawing the damn thing so I draw what I want to draw. More often there are two that are picked, one I really like and one everyone else likes. Then I just accept it. Sometimes the one I like is the one I think is clever, but it's the other one that gets the big laugh. The simpler joke gets appreciated. I'm grateful to have people around to tell me that.

The ideas that don't get in go straight in the bin. There's usually one or two where I think the subject or the joke could last, and I never remember the joke, so I put those in a drawer. The slight problem I have, some days you think of two or three things that you think could go in again. But people get scathing and say they saw it yesterday. Some of my best jokes have had two or three goes at getting in. It just happened that on the days I first thought of them, there was a lot going on and much bigger stories may have knocked the joke off.

My most valuable piece of technical equipment is the cardboard frame that gives me the proportions of my cartoon. My drawings are reduced to about seventy per cent of their original size. If you reduce much more than that, the lines disappear and they look too tight. Rather strangely my drawings work very well when they're blown up bigger.

I always draw with Edding Profipens, which I adore. I get through a huge amount of them. And I add the grey wash with watercolour paints. I do the wash and scan it as a greyscale. I like the way it looks. Newsprint is such bad paper that the drawings do suffer a bit. I am resisting doing them in colour. I think in black and white they look more newsy and direct, somehow. I use a Letraset smooth cartridge paper, quite thick, about 270 gram. I like the fibre tip lines on very smooth paper. I never use such a lot of wash that I have a problem with the paper buckling. I'm not using it over that big an area. The smooth paper can take the amount of wash I use very easily.

I scan the cartoon on the Apple Mac, use the tools in Photoshop and save it as a TIFF file. Then I go into Illustrator (I have no idea why I do it in Illustrator, I've just been told to do it this way) and open yesterday's cartoon as a template and save it as today's. Then I replace the drawing and change the caption. I print out four hard copies. I give one to the night editor to remind him what I've done. Just in case something disastrous happens

Matt cartoons © *The Daily Telegraph.*

overnight which could make my joke terribly inappropriate. One goes to the designer – if you're looking for my cartoon, this is what it should look like. One is filed for my own records. And then I take one home with me so that in the middle of the night I can leap up and say, 'My God, you don't spell that word like that!' I need to have a copy by my bed for midnight panics.

Out of the office, I completely switch off. I don't even keep a sketchbook. If I see news, I don't even think of ideas. I've found that the way to have ideas is to sit here, at this desk. If I think I've had a brilliant idea somewhere else, especially late in the evening, it's always absolute rubbish.

Moments of inspiration are to be avoided at all costs. I once dreamt a cartoon, woke up and drew it. I looked at it in the morning and it was the worst idea I'd ever had. It's not divine inspiration, it's just the product of a deranged mind.

'Knife' (Duncan McCoshan)

Duncan McCoshan has been cartooning since the early 1990s under the pseudonym Knife. He is best known today for working in collaboration with Jem Packer on the *Private Eye* strip 'It's Grim Up North London'. They are also working on a range of children's books, all of which have the same quirky style as the *Eye* strip. Knife's work is instantly recognizable; a fine line, slightly gauche figures and a cheerful disregard for the rules of composition and perspective. As he says himself, his style has limitations. Knife's skill is working within those limits to give his cartoons a distinctive and appealing look.

I work in my small, one-room studio near home. I do work from home as well, occasionally in the evenings, on the kitchen table – needs must – but I'm mainly studio-based with a lovely view of a block of flats in Hackney. But I've got all the coffee shops nearby.

The schedule for 'Grim Up North London' is – we submit typescripts of ideas to Ian Hislop (Private Eye's editor), twelve at a time. He selects from that, so we know some months ahead what we're going to be doing. Normally we split the writing. Jem does a lot of it, but it depends what else we've got on. He'll fiddle with my ideas and vice versa. I do all the drawing but Jem has a very good eye and always has ideas on the drawings, so I find that helps a lot. We don't send in roughs, we submit the final artwork on the Thursday evening or Friday of an 'on' week. We used to take it in on disk but now it gets emailed in.

The artwork is drawn 27 x 12 cm. I think half size up. When we did the first one it was almost an arbitrary size and we've stuck to that ever since. I use Faber Castell Pitt Artist pens and Daler/Rowney 130gsm cartridge paper. The colouring is done on computer. We use a standard Dell printer/scanner and use Photoshop for colour. The roughs are done in Staedtler HB. I don't use a blue pencil at all. If modifying I'll just Tippex out. I'll usually send a rough to Jem and if he's got any thoughts on it we'll make the changes at pencil stage. Then I'll ink it and either myself or Jem will colour it.

Regarding style, I play to my strengths and try to know my limitations. That's how the style has come about. I've just learnt on the hoof, really. I admire cartoonists like Ed McLachlan who seem to be able to draw anything from a single person to a whale sitting at a banquet.

I keep a sketchbook and I'm always jotting stuff down. A lot of our energy is going into kids' books at the moment, so there's a lot of sketchbook stuff for that, character development and so on. I like sitting at coffee shop windows trying to justify that it's work.

I've been cartooning full-time since 2000. I was submitting stuff to The Spectator in the early 1990s and for a while I ran a magazine, The Journal of Silly, with fellow cartoonist Ham Khan. Then he moved to Argentina and for logistical reasons it just became impossible to continue. It had a good subscriber base, though.

'It's Grim Up North London' - © Knife & Packer, first appeared in *Private Eye* 2009.

We sell originals of the strips and we're continually getting enquiries via the Eye. *As for other cartoonists – there's a new guy in the* Eye *called Wilbur, I like his style. I like the* New Yorker *people. When I was growing up I admired all the usual stuff – Asterix, Tintin, Thelwell, Peanuts.*

And yes, I do like being a cartoonist. I know what you mean when you ask that question. It's not one of those furtive things you're afraid to bring up at parties. It's something to be proud of.

Charles Peattie – 'Alex' Strip (*The Daily Telegraph*)

Peattie's fine, distinctive style has graced a number of strips over the years – 'Dick' in *Melody Maker* and 'Celeb' in *Private Eye*. But he is best known for 'Alex', the 1980s yuppie banker which started life in *The Independent* and then moved to *The Daily Telegraph*. He works on the strip with writer Russell Taylor. Peattie has a traditional pen and ink style, with large amounts of cross-hatching and shading. Background details are very detailed and yet the overall appearance doesn't get bogged down by realism – a very clever balancing act. His figure drawings are superb and I can spend ages staring in admiration at his deft characterizations.

Russell and I work closely together and the schedule has changed over the years. In the old days we used to sit and write together, usually working on the next day's strip. Now he does most of the writing and we have a week's worth of jokes planned by the beginning of the week. I draw them up from Monday onwards. The actual strip takes the first three days or so, leaving me free to work on other projects. If something crops up in the news or we're overtaken by events, I may have to draw another strip. But we try and be safe by keeping a couple of days ahead of publication, in theory.

When we started, Russell hadn't really done cartoons before, whereas I had. So basically we drew out our ideas in the form of little strips, with little sketchy drawings of the characters, and passed them to each other. Our method today is still quite like that. He still sends me strips. Russell is very brainy and sometimes I don't understand them at all, so I'll suggest a rewrite. Or I send him an idea

'Alex' cartoon strip, © Peattie & Taylor, courtesy of *The Daily Telegraph*.

of my own in the form of a strip. We don't submit roughs to The Telegraph. I don't know if they would like that or not – it's a subject I prefer not to raise. Basically I think they trust us, so they don't want the extra work.

The artwork for 'Alex' is 36cm x 10cm and drawn on marker pad. I really like working on board but it's expensive and I use a light box. The strip tends to be four frames. If the images are alike I will draw my basic arrangement on one bit of paper and then I'll trace it through into the four separate frames but vary the character position. I draw the actual frames afresh for each strip – no template, just a ruler and measure it out each time. I use a plain dip pen and Rotring ink. I always pencil them in first. I probably should use blue pencil – I always use one for animation – but I just use a normal pencil. I work mostly from home. I have an office in town which I share, but cartoonists can work mostly anywhere. I often work standing at my drawing board, just so I don't get cramp.

I tend not to think of myself as having a distinctive style. I think of it as a basic, 'how to draw cartoons' sort of style. I started drawing cartoons when I was really young, so I think of it as continually evolving. It evolves partly as a result of what I have to draw. The jokes are often about something small – a car key ring or something – and I have to be able to draw cartoon people and something really small on a table, such as a memory stick. The readers have to recognize it. So the style has evolved to fit the level of realism and the type of content in the strip. But I'm always looking at other cartoonists. If I like something I see, I tend to steal it!

I keep sketchbooks in the form of index cards which I carry around all the time. So if I see someone sitting in a particular position and I think, 'I wouldn't have thought of drawing that', I make a note of it and I'll use it sooner or later. I file them all away in boxes in sections – people, clothes, pubs, offices, hospitals – that kind of thing. Twenty-five years in and I've had to become like that. I think of the strip as a bit like acting – the script comes in and I have to give it my best shot, give my characters the best chance of delivering the lines.

If there's an action at the end of the strip, I'll often rough that first and work back. At an early stage I work out how the background works, where the location is. Usually there are at least two people in the strip, so I have to figure out body spaces and body language. If it's two people standing at a bar they've got to look how two people at a bar would look like.

I use the computer to scan and clean up the artwork. With my animation, I draw directly on screen with a tablet and stylus – using a Wacom Cintiq – which is a nice way to work. But I always start with a key drawing done in pen and ink. I scan at high resolution and then send them to Russell, as a final check, in case I've made a mistake. He usually puts the 'Alex' flash on, then sends the file to The Telegraph and archives it.

Am I proud to be a cartoonist? I wouldn't say I suffer indecently from the sin of pride but I'm quite happy with the label. The thing that's nice about being a cartoonist is that it's a job which people are quite pleased to hear about. Nobody ever thinks you're a bastard. I like that!

I really like cartoons. I feel that the way one can draw cartoons nowadays is one of the hidden evolutionary things that's happening in the arts in the twenty-first century. I used to be a fine artist – I started as a portrait painter – but I find drawing cartoons is much more interesting and more satisfying. It is a different way of looking at the world.

Arnold Roth

Arnold Roth is one of the great cartoonists of our time. Based in New York, his work has appeared in *Playboy*, *Punch* and virtually every major US magazine published in the last fifty years. Now in his eighties, he continues to live and work in New York. Along with Ronald Searle, I've always loved Roth's work for the playful, free-flowing penmanship, the superb quality of line and the instantly-recognizable interpretation of the human form.

I have a studio in the apartment which I have used the last four years. It took away our guest room which is a double blessing; I save a whole lot of rent and we're no longer running a hotel. I have my drawing board and, as this is my fifty-eighth year of freelance, I have a lot of junk accumulated. I work in a room that's about 12 feet by 17 and I like it. I have north light. I don't know why I've always made a big thing about getting a north light window; most of my work is done late night on deadlines by electric light.

I think the most important material we work with is the paper, so I try to use very good paper and I always have. I work on 140 pound hot press paper – Darsh and Fabriano. The ideal paper was the old Wattman but they stopped making it.

I block in my drawings in pencil, especially if it's got to fit in a particular space. I don't really draw, I just delineate where I want things to fall and then draw in pen and ink. I use all sorts of holders, using a dip pen. I use a lot of Gillots, some of which I buy via the Internet from London. I use flexible points, generally, but I use quite a variety of

points. It all depends on the feeling that day.

I have thousands of nibs, many of which I bought years ago at His Nibbs, which used to be in Drury Lane, about twenty or thirty years ago. In those days a nib was a penny. So you bought a box of a gross. Anytime I saw an art store selling up its stock, as everyone stopped using nibs and holders, I would rush in and buy any nibs that they had. So I have quite a back stock. But when I buy new ones I buy a lot of the Gillott Crow Quills, Mitchell manufactured points. I also have a lot of American points which are very serviceable.

For a rough, I scribble in margins and think of what I want to do before I start. The real art of the artwork comes when you give it the deepest concentration. So I'll block in a figure. But avoiding awkwardness is very important to make a good and attractive drawing, one that is expressive of the idea and the joke. That's what I shoot for; legibility and clarity.

I rarely have mistakes. I may get occasionally a smear of ink, especially late in the evening. And then I'll use acrylic white ink for black and white, but if it's something I've painted over, I'll make up a matching colour with watercolour. Depending on the size of the publication, with my ageing eyes, I usually work about one and half times up if that's a decent size. If not, I'll go twice up.

The bulk of my work is for magazines. I operate as an illustrator but I have never truly illustrated anything in the story. I usually do an expressionistic, self-contained drawing, trying to express a humorous idea about that subject in general. When I give talks, I always give an impression of how editors think people read magazines: I open a magazine and put my hand over the illustration and say, 'Hey, this is a pretty good story, I think I'll look at the picture.' And as we know, it works completely the opposite.

I've never been conscious of developing a style. I knew people in art school who were working on their style and I used to say, 'You mean, you want to know exactly how you're going to draw something for the rest of your life?' I always thought of it as hand-writing and did it the best I could at the time and in a manner that I enjoyed and conveyed the idea best. I figure it's like nature, that part

© Arnold Roth.

PERFECT SUMMER

SUMMER KITCHEN

ROCK'N'ROLL-WILL-NEVER-DIE SUMMER

© Arnold Roth.

146

will take care of itself. I think of myself as a cartooning expressionist. In jazz terms, that's the bag I would fall into.

In the early days, I admired and was influenced by practically everybody but for different things. Saul Steinberg, in the 1940s, was like a lightning bolt out of the blue. And just before I started freelancing in 1951, Ronald Searle came along and he influenced everyone. There was no avoiding him and he's great, so that's understandable. But the other influences were all the other cartoonists I grow up with as a kid. The fact that they're getting paid to do it is inspirational in itself.

I sell some originals. In the past I used to trade them but I never kept track of them. So I sent them out to Ohio State University Cartoon Research Library. But I still have some here and there around the studio. The worst thing I have to do is select artwork to go to a show, and I get asked all the time for that. Fortunately I have a bright, hard-working wife and she handles most of that. Cartoonists must have a wonderful wife so that they can concentrate on being cartoonists. Someone to handle real life.

Am I proud to be a cartoonist? Oh absolutely. It was my life's desire, since I was a little kid. I knew I'd never be a major league baseball player. But cartooning was never a second choice. I always liked to do it, I liked what I saw when other people did it, and still do, to a great extent. That was my aspiration. I guess I'm living proof that if you set your sights low enough you can have a wonderful life.

I also received a great honour about a month ago, I was voted into the Society of Illustrators Hall of Fame. I'm already in the Cartoonists' Hall of Fame, so the only thing I can shoot for now is the Baseball Hall of Fame. I guess what happens if you stay in this business and live long enough you automatically become a venerable. It's more a reward for prevailing than anything else, but it's an acknowledgement so it's very nice that they do it. Retire? Oh never. I figure nature will retire me.

Grizelda

In cartooning, as in stand-up comedy, the number of male practitioners far outnumbers the female. Most of us would be hard put to name more than half a dozen or so. Grizelda is one of the best. Primarily a gag cartoonist, her work appears regularly in *Private Eye*, *The Spectator* and *The Sunday Times*, as well as in books and postcards. She has a distinctive, relaxed style of drawing, which is engaging, fun

and deceptively naive-looking. When I spoke to her, she declined to give me her full name, preferring to remain a woman of mystery behind the pseudonym.

I'm not art school trained. I've been drawing since I was a kid and just carried on drawing, like a lot of cartoonists. I've been a full-time professional cartoonist for about ten years. For about ten years prior to that, I had a part-time job, supplementing my income whilst I drew. My very first cartoons appeared in News Shopper *in Bromley. I've still got them. They're funny in that they are so unfunny. My first national cartoon was in* Private Eye *in the mid-80s. My sister's boyfriend told me a joke and told me to draw it up, so I did and it got in. But that stood alone in that decade. Then I started selling to them in the 90s.*

I rent work space in a studio, where I've got a table and an A2 table-top drawing board. It can get quite noisy in the studio so I retreat to home if I need to think up jokes. I work in the dining room, which is kind of seen as my room. There's just a laptop in there. Well, apart from the table and chairs.

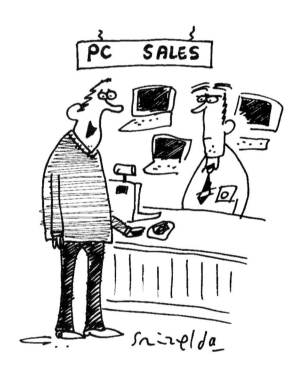

"I'm looking for something to help me waste time more efficiently."

Reproduced by kind permission of *Private Eye* magazine/Grizelda.

I never do roughs. I send off the final drawings. They're quite small. There's no point drawing really big, because that's more work. The originals are about 10cm by 7.5cm. It's quicker to draw that size. Plus if it's too big it won't reproduce very well. I do sometimes sell originals but you certainly wouldn't make a living from it.

As far as paper goes, I don't use anything very exciting. It's high quality photocopy paper. It's a fairly nice surface to work on because you need to be able to ink on it and colour without blotting. I draw with pencil and then ink it in with a Rotring Isograph – those wonderful things that keep clogging up. Sometimes I use a little black pen with a smaller nib for a bit of shading and stuff. Corrections are usually done on the computer. You can't really draw over Tippex, particularly with a Rotring.

I scan into the computer and colour on there. Sometimes I tidy the drawings up. Actually most of it is removing all the blobs from the scanner. I'm on a Mac, of course, and work in Photoshop. The artwork mostly goes out by email. Sometimes people want things posted or faxed. Private Eye print off everything they receive so I send them Word pages with the cartoons imbedded in the page. I worked there for a while and their paper usage is appalling!

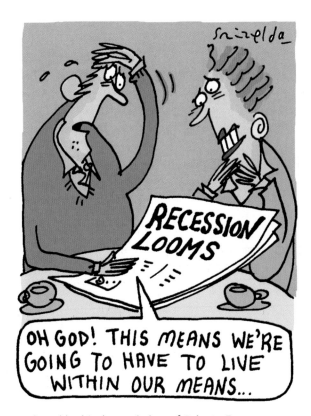

Reproduced by kind permission of *Private Eye* magazine/Grizelda.

I have consciously worked on bits and pieces to develop my style. I used to do knobbly knees and elbows but now I do bendy arms and legs. Years ago people couldn't tell my females from the males. So now all the females have loopy breasts and all the men have stubble to distinguish them and place them firmly in their gender roles.

I keep a sketchbook. When I think about jokes I tend to draw the ideas rather than write them down. I did have sketchbooks going back to the 80s, then about five years ago I chucked them all out – well, recycled them. I had a whole cupboard full. I was told it was a terrible thing to do but I thought, no one is ever going to look at them, so it's much better that they get turned into recycled toilet paper. You can't carry all this stuff around with you for ever, can you? And anyway you look back at that stuff and it's just embarrassing.

One of my early cartoon influences was Pete Maddocks. I got one of his how-to-do cartoon books in the mid-80s and went painstakingly through it. Style-wise, I love Robert Thompson's composition and Nick Newman is brilliant, his ideas and the simplicity of them. I think Kathryn Lamb is very under-appreciated. And Ken Pyne is a living genius. I could go on....

Am I proud of being a cartoonist? That's a nice question. Yeah, I always dreamed of making a living from it and it's come true. But I also imagined it would mean being really, really rich and having a huge house and lying in bathtubs most of the day and not really doing any work. That's how I imagined it would be like. Mind you, I did have a swim today but that was in a municipal bath.

By the way, I hope I won't regret this when some whipper-snapper cartoonist reads your book and comes along and does me out of a job. Make it sound as difficult as possible.

Anita O'Brien – Curator, the British Cartoon Museum

The Cartoon Art Trust was formed in 1988 to promote and preserve the best of British cartoon art. Astonishingly, prior to that Britain did not have a cartoon museum, despite practically inventing the form. After a number of years in London's Brunswick Centre, the new British Cartoon Museum opened in Little Russell Street in 2006. It is a fabulous place to see all manner of cartoon originals and has a rolling programme of exhibitions and special events. The museum's curator, Anita O'Brien, is passionate about the work of the museum.

One of our jobs is to help people realize the connections and influences in the work of our cartoonists. For example, Kevin O'Neill is a great admirer of Heath Robinson, but I don't think many readers of 'The Extraordinary League of Gentlemen' would realize that. Similarly, many people who love the Bash Street Kids and Leo Baxendale may not realize how much he was influenced by Giles. When you see the complexity of Leo's sets and backdrops and the amount of detail, it compares to a lot of Giles's work. In fact, there is a letter written by Leo to Giles in the 1970s, offering to write his biography.

The term 'cartoon' is quite vague and means very different things to different people – animation, graphic novels, bande dessinée. Our focus is British, though we do collect influential work from overseas. We have an Asterix, a Thurber, a Dick Tracy by Chester Gould. If I was able to get a Doonesbury strip from Gary Trudeau, I would not say no – Doonesbury has been part of the British scene for a long time and is world famous.

In museum terms, the problem with acquiring a particular cartoon is that it may be wonderful on the day, but will it last? Is it typical of that artist's work? Is it a good example? Could we use it in a range of exhibitions over time? Does it say anything about Britain today? Is it well done and attractive to look at? All of those considerations come into the purchasing decision. You have to look at cartoons as satire, art history and humour. When you're collecting things for the longer term, the difficulty is knowing whether it will say something about Britain in the early 2000s and will people find it funny or interesting or a great drawing. That is the challenge.

At the moment there are about 1,500 pieces in the

collection. The British Cartoon Archive at the University of Kent can take an artist's life's work but we don't have the facility to do that. We would rather have ten or twenty or thirty good examples of that artist's work and show it as often as possible. We are very small and sometimes compare ourselves to a minnow in the shadow of a whale. We're not the British Museum, we're not the V&A. The difference is we will show the work all the time on an on-going basis. The University of Kent has over 100,000 cartoons and we work very closely with them and feel we are complementary. We often borrow work from them and hopefully through us people find out about the archive.

We've done four exhibition catalogues over the last eighteen months. One of the things we do want to do is contribute to the scholarship of the field. Plus it is a permanent record of the exhibition. In the past, for instance, the books of Pont's cartoons never reproduced them very well. We were fortunate in being able to work with original artwork, so we got good quality reproduction.

You can't tell what a piece is like from a printed cartoon. The printed version is the final artefact, in a way, but you never have any idea what the originals are like. You don't know how big they are or see the bits pasted on, things where the cartoonist is trying out colours and spellings in the margins. That's what people find so inspiring.

The thing we can offer people here is some sense of the process. I often ask artists if they keep roughs or do they have sketchbooks – because that's a hugely interesting insight into the direction or the development of an idea. Without that, it's hard to get the idea of drafting and re-drafting, a sense that a cartoon doesn't just come out perfectly formed.

What always gives me pleasure is when we do an exhibition and someone comes along who has never come across the artist. It's that sense of people discovering new things, new artists. I'd like visitors to feel it is a fun place where they'll discover something new or even an artist that's familiar but see them in a new light.

There are things you can only say in a cartoon; you can make people laugh but also make them think. That is the great strength of cartoons. In this place you get the thinking and the enjoyment, the nostalgia and entertainment and the artistic pleasure. We try to take cartoons and comics seriously without being too serious about them. Somehow people think that art can't be funny. People are allowed to laugh and relax in the exhibitions here.

COMPUTER HARDWARE

If you feel your eyes beginning to glaze over, take a pen and liven up the boring bits by doodling cartoons in the margin. I won't be too specific about what to buy because any prices or specifications mentioned here will be the funniest thing in the book within ten minutes of publication.

THE COMPUTER

Very handy, especially for surfing the Internet whilst you're supposed to be working (professionals call this 'seeking inspiration'). If you already have a computer, see what it can do before you feel compelled to buy a new one. If you haven't or you want one specifically for work, you have a choice of Windows, Linux or Mac, desktop or laptop. If you want a Linux machine you already know way more than I can tell you.

I won't go into the Windows vs Mac debate here, except to say … get a Mac. They're friendly, easy to use and don't get in the way of what you want to do (mostly). They have the advantage that the majority of the designers you work with will also be on Macs. In a Windows-dominated world, it's easier for a Mac to translate files to Windows than the other way round.

The choice of desktop or laptop is purely personal – most professional-grade laptops will cope with the kind of graphics software we're likely to use for cartooning. Ergonomically, laptops are not ideal as their screens and keyboards are too restrictive. However, you can add an external monitor and, let's face it, the laptop has the added cool factor of imagining you can work anywhere in the world at a moment's notice (or the garden, if fine). I worked for years with an Apple Powerbook and an external Apple Cinema Display, only changing when I needed something bigger. Working this way has one interesting aspect – you can spread your computer desktop across two screens. So, for example, when working in Photoshop I did all my drawing on the large screen and kept all the palettes and clutter on the laptop screen.

Sales people and magazines gibber on about getting the fastest machine on the planet. Ignore them. Get the next model down and add extra memory and a bigger graphics card so it will cope with your artwork.

The Monitor

Macs have very good monitors (which is why they cost more) whereas PCs are sometimes bundled with any old junk that displays a picture. The monitor is *important*. You are going to be spending all your computing time looking at it. It needs to be sharp, detailed, not fry your eyeballs and be able to display colours accurately. These things do not come cheap. Buy a recognized make and go for size. Never underestimate how much screen real estate you will need.

The days of large cathode ray tubes have long gone and now there are basically three types of liquid crystal display (LCD) screen technology at present. If you want to know which is best, look at www.tftcentral.co.uk. If you want to check which type your monitor has before you buy it, you can look it up on www.flatpanels.dk/panels.php.

Check into a few illustrator forums and see what people are using. There are a few makes which crop up regularly – LaCie, NEC, Eizo, Apple.

The Scanner

For black and white line work you can get away with a modest desktop scanner costing £60 upwards. You don't need a transparency head for doing slides, so that will keep the price down. Canon makes a series of A4 size scanners which connect via USB, don't require their own power supply, are quite portable if you use a laptop for work and produce perfectly good results on black and white and greyscale. Most of the line art in this book was scanned using one.

Scanning colour work is more demanding and requires

something more expensive. The cost is coming down all the time, but don't expect to get anything for producing print-quality scans for less than a few hundred pounds. If you do a lot of work in colour you may also want to consider calibrating everything, from scanner and monitor through to the printer you use, so any work you produce has consistent, matching colours from start to finish.

As usual, check the reviews and use the forums to ask what other illustrators and cartoonists are using. Epson and Canon are both good for our sort of work and have models which range from the astonishingly cheap to the eye-wateringly expensive. An all-in-one machine – which scans, faxes, prints and hoovers the lounge – is too inflexible and the scanner part is usually pretty low spec. As you get into computer art you may find yourself wanting to upgrade your scanner separately from the printer.

Additional Hard Disk

Get one of these and back up your computer onto it every day.

I can't emphasize this strongly enough if you're working professionally. Salutary story: despite having external hard disks, one week I was particularly frantic and made the idiotic error of thinking I was too busy to back up my computer. At the end of the week, the inevitable happened, something went wrong and the hard disk got scrambled. Fortunately, that week's work was for a website and everything had been uploaded to the web, so all I lost were emails and a few scans (I still had the original drawings). I could get all my work back from the Web. Now I back up whenever I'm feeling paranoid, which is usually several times a day. (Macs have a back up utility built in called Time Machine which backs up several times a day. You can even rewind a few hours to a previous version of a single file. Did I mention that you should get a Mac?)

Graphics Tablet

There are two schools of thought on graphics tablets:
- I've never used one.
- I wouldn't be without one.

They are brilliant, an absolute boon to the computer part of your drawing equipment and make you wonder why anyone bothered to invent the mouse.

Basically, a graphics tablet is a rigid plastic pad which plugs into your computer. You draw on the surface with a special,

wireless pen. The marks you make don't appear on the pad, they appear on the computer screen. So far, so mouse-like, but:
- it's like using a pen, so it feels familiar and you work in a familiar way
- the better ones are touch and tilt sensitive, so if you are drawing in something like Photoshop or Painter you can vary the thickness of line
- some pens have an eraser at the end; flip the pen over and you can rub out the marks you've just drawn.
- the buttons on the pen and tablet can be assigned shortcuts, to further speed up the way you work
- you can get different types of pen, some feel more like using an airbrush
- the tablet will have a transparent overlay so you can slip a drawing underneath and trace it.

Every serious computer artist uses a graphics tablet. There are one or two different makes, but for professional use it is only worth buying a Wacom. Wacom has been in the game longer than anyone else and works closely with the art industry. If Wacom tablets seem expensive, compromise by getting a slightly smaller one. I use two – an A6 with a laptop and an A5 at the desk, which works fine with my 24in screen iMac.

Getting used to a Wacom can take a little time. At first it feels unnatural to be drawing on the desk, while seeing the results on your screen. Unplug your computer mouse, tuck it away in a drawer and just use the graphics tablet. By the end of the day, you won't want to go back. The mouse which came with my iMac has never been out of its box.

Wacom also makes wireless tablets, though they don't feel as responsive as the sort with wires (in my opinion).

Cintiq

A Wacom product whose prowess is legendary. It's basically a Wacom tablet with a built-in screen, so you draw directly onto your monitor. This makes it very responsive and it feels much more like real-world drawing. It is fast, flexible and enormous fun. It also takes a few days to get used to and is expensive to buy. If tempted, find somewhere that will allow you serious time playing on one before you buy.

Printer

You'll be using this mostly for proofing, writing letters and (we hope) mailing out invoices. Professionally, most of your

digital artwork will go out via email or on disc. Occasionally, you might want to use one to produce prints or greetings cards, in which case you need a printer that can cope. Most decent inkjet printers can cover all these requirements. The better the printer, the more colour accurate, the greater the range of paper it can use (card and textured art paper), the faster it prints and, in general, the less it costs to run. Sometimes, if you are supplying work on disc, the client will also ask for a print-out in order to match colours. In which case, it is worth buying a good printer and calibrating it to your monitor and scanner.

Software

Photoshop is the industry standard bitmap program and Illustrator the ditto vector. Both cost hundreds of pounds and will do far more than a cartoonist will ever need. There are a number of small art programs around, many of them very good. Arguably, they may be all you need. Adobe makes a cut-down version of Photoshop called Photoshop Elements which is almost as capable. It comes free with Canon scanners.

The other big bitmap program is Painter. This is aimed squarely at artists, mimicking most of the naturalistic effects you can achieve in real media, from oil paints and charcoal to crayon and watercolours. There is a cut-down version, Painter Essentials, which is cheaper and very powerful in its own right.

Increasingly, there are less expensive software packages available that are capable of doing the majority of what a cartoonist might need from Photoshop and Illustrator. After all, you're a cartoonist, not a photo retouching artist. Two of note on the Mac are ArtRage (bitmap) and Lineform (vector). See Appendix 2 for addresses.

If you want to go really cheap, visit www.versiontracker .com, search for bitmap or vector drawing and see what's available. You may find shareware, freeware or innovative, cheaper programs which do exactly what you need.

One final point – don't feel you have to keep up to date with the latest versions of the software. Staying with what you have will save a ton of money and you won't spend time learning new features when you should be drawing.

That really is enough techie stuff. If you have bought the computer and the software, now you need to start drawing to fill the hole in your bank balance.

FROM IDEA TO PAGE

The process of drawing a cartoon is basically the same whether it is for a national or a regional newspaper. I discuss stories with the newsdesk and prepare rough sketches to show the editor. When he has decided which one to use, the final artwork is produced and placed on the page. In the case of The Westmorland Gazette, I have three hours for the whole process and produce a minimum of four sketches. Occasionally, I don't quite hit the mark and the editor asks for more roughs. The maximum so far has been twelve.

My sketches are in 2B pencil and always very quick.

Finished artwork is drawn with Faber Castell brush pen on A4 cartridge paper. It's scanned, a grey tint added in Photoshop and then cropped for the front page. Finally, I produce a colour version which appears each week at www.shelbourn.com/gazette.

During the Great Blizzard of January 2010, snow fell and the UK ground to a halt. Roads weren't gritted and rubbish was left uncollected. Here are two successive weeks' rough sketches and the finished cartoons.

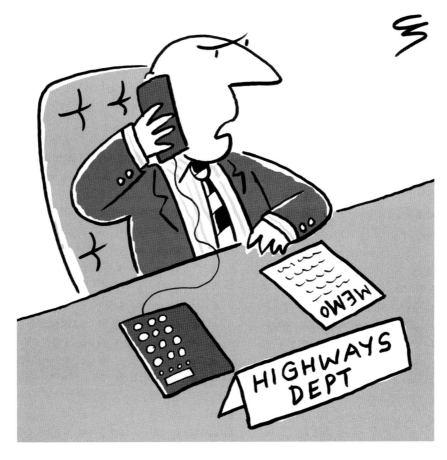

"Make sure you don't grit any paths leading to the complaints department."

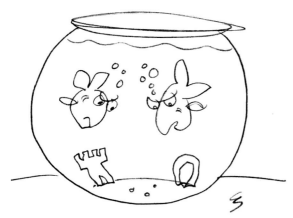

" Hey, where's all our gravel disappeared to ? "

"Let me through, I'm a councillor with an apology ... "

" He didn't slip - he saw some grit on the road and fainted with shock. "

" It's not a snowman - it's a pile of uncollected bin bags."

"It's not a snowman – it's a pile of uncollected bin bags."

FURTHER INFORMATION

This is a round-up of addresses and websites mentioned in the main text. I've included websites for some of the cartoonists mentioned and random items of interest.

INTRODUCTION

The best online resource of Carl Giles's cartoons is the British Cartoon Archive. This is at the University of Kent and has over 130,000 originals in its keeping. It acquired Giles's collection of originals and there's now a dedicated section on their website: www.cartoons.ac.uk/artists/carlgiles/biography and at the other extreme end of the cartooning spectrum – www.purpleronnie.com

CHAPTER 1

There is a new initiative that aims to put budding cartoonists in touch with workshops and teachers across the UK. For details of your nearest workshop, visit www.cartoonclassroom.co.uk.

CHAPTER 2

General art materials

London Graphics Centre, 16 Shelton St, London WC2H
Tel: 020 7759 450
www.londongraphics.co.uk

Cowling & Wilcox Ltd, 26–28 Broadwick Street, London W1V 1FG
Tel: 020 7734 5781
www.cowlingandwilcox.com

A splendid online resource for materials is www.artifolk.co.uk. You can also ring them on 08000 434 617.

For felt tip, brush and technical drawing pens of all descriptions, I can recommend Cult Pens in Devon. They boast they have the widest range of pens and refills on the planet:
Cult Pens, The SQL Workshop, Unit 5 Tiverton Trade Centre, Lowman Way, Tiverton, EX16 6SR
Tel: 01884 259856
www.cultpens.com

Sketchbooks

Elson Graphics Ltd, Unit 1 Brook Street, Syston, Leicester, LE7 1GD.
Tel: 0116 260 2917.
You have to order in quantity to get these but you can sometimes find them in shops in London (the Royal Art College has them). Alternatively, check out my webpage and if I have stocks for sale I'll provide a link to eBay.

Roberson 'Bushey' are available from London Graphics and The Heaton Cooper Studio Ltd, Grasmere, Cumbria LA22 9SX.
Tel: 015394 35280
www.heatoncooper.co.uk

Daler sketchbooks are available in most graphics and art stores.

For detailed information of Quentin Blake's working method, visit his website, www.quentinblake.com, and follow the link to www.houseofillustration.org.uk where there is a lot more information on the art of children's illustration. The site is hoping to raise enough money for a permanent museum.

CHAPTER 3

You can find examples of Hergé's artwork at www.tintin.com. The unofficial site is also worth visiting at www.tintinologist.org.

Pixar's *CARS* is a very clever example of how to get expression into inanimate objects. Have a look at their site at www.pixar.com/featurefilms/cars.

Find more on *The Simpsons* at www.thesimpsons.com.

CHAPTER 4

If you really must, you can find the Stick Figure Death Theatre at www.sfdt.com.

CHAPTER 5

There is no dedicated website to the work of Fougasse, which is a shame. You can find some of his cartoons in the *Punch* library at www.punch.co.uk. The British Cartoon Museum has a few of his originals on permanent display (*see* below).

Steamboat Willie – you can find the original film on www.youtube.com

CHAPTER 6

Ronald Searle's cats appear regularly in exhibitions at the Chris Beetles Gallery (*see* below)

Calvin and Hobbes – www.gocomics.com/calvinandhobbes/ Harry Hargreaves *Bird's Life* cartoons – http://bearalley .blogspot.com/2009/03/harry-hargreaves-its-birdss-life.html.

CHAPTER 7

The official Asterix website is, unsurprisingly, www.asterix.com.

For Lucky Luke and comic book superheroes generally, visit www.internationalhero.co.uk.

The Cartoon Archive (*see* above) has examples of Mel Calman's drawings on display. As does the wonderful Dutch comic book shop, www.lambiek.net (*see* below for more glowing reviews of Lambiek).

CHAPTER 8

Shoe boxes are ideal for manufacturing cardboard theatrical sets, but if you want to go the high tech route, try: Cinema 4D – www.maxon.net/products/cinema-4d.html

For Terry Gilliam's gloriously low-tech animation, there is a video of his first short film at http://www.cartoonbrew .com/shorts/terry-gilliams-storytime.html

Finally for this chapter, you can find more cartoon postcards at www.cardtoons.co.uk

CHAPTER 9

Bob Staake – www.bobstaake.com
 There is a demonstration of his method of working on YouTube. Type his name into the search engine and see the latest videos.

Hardware

Macs – www.apple.com
PCs – www.dell.com
www.jigsaw24.com is good for PCs configured for graphics use
Wacom and Cintiq – www.wacom.com
Scanners – www.epson.co.uk and www.canon.co.uk (the slimline A4 ones mentioned above are the LIDE range)
Monitors – www.eizo.com/products/graphics and www.apple.com
www.tftcentral.co.uk
www.flatpanels.dk/panels.php

Software

Photoshop and Illustrator – www.adobe.com
Painter and Painter Essentials – http://apps.corel .com/painterx/uk/index.html
Expression – www.microsoft.com/expression. New versions

are Windows-only but the last Mac version is available as a free download at www.macupdate.com/info.php/id/14792
Lineform – www.freeverse.com/lineform
ArtRage – www.artrage.com

Wacom Cintiq

Typing Cintiq into YouTube will bring up a number of reviews and demonstrations. There is a good video showing the process of producing semi-realistic comic book art at http://uk.youtube.com/watch?v=Kwhp0Yf6-k0&feature=related.

Chad Essley's sketchbook is interesting – although he uses a TabletPC, his techniques apply to the Wacom. You can find his sketchbook at www.cartoonmonkey.com

CHAPTER 10

Rolf Harris's artwork is on display at www.rolfharris.com
Chris Riddell's site is www.panmacmillan.com/chrisRiddell
The Artist's and Writer's Yearbook – www.writersandartists.co.uk
The Writer's Handbook – www.thewritershandbook.com

CHAPTER 11

Pugh – www.pughcartoons.co.uk
Mac – www.dailymail.co.uk/coffeebreak/cartoons/mac.html
A selection of Mac's cartoon originals is on permanent display in the Mac Room at The Admiral Codrington, 17 Mossop Street, London SW3 2LY
Tel: 0207 581 0005
www.theadmiralcodrington.co.uk
Matt – www.telegraph.co.uk/news/matt
Knife – www.knifeandpacker.com. Knife and Packer are also active in children's books, including the splendidly silly *Fleabag Monkeyface* series published by Walker Books (www.walker.co.uk)
Peattie – www.alexcartoons.co.uk. Charles Peattie and Russell Taylor's creation has appeared in a number of books, the latest of which is simply called *The Best of Alex*.
Scarfe – www.geraldscarfe.com
Arnold Roth – www.arnoldroth.com. His book, *FREE LANCE*, is a 50-year retrospective of his work, published in the US by Fantagraphics Books (www.fantagraphics.com)

The Cartoon Museum, 35 Little Russell Street Street, London WC1A 2HH
Tel: 020 7580 8155
info@cartoonmuseum.org
www.cartoonmuseum.org
The British Cartoon Museum is the only museum of its kind, dedicated to cartoons, comics and graphic novels. It has a changing exhibition and a permanent display of cartoon and comic book art. They also run courses, workshops and have a quarterly newsletter. It is well worth joining the Trust to receive the newsletter and be kept informed of what is going on in the cartoon world.

The Political Cartoon Gallery, 32 Store Street, London, WC1E 7BS.
Tel: 0207 580 1114
www.politicalcartoon.co.uk
The Political Cartoon Gallery is the world's only dedicated political cartoon gallery. The website has a splendid set of biographies of leading British political cartoonists and the shop has regular exhibitions and events. You can also find originals for sale.

The Chris Beetles Gallery is near Bond Street, London's centre for art dealers. Don't be intimidated – in addition to fine art and photographs, the gallery specializes in cartoons. They hold regular signings and book launches and usually have original artwork for sale. It's worth visiting just to see what the originals look like and how much they fetch. They have very friendly staff who will put you on their mailing list so you don't miss any exciting exhibitions.
Chris Beetles Ltd, 8 & 10 Ryder St, St James's, London SW1Y 6QB
Tel: 020 7839 7551
www.chrisbeetles.com/index.htm

Cartoon and Comics Shops

Gosh! 39, Great Russell St, London WC1B 3NZ
Tel: 0207 636 1011
http://goshlondon.blogspot.com/

Forbidden Planet, 179, Shaftesbury Ave, London WC2H 8JR
Tel: 0207 420 3666
www.forbiddenplanet.com

Lambiek in Holland is probably the best comic shop in Europe. It is well worth the trip across the North Sea for the enthusiastic cartoonist.
Lambiek, Kerkstraat 132, Amsterdam 1017 GP, The Netherlands
Tel: +31 20 626 7543
www.lambiek.net

Organizations

Cartoonists' Club of Great Britain
www.ccgb.org.uk
The Cartoonists' Club meets on the first Tuesday of every month, downstairs in The Cartoonist Public House, 76, Shoe Lane, London, EC4A 3JB, from 7.30pm, with a guest speaker at most meetings.

Shrewsbury has an annual international cartoon festival that regularly attracts big names – www.shrewsburycartoon festival.com

The UK Professional Cartoonists' Organization has an online blog at http://thebloghorn.

The Association of Illustrators, 81, Leonard Street, London EC2A 4QS
Tel: 0207 613 4328
www.theaoi.com
The Association of Illustrators is Britain's leading organization for professional artists and illustrators. They issue guidelines and offer help on assembling a portfolio, pricing and running a business. As with the Society of Authors, the organization is for professionals, although they do have a student membership.

There are innumerable websites and discussion forums dedicated to cartoons. One of the very best is US-based The Weisenheimer. Membership is international and discussions are friendly. It's run by professional cartoonist Ted Goff and it is a great place to hang out.
www.thewisenheimer.com

There are loads of blogs and sites dedicated to illustration, comic book art and cartoons. Two of the best are:
http://drawn.ca/
http://thedailycrosshatch.com

Finally

Listing addresses and websites in a book like this is asking for trouble as things get out of date so quickly. To try and counter this, I will keep a dedicated section of my website with current links, addresses and anything which I think may be of interest to readers. So if you have a favourite comic book shop, cartoonist link or exhibition you want the world to know about, send me the details and I'll include it on the page: www.shelbourn.com/drawingcartoons. My weekly blog touches on cartoon subjects from time to time and you can read it at: http://radiocartoonist.blogspot.com.

INDEX